# *Decorative* GLASS

*of the 19th and early 20th Centuries*

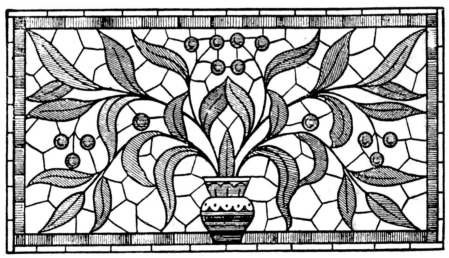

A SOURCE BOOK

•NANCE FYSON•

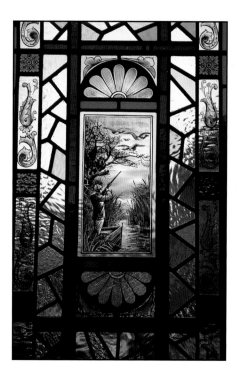

A DAVID & CHARLES BOOK

Conceived and designed by John Strange and Megra Mitchell

First published 1996
First published in paperback 2001

ISBN 0 7153 1258 8 (paperback)

Printed in Singapore by C. S. Graphics Pte Ltd
for David & Charles Publishers
Brunel House   Newton Abbot   Devon

# Decorative GLASS

### of the 19th and early 20th Centuries

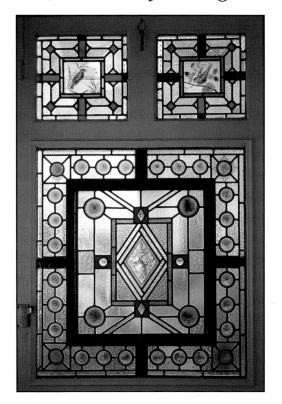

## A SOURCE BOOK
### •NANCE FYSON•

David & Charles

# Contents

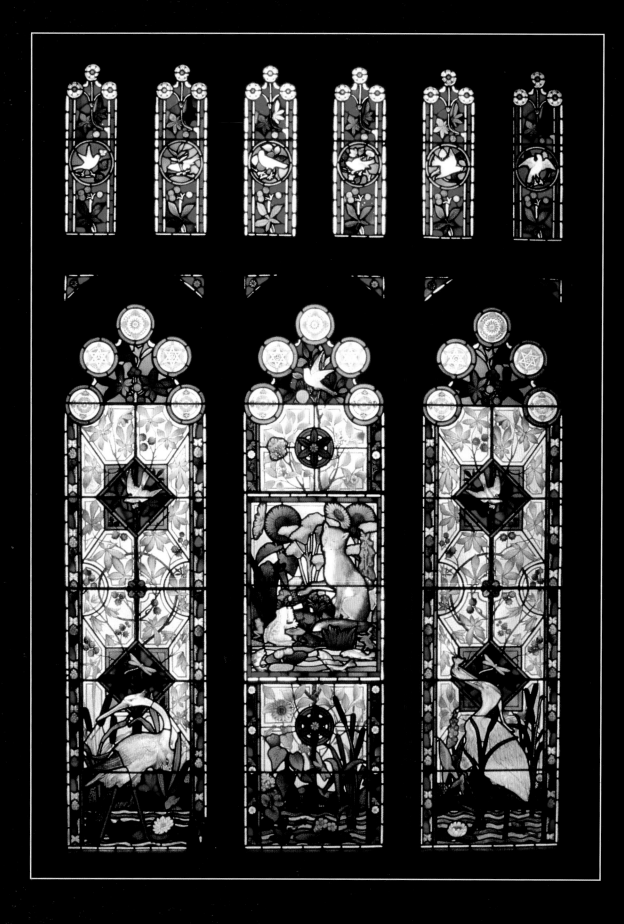

# CHAPTER 1

# *Introduction*

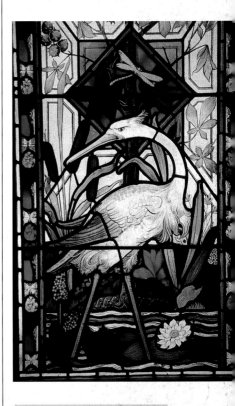

*G*lass is a magical material, adding comfort as well as beauty to our lives. One of its great advantages is that when heated, it becomes malleable and can take on varied sizes and shapes. Whether colourless or coloured, transparent, translucent or opaque, glass can be formed into many decorative as well as useful objects.

The enormous interest in decorative glass over recent decades draws on very traditional as well as recent technologies. Modern innovations have simply widened the scope for using glass artistically, creating alternative, lower-cost ways for simulating the hand-crafted effects of previous eras. Older craft methods still enjoy great favour as well, sometimes using very contemporary subjects and styling.

All glass is made mainly from the mineral silica, which can be sand, quartz crystal or flint. Most glass also has a flux to help the fusion. There are three basic types of glass — soda glass, potash glass and lead glass — and each has its own characteristics.

Soda glass is produced from sand and sodium carbonate and, in early times, Mediterranean plants supplied the necessary ash for flux. This type of glass is the lightest in weight and can be manipulated into highly decorative shapes, such as those favoured by the Venetians.

Potash glass, also called forest or fern glass, uses the ash of inland plants to yield potassium carbonate as the flux. This type of glass, which was especially favoured in Bohemia (now the Czech Republic), is heavier than soda glass and becomes rigid more quickly. While less easy to fashion into complicated forms, it is more suitable for wheel engraving and facet cutting.

Lead glass (also called flint glass), although it was known in Roman times, was primarily a late seventeenth-century English development by George Ravenscroft. Being the heaviest of all glass, it is the best for facet cutting and was used in the eighteenth century to create paste jewels.

*As the ancient rural pattern of life was disrupted by machinery during the Industrial Revolution of the nineteenth century, a wave of nostalgia for all things medieval gripped artists and intellectuals and from this the English Gothic Revival was borne. This movement was to have a powerful influence all over Europe and the United States.*

*Early sixteenth-century English quarries. 'Quarry' glass, square or diamond in shape, usually with brown enamel detailing, was frequently used where simple masses were desired.*

### HAND-BLOWN OR MACHINE-MADE

Despite modern innovations, the basic material known as 'glass' remains very much as our ancestors knew it. One of the most fundamental distinctions is between hand-blown (antique) and machine-made varieties.

With the hand-blown types, a blob of molten glass is picked up on the end of a blowpipe and blown into a bubble. For 'crown' or spun glass (rare today but common in old windows), the round bubble is attached at its thickened nub to an iron rod. The blowpipe is cut away and the rod is spun rapidly, creating a flat disc with a central bull's-eye. For 'muff' or cylinder glass (most commonly used in stained glass), the bubble is elongated into a cylinder by swinging. The top and bottom are cut off, the cylinder is split and then opens to a flat sheet.

Both crown and muff processes were used in the Middle Ages, while a third main type, Norman slab, was invented in the nineteenth century. This 'bottle glass' has a long bubble of glass blown into a rectangular mould, with the sides then divided into separate slabs.

Antique (hand-blown) glass is available in a variety of attractive patterns and effects. For example, 'seedy' antique is sprinkled with small bubbles. 'Crackle' has a pattern created by quickly dipping the hot glass into water. There are variations in thickness too – the inherent imperfections and irregularities are part of the charm.

The spread of machine-made glass has been achieved by the more recent development of squeezing the semi-molten mixture between metal rollers to create a flat ribbon of glass, known as 'rolled' glass. A wide range of decorative textures and tints can be produced this way as well. The most recent technique involves floating the molten mixture on a bed of polymers which produces a glass with far fewer flaws or blemishes than with rolled glass.

One main textured, transparent type is 'cathedral' glass, with a pattern or texture on one side which can diffuse and scatter the light, while the other 'cutting' side is smooth. Another machine-made glass which is commonly used, called 'opalescent', is translucent and marblised. It is smooth on both sides, fairly opaque and the hardest mass-produced glass.

Whether hand-blown or machine-made and whatever shaping is used, all glass must be 'annealed', which means cooled very gradually. This is often done on a conveyer belt which passes along a heated tunnel called a 'lehr'.

### COLOURING GLASS

The natural colouring of glass is a slightly greenish, yellowish or bluish tinge that is caused by impurities in the raw materials. This colour can be taken out by adding a small amount of manganese oxide, a technique known in the first century

and rediscovered by the Venetians in the fifteenth century to make their clear '*cristallo*' glassware.

While clear glass is often desirable, colouring may be added as well as taken away. Mosaic-coloured windows and glass objects are frequently now referred to as 'stained glass', but there are in fact four distinct techniques for adding hue – pot metal, flashing, staining and enamelling.

Pot metal has various metal oxides added to a clear glass as it is being processed, so the glass is coloured right through. (Adding copper oxides makes blue-green, gold produces red or ruby, cobalt makes blue, manganese oxides yield purple and iron oxide results in various greens.) While pot metal is only a single colour, 'streaky' glass has an additional colour running through it.

Flashed glass is made by coating white glass with a thin layer of pot metal. This flashed glass is more translucent, and is used especially for producing red glass.

Staining glass, a technique discovered in the fourteenth century, requires clear or light-coloured glass to be painted with silver sulphide or chloride. Oven firing changes the glass to a yellow colour, and the staining and firing can be repeated to create a deep orange.

Enamelled glass is a technique that uses the fact that compounds of ground glass and oxides become nearly transparent when heated and fused to a clear or white glass. Painting on glass with enamels became widespread during the seventeenth and eighteenth centuries, virtually replacing other methods. In the nineteenth century, enamelling lost favour as the earlier techniques for colouring were revived.

## THE EARLY HISTORY

The discovery of glass dates from over 4,000 years ago and was made in the Near East in Mesopotamia and Egypt, where it rapidly became a cheaper substitute for gems and was fashioned into beads and other jewellery. Most early glass was opaque and coloured. It could be cut and polished more easily than precious or semi-precious stones.

In about 1650 BC, glass vessels were being made using a core-formed technique. A mix of sand, clay and mud was shaped around a metal rod and then dipped into molten glass. The vessel was rolled, decorated on the outer surface and then rolled again. Handles, rims and bases were attached, the metal rod was taken out and the core removed. Another basic technique which developed around 1500 BC in Mesopotamia involved casting mosaic glass to make bowls and goblets. Segments of glass 'canes' were put in a shaped mould to make a pattern and then heated until the canes were fused. The mould was then taken away and the vessel was polished until it was smooth. An array of items were made from about 1600 BC, including glass plaques to ornament royal palaces, seals, amulets and jewellery, as well as inlays for furniture.

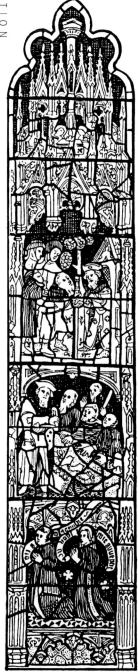

*A late Gothic window, north aisle, All Saints' Church, York.*

*Design influences of ancient Greece can be seen in the shape of the urn in this window. Colour as well as form was a great factor in early Greek art.*

The glass industry then spread to areas such as Palestine and Syria, along with the Mediterranean islands of Rhodes, Cyprus and Crete. Small, rectangular thin tablets called 'appliqués' have been found, used as personal adornment. The blue and green glass which emerged in the eighth century BC around northern Italy (Etruria) was used for small objects such as bracelets and beads. By 450 BC, Aristophanes wrote that glass vessels were second only to gold in cost.

The years 330–30 BC were known as the Hellenistic Age and luxury glass items, such as dishes and bowls, were made by skilled craftsmen. By the end of the era, the creation of glass had become widespread all around the Mediterranean and production was for much more than simply wealthy patrons. The Romans continued Greek glass-making techniques and began using new colours. They were highly skilled in glass arts and much from this period survives today. Glass mosaics were made from

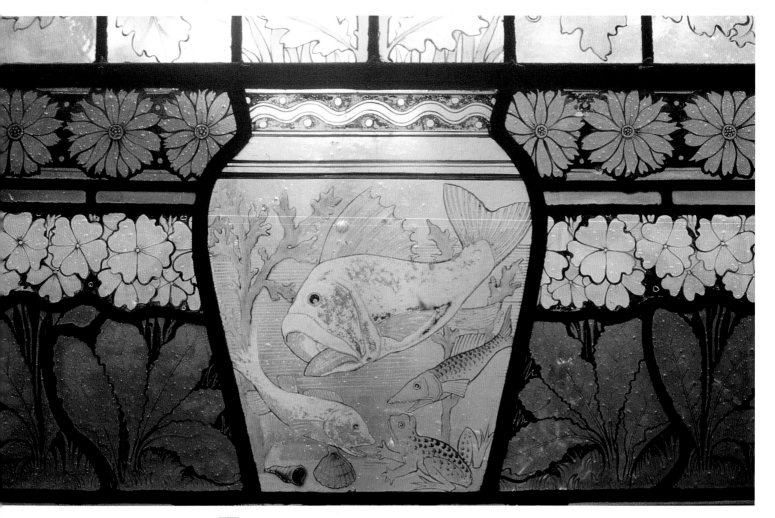

pieces of coloured glass that had been backed by a reflecting metal foil. Vessels were made that exhibited this mosaic style, using sections of coloured glass fused in moulds (foreshadowing the decorative technique of millefiori).

The technique of glass-blowing developed in the second half of the first century BC, with widespread effects. Glass vessels could be produced more quickly and cheaply and they became used for eating and drinking, as well as for storing everything from oil and wine to cosmetics. Blowing into a mould allowed identical bottles to be made in sizable numbers. The first century AD was a time of great experimentation and innovation, with engravers and enamellers decorating colourless glass. Painted glass was introduced to northern Italy by the Syrians. Bright colours were painted on the outside of a vessel then fired in a furnace so the colours would fuse.

Cage cups were one type of luxury glass of the late Roman Empire, decorated by a net attached to the main part of the vessel by tiny bridges. During the third century, the Romans began producing gold sandwich glass made by fitting two vessels together. The exterior of the inner vessel was covered with gold leaf, forming patterns. The most impressive examples of luxury ware were made of cameo glass. This involved cutting away an outer white layer of glass, leaving the design in relief against a dark background. The Portland Vase, in the British Museum, is a superb example of this technique.

Glass-blowing also encouraged the use of glass in windows. The earliest window glass was made either by casting in a shallow mould or by blowing a bubble, and then cutting off one end and splitting the length of the cylinder to make a sheet. Slabs of window glass have been excavated from the

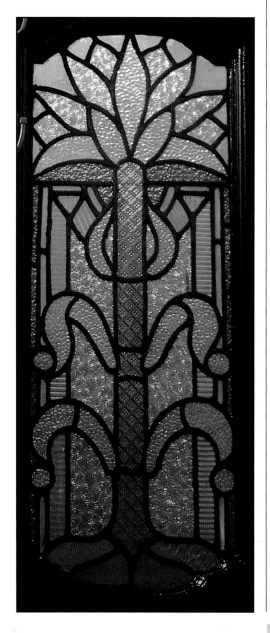

*The influence of the ancient Egyptians can be seen clearly when this window (left) is compared with the illustration of an Egyptian lotus flower (above). This flower was the first flower of the Egyptian spring and the people viewed it as the harbinger of coming plenty. These illustrations were taken from an article (c1870) by the designer Christopher Dresser. He was greatly influenced by Egyptian ornament.*

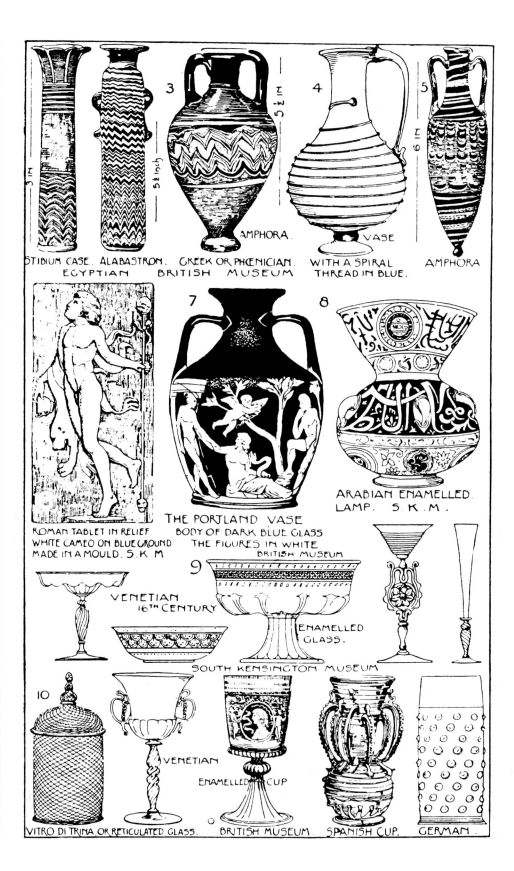

*The tradition of glass dates from the remote past with glass blowing being represented on the tombs of Thebes (2500 BC). The illustration shown here is taken from A Manual of Historic Ornament by Richard Glazier, 1899.*

ancient sites of Pompeii and Herculaneum. The effect of being buried for 1,800 years has caused a natural rainbow-like iridescence on the surface of most pieces. Many modern creators have tried recreating this effect on new wares.

After the decline of the Roman Empire, there was little decorative glassware made in Europe until the Florentine Renaissance early in the fourteenth century. During the intervening period, serviceable potash glass was being made in forests, using the ashes of plants there. Lime was added to make the Waldglas more durable. By the early ninth century, glass-making as an art had virtually disappeared in Europe, as the Church claimed it was a form of black magic.

Meanwhile in the Middle East, and in particular Egypt and Syria, the artistic production of glass continued. By the early thirteenth century, Islamic craftsmen had mastered the techniques of gilding and enamelling and glass-workers were also using the metallic lustre pigments which had been used on pottery in the area since the ninth century. Enamelling is a process of applying a thin coat of glass in powder form to a metal. This melts and fuses to the metal when heated to a temperature of about 760° C (1,400° F). Some of the best-known items of enamelled glass were the mosque lamps produced in Syria in the thirteenth and fourteenth centuries. These lanterns were the earliest known use of glass for carrying light. They were gilded and enamelled with quotations from the Koran, then hung from the ceiling using loops of chain.

## STAINED GLASS

It is likely that the decorative art of combining small pieces of glass together to make a picture or pattern, what is now commonly called 'stained glass', began in the Middle East, probably to infill small holes in walls. While glass was made in England during the Roman occupation, there is no evidence of decorative coloured glass. France has a much stronger early tradition and most of the early coloured glass in Britain was French. It was common to import the craftsmen along with the material.

Glass, and especially coloured glass, was regarded as very precious during the Middle Ages. It was very expensive to make, used primarily in churches and the secrets of production were guarded closely. Since the eleventh century, the glass has been held together mainly by lead 'calms' (from the Old English word 'calme' meaning 'length'). The durability and flexibility of lead makes it very suitable for this craft, and it is also fairly easy to cut and solder.

By the twelfth century, new cathedrals were filled with stained-glass windows showing scenes from the lives of, or imaginary portraits of, Christ, the Virgin Mary and the prophets, and martyrs and saints. Stained glass was practical for letting in light and the brilliance is all the more intense because of dark church interiors. While the

*An example of early* grisaille glass, Salisbury. Grisaille *means a decoration in tones of a single colour, especially grey, and is designed to give a three-dimensional effect. The north transept window in York Cathedral, called the 'Five Sisters', is typical of this technique. The finest examples, however, are at Salisbury, Canterbury and Chartres cathedrals.*

*The glass panels in the bay window of Castle Lodge, Ludlow are characteristic of the Elizabethan and Jacobean periods. The house dates from around 1564 when it was built for Thomas Sackford, Master of Requests at the court of Queen Elizabeth I.*

technique of stained glass was well known by the twelfth century, some people felt that too much ornament in the churches would distract worshippers from spiritual thoughts. Abbot Suger (1081–1151) was one of those taking the opposite view. He regarded delight in the House of God as spiritually elevating in itself, claiming 'the loveliness of the many-coloured gems has called me away from external cares...'

The earliest English window still in its original setting is twelfth century, at Brabourne, Kent. Its near abstract pattern is an example of '*grisaille*', a glass design using mostly white glass and muted colours, often grey. While the earliest patterns were abstract, mid-eleventh-century panels were also showing figures. A famous example is the five prophets of Augsburg Cathedral, which is the oldest complete stained-glass window in the world.

In the twelfth century, there was usually a border around a window to use up the precious excess chips of expensive glass. Figures from this time were bold and heavily leaded, creating the effect of glass

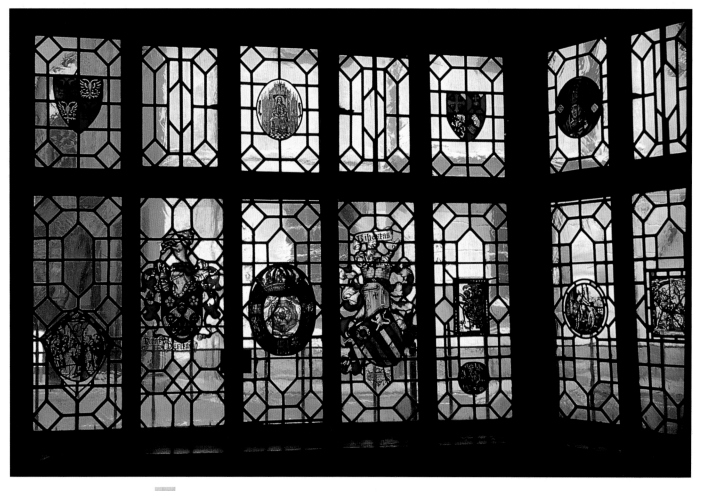

mosaic, and little brushwork used. The rise of more narrative stained glass in the thirteenth century paralleled the development of drama as an art form. Stained glass reached a pinnacle in the twelfth- and thirteenth-century cathedrals of Chartres, Canterbury and York, among many others in France and England. Much fine stained glass from that time still survives in England, including the windows of York Minster which has more medieval stained glass than other English churches combined.

By the fourteenth century, larger panels of coloured glass were available and the transparent yellow surface stain made from sulphide of silver was developed, making windows much lighter. The role of the painter, who added details, increased. By the fifteenth century, silver stain was an important part of glass painting. Abrasion of sheets of flashed glass developed, which made it possible to pick out details in white on a coloured ground. In the mid-sixteenth century, transparent enamel pigments were being painted onto clear white glass.

As medieval stained glass was linked with the Catholic Church, there were growing Protestant objections to the imagery. Craftsmen were diverted into making small panels for secular use. Stained glass first appeared in domestic buildings in about the fourteenth century, in France. By the late fifteenth century, houses in Switzerland, Germany, the Netherlands and England used them as well. Religious

and mythological subjects, as well as coats-of-arms, were popular.

By the sixteenth century, there were fewer commissions for religious glass and the demand for secular production increased. During the English Civil War (1640–48), patronage for stained glass virtually disappeared. The Puritans destroyed much, claiming it to be the

*There was a mid-century revival of Gothic architecture with a movement away from the severe straight lines of the Classical style. This prompted renewed interest in stained glass, often complete with heraldic symbols.*

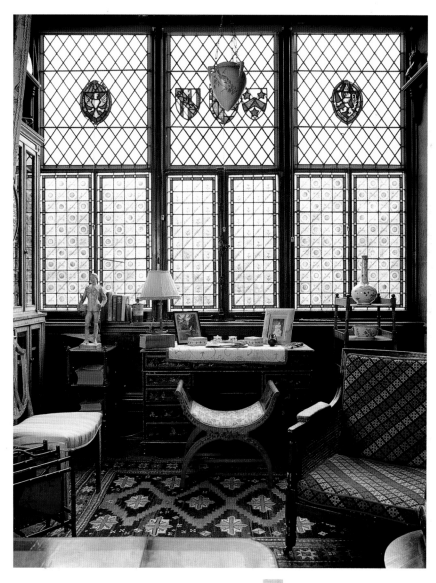

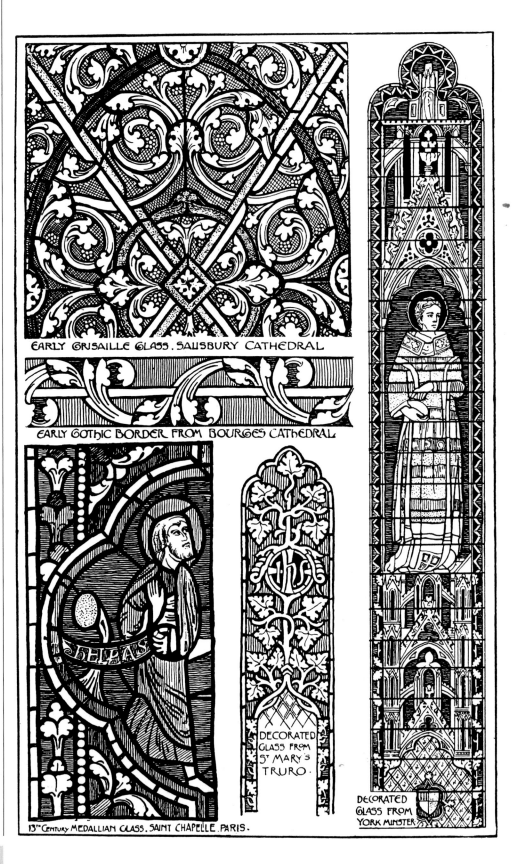

EARLY GRISAILLE GLASS. SALISBURY CATHEDRAL

EARLY GOTHIC BORDER FROM BOURGES CATHEDRAL

13TH CENTURY MEDALLIAN GLASS. SAINT CHAPELLE. PARIS.

DECORATED GLASS FROM ST MARY'S TRURO.

DECORATED GLASS FROM YORK MINSTER

*Stained glass changed through the different periods from the rich coloured mosaic of the Normans; the equally rich coloured medallions and grisaille glass of the early Gothic; the decorated Gothic, with glass in lighter colours and a prevalence of yellow stain; culminating in the later Gothic period, when largeness of mass, lightness and silvery colour were the characteristics.*

work of the Devil. Some windows were saved by being removed and hidden — but many church windows in London that survived the Puritans were then lost in the Great Fire of 1666.

## GLASS IN THE AGE OF ENLIGHTENMENT

Elsewhere in northern Europe, nearly all the glasshouses for making stained glass were centralised in Lorraine, bordering the Rhine. When Lorraine was torn by war in 1663, the glasshouses were demolished and workers fled in disarray. As the supply of coloured glass was much reduced, European artists tried using enamel paints on clear glass. The result was not translucent and the tradition of making pictorial windows that transmitted light was temporarily lost. The increased availability of large panes of clear glass for windows also encouraged the decline in stained-glass art from the mid-seventeenth century.

Glass-making had been carried on in Venice since early times but it was soon after the year 1200 that the craft began to flourish. By late that century it was decided that there was considerable risk of fire from the furnaces, so the industry was moved to the adjacent island of Murano, where it remains today. By the second half of the fifteenth century, Venice had been established as Europe's leading producer of luxury glass. The use of gold flecking, coloured canes and trapped air bubbles has never been bettered. The term 'cristallo' was first applied to decolourised glass objects made in 1409. Opaque white 'lattimo' glass was produced after 1475, imitating Chinese porcelain.

Venetian glass continued to be popular during the sixteenth century, and it became lighter and less coloured. A technique called vetro a filigrana developed, using twisted designs and criss-cross inlays. Another technique, called vetro a reticello, used criss-crossed bands trapping bubbles of air to make a net in the glass. Ice glass also originated in Venice, which shows a cracked irregularity. In the later part of the sixteenth century, engraved glass became very fashionable.

There were notable changes in the decoration of glass during the seventeenth century. George Ravenscroft, who set up an experimental glasshouse in London in 1673, produced a metal, lead crystal and ancient Roman methods of cutting were re-introduced. New processes enabled the creation of large sheets of glass and mirrors. The focus of European glass-making generally moved from Venice to Germany and Bohemia.

The very first European lanterns were simply boxes to protect live flames, but elaborate chandeliers had developed by the 1730s. In 1784 the Argeund lamp was invented, which was fitted with a glass tube. While stained glass was not an important art form in the eighteenth century, its popularity revived considerably in Victorian times.

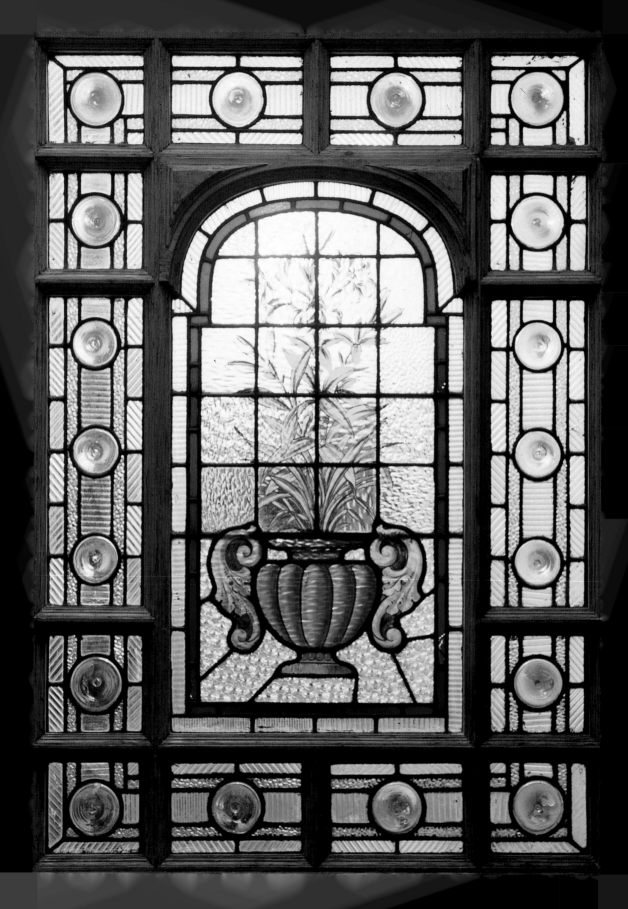

# CHAPTER 2

# The Victorian Era

T he nineteenth century heralded a revolutionary approach to glass generally. Cut-glass was dominant until about 1825, then Bohemian glass-makers set a new fashion with coloured and opaque-white pieces using enamelled and gilt decoration. Both England and Bohemia (now the Czech Republic) were leading artistic glassware producers by about the middle of the century. France was important as well, having created a translucent, milky-white glass called 'opaline' in about 1810. There was also a revival of Venetian glass-making led by Antonio Salviati. The popular styles of sixteenth- and seventeenth-century Venice became fashionable again in Europe and America.

Besides techniques of enamelling and gilding, wheel-cutting and engraving, new processes such as acid-etching and transfer-printing were introduced. Acid-etching involved scratching a pattern through a layer of bituminous paint, after which the article was plunged into an acid mix to dissolve layers of the unpainted area. Transfer-printing on glass, which started about 1809, involved an engraved copper plate inked with a design which was then transferred to paper. While the ink was still wet, the pattern was pressed on to the glass and then fixed by firing.

Cameo glass, which was probably first developed by the Romans, was revived in England in the later nineteenth century. Layers of glass, often using different colours, were laminated together and then either etched to make a design in relief, or carved on a wheel. The relief decoration was usually in white against a coloured, translucent glass background. In England, Thomas Webb's glassworks began production in 1856. Their main focus was cameo glass and

*A detail from a leaded panel shows how areas of opaque designs were incorporated. Nineteenth-century artists often used glass as a surface for painting with enamels. Transfer-printed designs were added as well.*

*Plants and flowers were a favourite Victorian subject for windows as the reverence for nature gathered pace in the nineteenth century. By later decades, trends such as the Arts & Crafts movement and then Art Nouveau produced much freer, swirling lines to depict these subjects.*

rock crystal (engraved lead glass cut to imitate the facets of real rock crystal). Other noted makers included Stevens & Williams of Stourbridge and J. & J. Northwood. In France, Emile Gallé began producing a type of cameo glass in about 1884. His technique involved cutting the pattern into the various layers of coloured glass using a wheel.

In the late nineteenth century, bevelled glass also became part of the decorative scene. The availability of inexpensive plate glass from the 1880s onwards started a trade in ornate panels made of small, bevelled pieces with tiny notches on the edges. Faceted jewels were often included as well, and by the mid-1890s there were dazzling combinations of stained and bevelled glass.

The significant invention of press-moulding in America in the 1820s made it possible to produce decorative glassware much more cheaply. The molten glass was poured into a mould to determine the

*Pressed glass, which began with the invention of the process in 1827 by Deming Jarves at the glassworks of the Sandwich & Boston Glass Company, brought the elegance of more expensive cut-glassware to the most ordinary table.*

outer shape, and a plunger was then thrust in to determine the inner shape. A much wider sector of the population could now afford glass, and the technique spread to Europe over the following decade. The presses were hand-operated until steam presses were patented in 1864. Press-moulded wares were mainly domestic items, usually in a clear glass to imitate more expensive cut-glass.

The Boston Sandwich Glass Co, which functioned from 1825 to 1888, specialised in producing a lacy, pressed glass. Another important glassworks near Boston, called Mount Washington, in operation from 1837 up to 1958, produced a full range of glass products including 'Burmese' glass lamps. These had a matt satin surface, often with elaborate ornament in coloured enamels. The fish was a popular Mount Washington design, while some Burmese ware had quilted or cross-hatched designs.

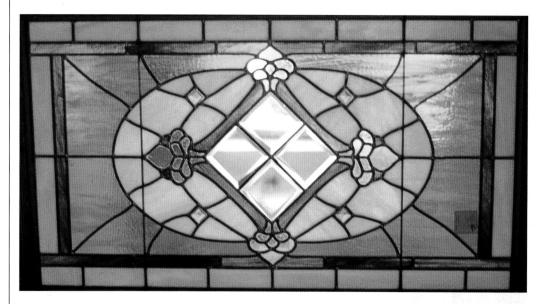

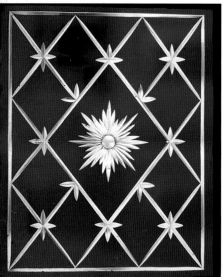

The availability of inexpensive plate glass from the 1880s onwards started a trend in ornate panels made of small, bevelled pieces with tiny notches on the edges. Faceted 'jewels' were often included as well. By the mid-1890s, there were dazzling combinations of stained and bevelled glass.

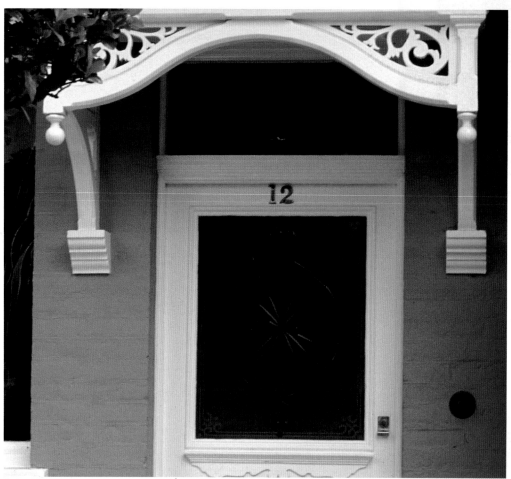

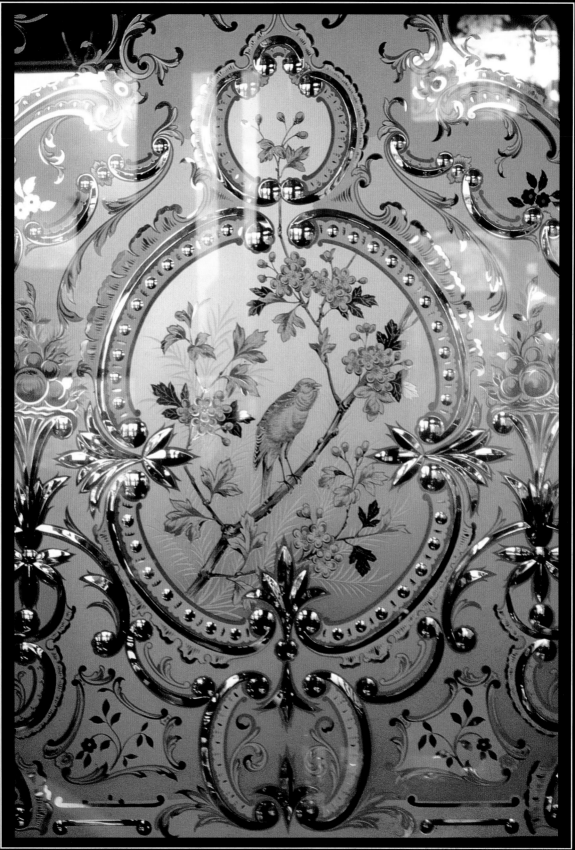

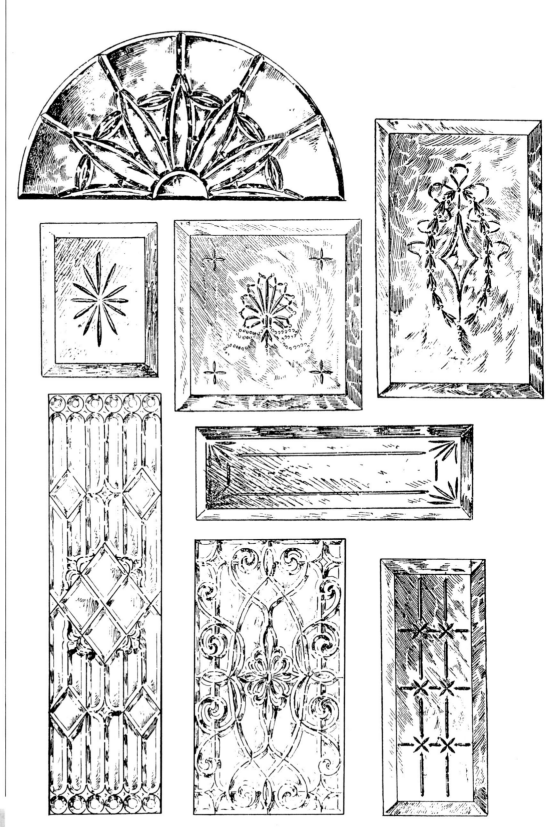

*A selection of some of the many designs for etched and bevelled glass panels available from glass-makers' catalogues during the latter half of the nineteenth century.*

*These etched panels, decorated with a diaper design, give privacy while allowing light to enter a room or hallway. Glass of this type was often used in entrance doors as a less expensive alternative to stained glass.*

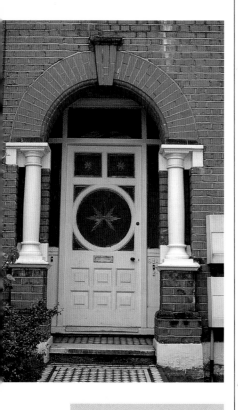

*Etched glass was often used as an alternative to stained glass, and in recent years it has become quite sought-after. Redundant windows from pubs and offices are still to be found in architectural salvage yards but they are becoming increasingly rare and consequently quite expensive.*

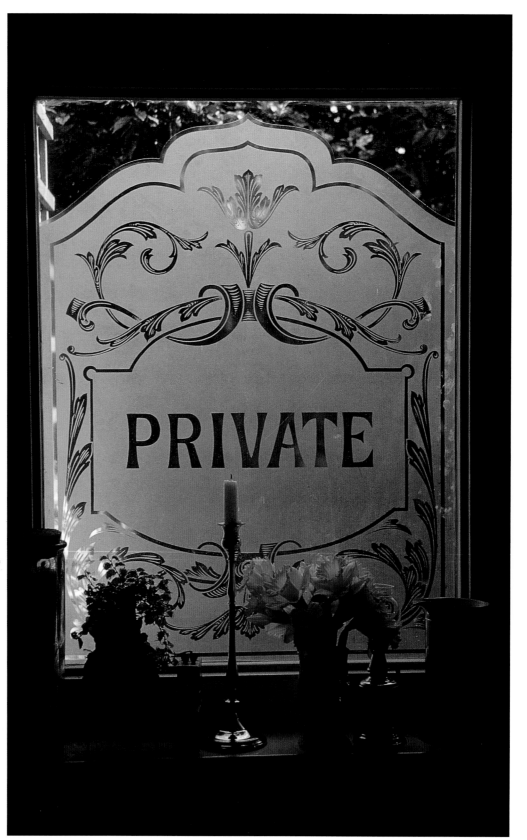

PRIVATE

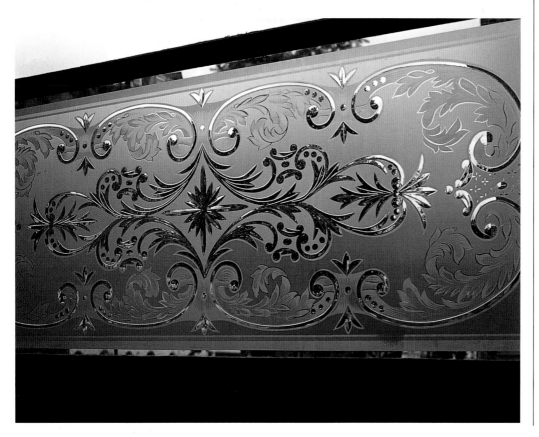

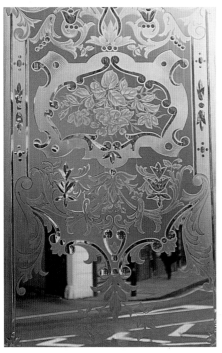

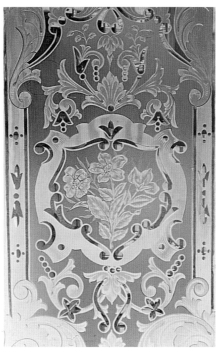

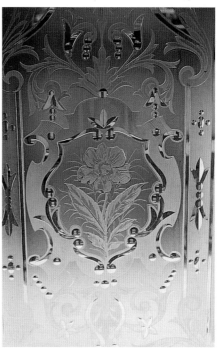

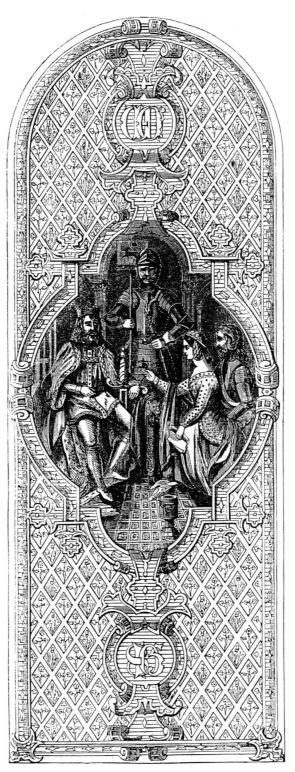

*This stained-glass panel was exhibited at the Crystal Palace exhibition in 1851. The entry in the catalogue reads as follows: 'Stained glass window, executed by Messrs. Ballantine & Allkan of Edinburgh. It is intended for the entrance-hall of Glenmoriston, the property of Mr W Chambers. This estate is held direct from the Crown, on condition that the proprietor, when required, shall present the sovereign with a red rose on the festival of St John. The design in the centre of the window represents this ceremony, which, according to local tradition, was last performed in 1529. The picture, as well as the entire window, is surrounded by a rich border of ruby and gold, studded with imitations of gems. The background is pale blue, with gold bands, stencilled in white enamel with the united national emblems — the rose, shamrock, and thistle.'*

Architectural glass was experiencing a similar expansion during the century. During the early decades, artists were still using glass as a surface for painting a picture and avoided leading as a way of joining small pieces. But in 1827, the French government provided support to set up a studio for making stained glass at the Sèvres Porcelain Factory. The workshop lasted about twenty-five years, producing windows that copied old paintings or used designs by artists such as Eugene Delacroix (1798–1863). By the middle of the century, the number of stained-glass workshops in France increased from a mere three to about forty-five.

The British glass industry was encouraged by the lifting of excise duties on glass in 1845 and again by the abolition of the window tax in 1851. The Crystal Palace, which was built in 1851 to house the Great Exhibition, reflected the growing interest in glass for architecture. The traditional glass-blown method was used to make over 300,000 panes for the structure, requiring day-and-night production over six months. Stained glass featured in the displays and the catalogue confidently stated: 'It has been a popular notion that this art was lost to us; such is not the case . . . It has indeed been dormant, but never extinct. The fine work exhibited this year . . . announces its revival.'

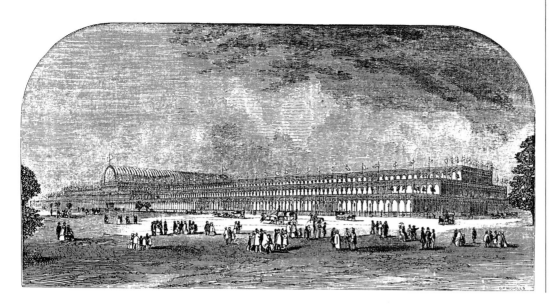

◀

*The south side of the Crystal Palace – site of the Great Exhibition, 1851.*

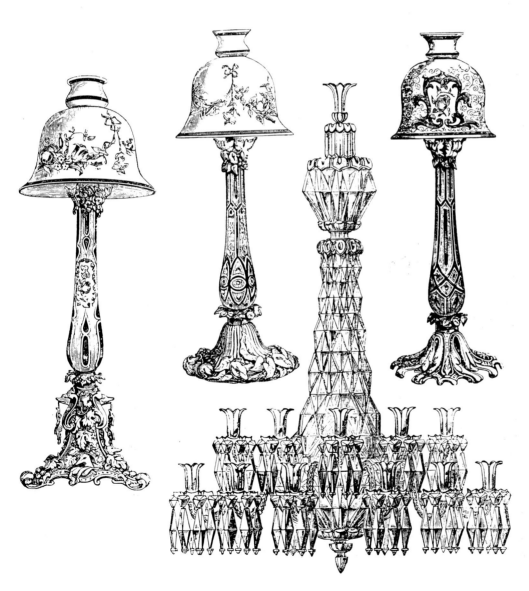

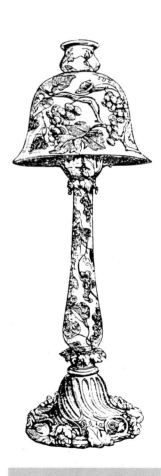

*A selection of glass items exhibited at the Great Exhibition.*

Dazzling, jewel-like colours in the transom (above right) contrast sharply with the muted, almost monochromatic use of colour in the window insert shown above.

▶

The influence of William Morris is evident in this romantic, leafy design. Morris turned to stained glass in the 1860s and was a leading figure in the Arts and Crafts Movement. He insisted that good decoration was an 'alliance with nature'.

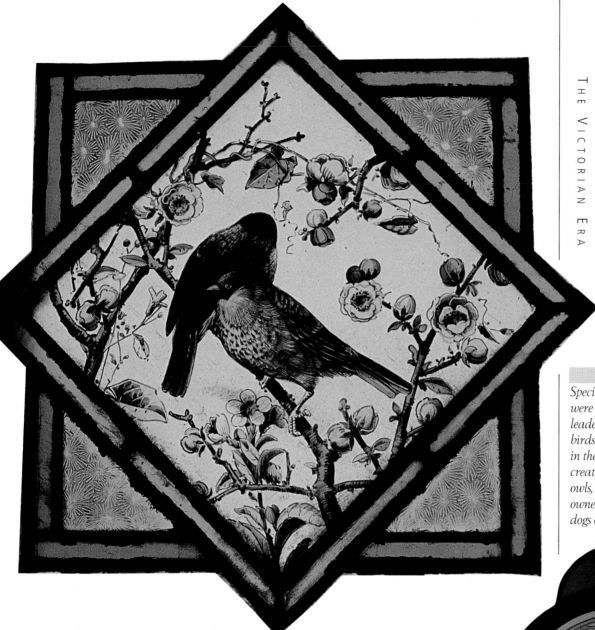

Specially painted inserts were popular in Victorian leaded-glass panels. Small birds were especially favoured in these medallions but other creatures, including ducks and owls, appeared as well. Home-owners sometimes requested dogs or cats.

## PAINTING ON GLASS

In the sixteenth and seventeenth centuries, both the Dutch and the Germans were noted for producing small enamel windows often containing, in the space of a square foot, several subjects. These were usually taken from sacred history and painted with great skill and elaboration. Besides these figure subjects, heraldic designs including coats-of-arms were very successfully treated in enamel colour. The old German painters were very careful to outline their work in tracing brown, and to produce a good, solid, finished effect in this way before proceeding to use the enamels. They confined their enamels to small parts of the design and usually restricted the enamels to blue, green and ruby.

As long as the enamels were employed

in small masses, as they were in the small subjects and heraldic devices of the old German glass painters, no harm was done, but when men proceeded to fit church windows with these painted windows, they were setting up a false art in place of the one they dethroned. Such windows are dark, gloomy and funereal as may be seen in the west window of the Abbey and in the windows designed by Sir Joshua Reynolds (1723–92) at Oxford. However, enamels are quite legitimate when used appropriately. Enamelled glass entirely superseded the old leaded stained glass which had made churches and cathedrals so magnificent in the fourteenth, fifteenth, and the early part of the sixteenth centuries. For nearly 250 years, stained glass windows ceased to be produced in Britain.

## REDISCOVERY

Working in stained glass was revived in the 1840s and 1850s by the exertions of a few men, foremost among them being Mr Charles Winston, a barrister. He examined the remains of old glass in English ecclesiastical buildings, and had some fragments of old stained glass analysed by a chemist whom he hired to help him. Slowly and with infinite patience they rediscovered the formulas for making medieval coloured glass. Starting in about 1850, by 1856 they had managed to duplicate the colours that had been used centuries before. They had retraced the craftsmen's steps back some 500 years, to

the time when the art of staining glass and combining it into windows was most successfully practised.

A few years of experimentation led to production of antique glass that was far better than what was produced in the twelfth and the thirteenth centuries. Winston approached the London firm of James Powell and Sons (Whitefriars) to test the findings in their sheet glass. These windows were referred to as mosaic windows, and were described as 'windows coloured by the use of various pieces of divers tints, fitted together something like a child's puzzle'.

The chief beauty of the old stained glass windows is their colour, and the art of the glass painter was to combine the various pieces of coloured glass into a harmonious and appropriate design. Colour can only be given to glass in its molten state if it is to retain its gemlike beauties of transparency and translucence. Glass coloured by means of enamel is dull, flat and opaque compared to 'stained' glass, and the gem-like qualities in the old windows, which makes them still so beautiful, are entirely wanting in enamelled windows. The most beautiful enamels made cannot have the same transparency as glass coloured through its entire substance.

## THE GOTHIC REVIVAL

One of the most important influences on glass artisans was the renewed fervour for medieval art and architecture. In 1848, several English artists, including Dante Gabriel Rossetti (1828–82) and

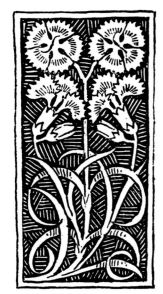

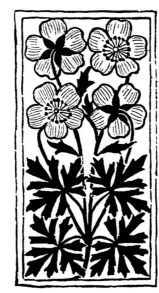

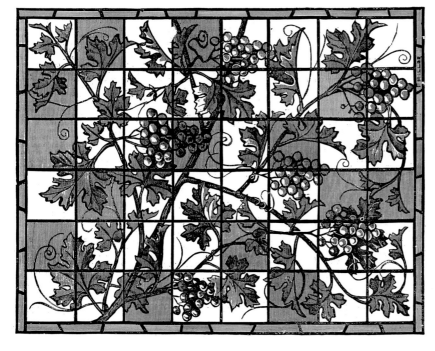

*Victorian building-supply catalogues showed a wide range of available glass patterns that could be ordered. The complex, neo-gothic style fashionable from the mid-nineteenth century is very evident here. Pattern books after the 1880s began showing a simpler style, often with neo-classical wreaths, ribbons and fleur-de-lys.*

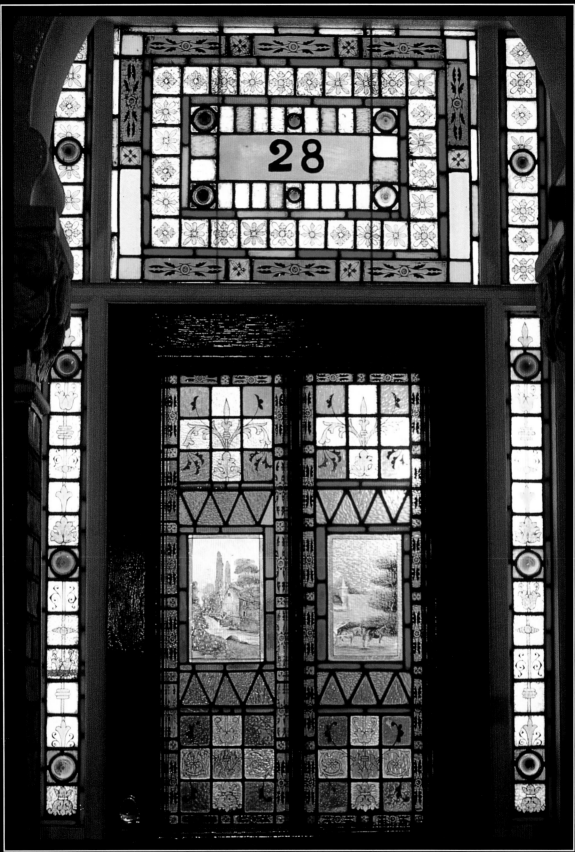

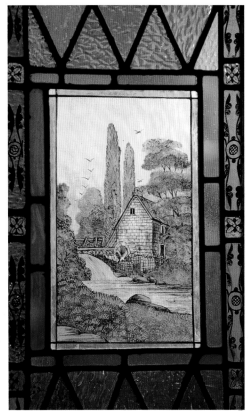

With the increase of speculative building, whole streets of identical houses were built . Often the only note of individuality visible from outside was the different central medallions or painted panels in the stained-glass doors. However, this can be a great advantage today when trying to replace a front door with an authentic reproduction, as a wander around the area will usually produce at least one or two doors which have remained intact and could be used as patterns.

*Illustrated here are two pages from a typical glaziers' catalogue of the period showing some of the wealth of designs that were available.*

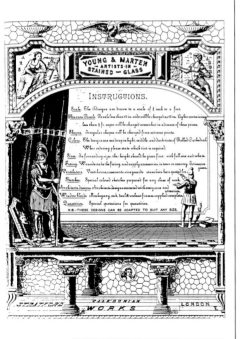

▲

*Title page from Young & Marten's catalogue of stained-glass designs.*

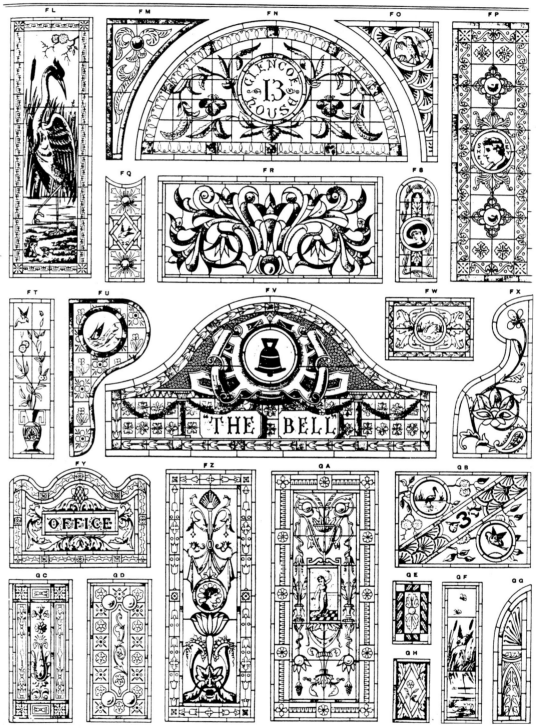

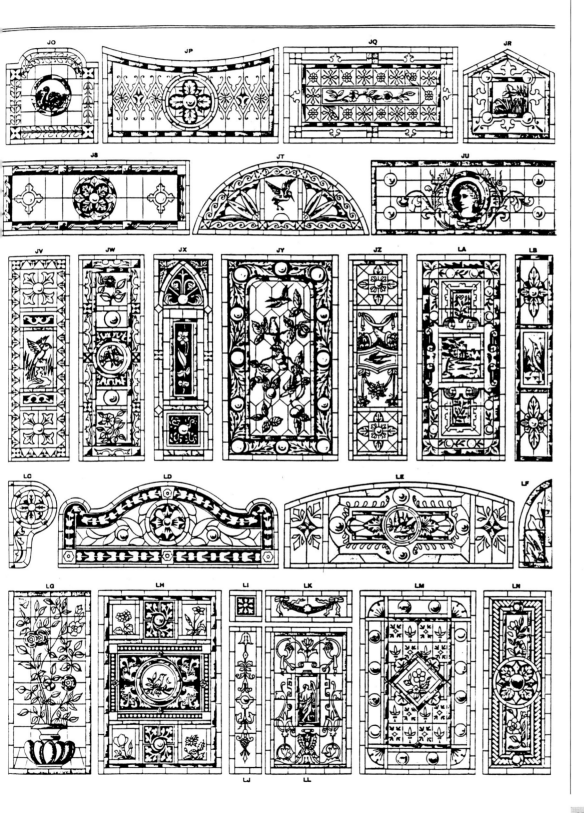

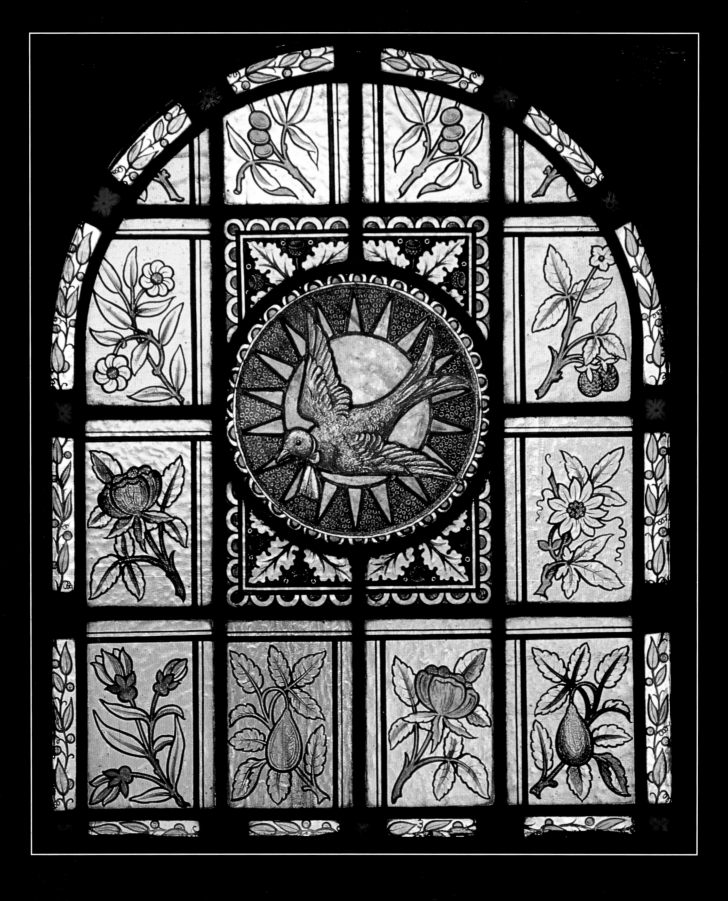

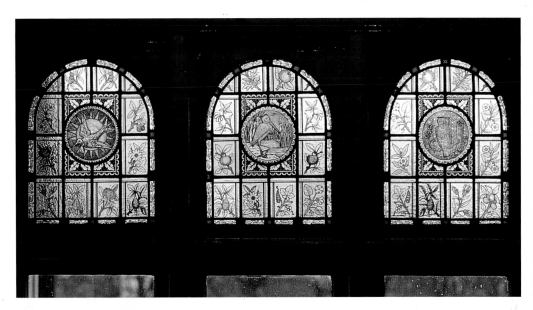

*These charmingly painted panels are surrounded with small glass panes each depicting a different flower or fruit. These panes, which can be square or diamond in shape, are called 'quarries'. They serve the purpose of being decorative while giving a light and airy feel.*

John Everett Millais (1829–96), formed a group that they called the Pre-Raphaelite Brotherhood. They were opposed to the received opinion that sixteenth-century High Renaissance art (as typified by Raphael) was the pinnacle of artistic achievement. They preferred instead the simpler inspiration of the Middle Ages or even nature itself.

Meanwhile, the architect Augustus Welby Pugin (1812–52) was encouraging a mid-century revival of Gothic building. He preferred its curving, organic shapes to the severe straight lines of Classical style. As stained glass was so much a part of medieval architecture, it is not surprising that it, too, was part of this revival. Pugin disliked the emerging industrial environment and equated the 'noble' look of medieval buildings with the more 'refined' spirit and taste of the Middle Ages. His notion that art and architecture could be used to help improve society was an important theme developed by others at the time. Examples of his designs include part of the décor of the Houses of Parliament and St Pancras railway station in London. Mid-nineteenth-century America shared the growing European fashion for Gothic designs.

## THE ARTS AND CRAFTS MOVEMENT

The ideals of the Pre-Raphaelites and Pugin were in harmony with another burgeoning trend. A wide variety of writers, artists and craftspeople were part of the Arts and Crafts Movement which developed in the second half of the nineteenth century. Their aim was to improve both the quality of goods and the satisfaction of workers by a return to a hand-craft tradition. Growing industrialisation was producing inferior products and Victorian workers toiled in unhealthy conditions. There was a general decline in taste and design in Western countries, as poor reproductions of earlier styles filled many homes. The Arts and Crafts Movement held the rather Utopian belief that overall social and artistic improvement could be found through a return to the craft tradition of the Middle Ages.

A founding father of the Arts and Crafts Movement was William Morris (1834–96), a writer, craftsman, architect and painter with a passionate interest in medieval art and an equal dislike for the social effects of the Industrial Revolution. 'Apart from the desire to produce beautiful things,' he once said, 'the leading passion of my life has been hatred of modern civilisation.' Morris idealised individual, handmade objects and rejected the growing trend towards mechanisation and the drudgery of factory conditions. He wished to recreate the medieval guild system where artisans and artists worked closely together producing beautiful hand-made objects. He loathed the factory system, and the mass-produced goods it spawned.

The influential writer and critic John Ruskin (1819–1900) argued similarly that

it was impossible for people to find fulfilment in industrial work. In *The Stones of Venice* in 1853, Ruskin wrote that, 'men were not intended to work with the accuracy of tools, to be precise and perfect in all their actions...If you will have that precision out of them, you must unhumanise them.' Pre-industrial society was thought to have an element of greater humanity and there was a romantic yearning towards the crafts and production techniques of the medieval era.

William Morris believed that the task was somehow to fit art into an industrial age. He wanted art to be integrated into everyday life as he felt it had been centuries earlier. While working conditions then had been difficult, there was a dignity in simple craftsmanship. Neither Ruskin nor Morris liked cut-glass, which was produced in factories where each piece was meant to be identical. Their feeling was that this repetition stifled individuality and creativity. The ideals first expressed in England were repeated by others in Europe and the United States over the next few decades.

## MORRIS & CO.

In the 1860s, William Morris turned to stained glass as part of his quest. He founded a firm — Morris, Marshall, Faulkener & Co., later Morris & Co. — that had tremendous importance for the Arts and Crafts tradition in both Europe and America. The original partnership was dissolved in 1875 and re-formed as Morris & Co., although the company was known by that name

*In the manifesto for his own decorating company Morris mentions 'Stained Glass, especially with reference to its harmony with Mural Decoration', but the skill required in stained glass did not interest him unduly and he and his colleague Burne-Jones were happy to paint on glass if that gave them the right decorative effect.*

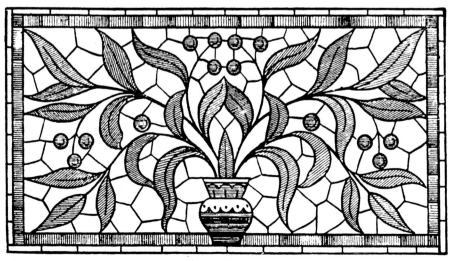

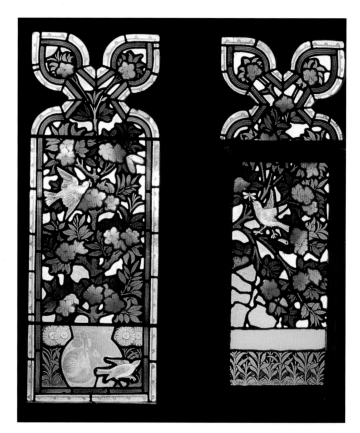

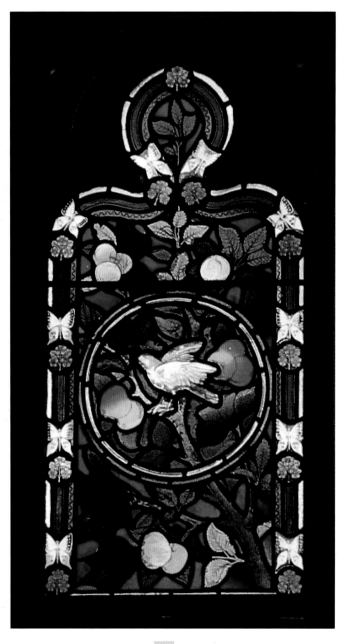

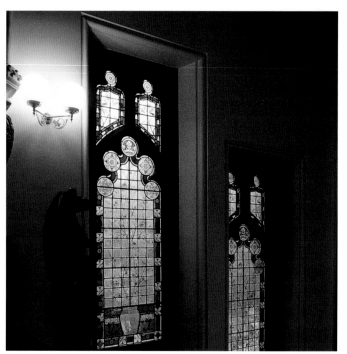

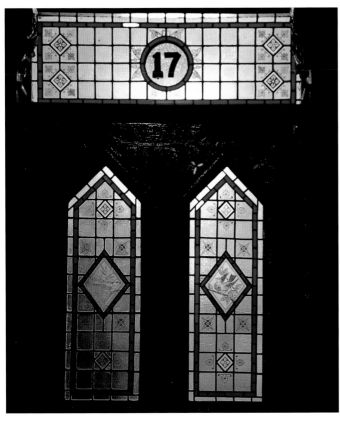

The Gothic Revival and the Arts and Crafts Movement in the middle of the century resulted in a resurgence of interest in the use of stained glass. Doors and windows were soon being decorated with beautiful glass panels, with floral patterns and designs based on medieval themes. As well as forming a pattern by setting coloured pieces of glass in lead, William Morris also encouraged the art of painting on the glass itself.

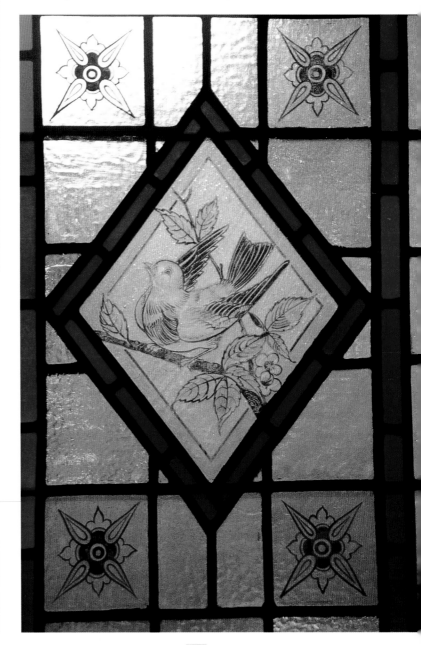

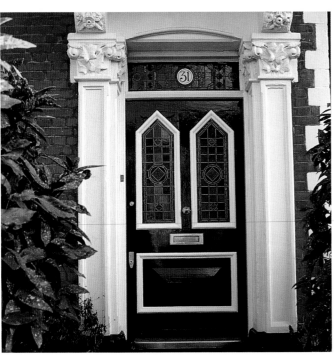

before that time. Its work ranged right across the decorative arts, from embroidery and furniture to metalwork and stained glass. Morris wrote that 'everything made by man's hand has a form which must be either beautiful or ugly'. Morris felt that if natural examples were followed, the result would be beautiful, so he used botanical shapes and curvilinear motifs drawn from nature as central to his designs. He also had a strong preference for the intricate motifs of Celtic and Romanesque work.

Much of Morris & Co.'s best glass designs were made between 1860 and 1876. Their first commission was for All Saints, Selsley in Gloucestershire in 1861. While he did not design stained glass himself, Morris, who had a strong interest in the rich pattern and colour of the medievalists, chose the colours and supervised the actual interpretation of the images into glass (the cartoons). There is a list of window designs by Morris & Co. in the City of Birmingham Museum; of these Morris can be shown to have worked personally on at least 130 cartoons. This was probably necessary to ensure continuity between the windows designed by different artists. Once the windows were assembled, enamels were used for details.

At the time, the Anglo-Catholic revival was in full swing. There was a great demand for ecclesiastical art of all kinds, including, of course, stained glass. The company employed leading Pre-Raphaelite artists of the time, such as Dante Gabriel Rossetti,

Edward Burne-Jones (1833–98) and Ford Madox Brown (1821–93), to make the initial designs. The company exhibited several items in the Medieval Court of the International Exhibition at South Kensington in 1862. A series of seven stained-glass panels on the Parable of the Vineyard, designed by Rossetti, were so well done that some exhibitors claimed they were touched-up medieval originals and tried to have them excluded!

A good example of the company's work is to be found in Peterhouse College, Cambridge, where the strong figures of Ford Madox Brown contrast with the more feminine designs of Burne-Jones. In 1862, the company designed a series of windows on the Tristram theme for Harden Grange. These panels are now in the Cartwright Memorial Hall in Bradford. The company was not averse to repeating a popular design – the 'St Peter' originally made by Morris for All Saints, Cambridge, was repeated at least ten times elsewhere. However, after 1878, the company refused to make stained glass for medieval churches, although they did accept commissions for 'modern' (ie eighteenth-century) churches. William Morris and his colleague Burne-Jones were happy to paint on glass if that gave them the right decorative effect, and produced many painted windows, or glass blinds as they were frequently called. These were popular in town houses and were used to obscure a less-than-inviting view in the place of the ordinary wire or wicker

blinds which were the normal remedy. A glass blind effectively shut out the gaze of the outer world and yet did not darken the room in the same way that the wicker or wire ones did. As was stated in the 1880 edition of Cassel's *Household Guide*, 'Indeed, nothing can vie with stained glass in all places where a rich effect of colour and semi-opacity is desired'.

Walter Crane (1845–1915) was yet another young artist who was part of William Morris's circle. Probably best known for his wood engravings made for children's book illustrations, he also designed glass and tapestries for Morris & Co.

Towards the end of his life, Morris accepted that his company's work had been essentially for richer people. As his aim was to provide quality goods for a wider public, he realised that there would have to be some compromise with the undoubted economies of mass-production that were offered by mechanised industry.

## OTHER MANUFACTURERS AND DESIGNERS

Stained glass produced by William Morris and colleagues was dominant in England in the second half of the nineteenth century – but there were other important names as well. John Richard Clayton and Alfred Bell produced well crafted windows for over forty years, including the west window of King's College Chapel, Cambridge. Another famous name was William Raphael Egintosh who created windows for

### A Glass Window Blind

FIG.1

A novel window blind, which comes to us from America, is illustrated in the two accompanying figures. The movable bars or slats of the blind are made of glass, either milky-while or coloured to any tint, and they are made of various sizes. The slats have no rods or bands to operate them and interfere with the entrance of the light; each is fitted at its ends with a small pulley, round which the cord passes, which opens or closes them all simultaneously. The blind admits of good ventilation and excludes flies and mosquitoes, besides forming

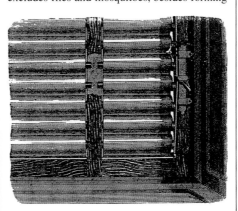

FIG.2

an additional impediment to burglars. Owing to the fact that the slats can be engraved with tracery, or tinted to any required shade in harmony with the furniture of the room, these blinds can be made an adornment to a room, and as they require no fresh painting and are easily kept clean, they must be considered an improvement on the ordinary Venetian blind. Fig. 1 is a section through the slats, showing the shifting pulleys; and Fig.2 gives a front view of the corner of a blinded window.

Cassells Family Magazine *of 1881 extolls the virtues of the latest in window blinds from America.*

When it came to putting back the stained-glass windows in this 1886 house, the owner took the opportunity to incorporate panels in the style of her favourite Victorian artist, John Gould. They were based on his painting 'Humming Birds' 1861, and were painted by a local, master glass painter. There are listings of both stained-glass artists and painters capable of carrying out this kind of work at the back of this book.

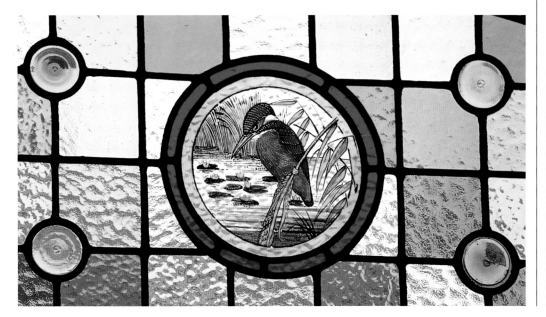

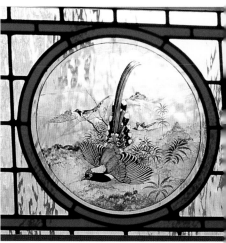

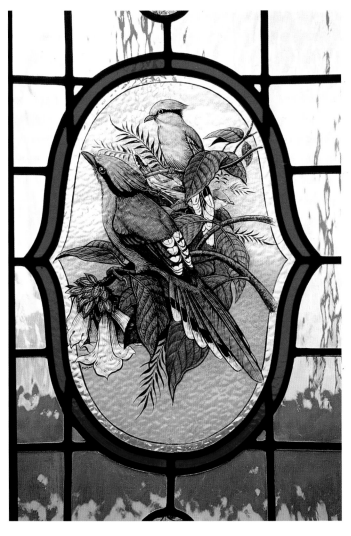

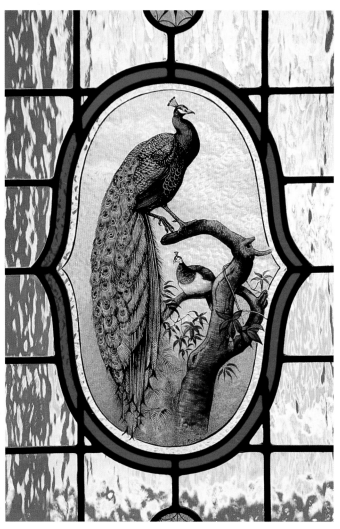

A selection of typical subjects which would easily translate into glass panels or medallions for entrance doors, and help to give a more authentic feel to new stained glass. These were taken from a selection of publications from the late nineteenth century. Original panels can still be obtained, usually from architectural salvage yards or antique shops, but good examples are now becoming scarce.

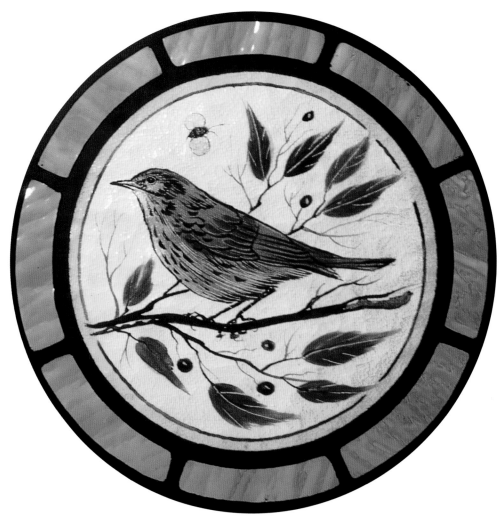

*The paintings on these panels
are quite simplistic and
obviously mass-produced
but, when grouped together as
illustrated opposite, they create
a charming effect.*

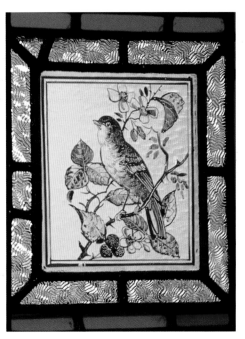

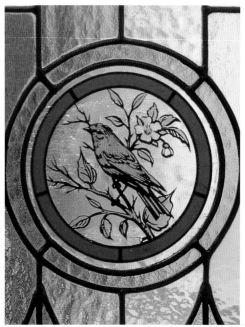

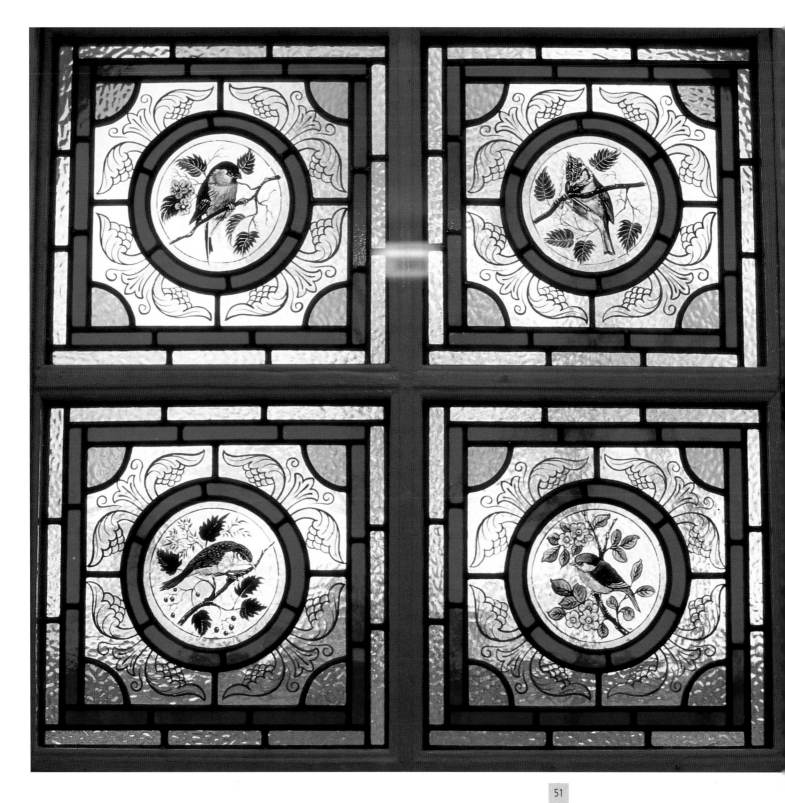

King George IV and other aristocratic patrons. Thomas Willement was another well known artisan in stained glass who worked for Queen Victoria and specialised in heraldic motifs. His main work can be seen in the Great Hall in Hampton Court. Other manufacturers of ecclesiastic and domestic stained glass were John Hardman & Co., who also produced metalwork; Clayton & Bell; Gibbs; Lavers, Barraud & Westlake; and Saunders & Co..

One particularly famous glass factory for windows was Whitefriars Glass Works in London, which was housed in a former Carmelite monastery between Fleet Street and the Thames. It was acquired by James Powell in 1834 and made coloured flat glass for stained-glass windows from the 1850s, including work commissioned by William Morris. Whitefriars were heavily involved in the rediscovery of how stained glass was made. Burne-Jones designed part-time for Whitefriars at first, but in 1861 gave up other commissions to work exclusively for Morris & Co.. Whitefriars then recruited a young artist, Henry Holiday (1839–1927), to make designs for them. His style is similar to that of Burne-Jones, but is more sentimental in theme, stronger in outline and less flattened. He was also better at drawing anatomy. The colours of glass used by Whitefriars tend to be different in shade and less dense than those from Morris & Co..

The example set by William Morris encouraged other entrepreneurs, such as the Century Guild founded in 1884 by the architect and designer Arthur Mackmurdo (1851–1942). The Guild was a band of designers, led by Mackmurdo, who marketed their designs jointly, although they also included some products from Morris & Co. Mackmurdo's designs elongated the natural forms characteristic of Morris, and his sinuous plant shapes are often cited as one of the first blossoming signs of Art Nouveau. Selwyn Image (1849–1930) was a member of the Guild, a priest who renounced his orders in 1873. An eclectic designer, painter and poet, many of his designs for stained glass were heavily influenced by

*These advertisements for stained-glass artists and manufacturers appeared in* The Studio, *an illustrated magazine of fine and applied art, 1900.*

SPECIAL·DESIGNS·PREPARED·AND·SVBMITTED·WITH ESTIMATES

FOR STAINED·GLASS WINDOWS·AND MEMORIAL BRASSES HERALDIC AND·LEADED GLASS·AND MOSAICS

ARTHUR·J DIX 34·BERNERS·ST LONDON·W

HENRY HOPE & SONS LIMTD 55 LIONEL St. BIRMINGHAM METAL CASEMENTS & LEADED LIGHTS CATALOGUE ON APPLICATION

Burne-Jones. The designs were made up by a company called Heaton, Butler and Bayne.

Another artist in stained glass, whose work was much admired in the 1880s and 1890s, was C.E. Kempe, who also worked as a general designer. He inspired the work of Edward Ould, the official architect, in building the extension to Wightwick Manor in Wolverhampton in 1893. Ould had constructed the original house in 'Victorian Tudor' for Theodore Mander in 1887 and the difference between the two sections is noticeable. Some fine examples of Kempe's glass can be seen in the 1887 section in the drawing room and the inglenook in the hall. Kempe also added stained glass to his (genuine) Elizabethan house in Sussex and is said to have overseen the designs for the stained glass at Wood House near Epping, Essex. The latter was officially designed by Kempe's nephew, Walter Tower.

Wiliam Burges, commonly known as Billy, had a long and fruitful collaboration with the third Marquis of Bute on Cardiff Castle between 1865 and 1881 when Burges died. Cardiff Castle then comprised the remains of a medieval shell keep and large enclosure, which included a range of medieval buildings which had been slightly updated by Henry Holland around 1776. Lord Bute was incredibly rich as his father had built the Cardiff docks' complex and owned other estates. The renovations and extensions centred on the existing medieval buildings and the interior decorations were extremely rich. Burges designed everything,

including the stained glass which was manufactured by Saunders & Co..

During the years of 1870–72 , designer Christopher Dresser was commissioned to write a series of articles on ornamental design by the editor of *The Technical Educator, An Encyclopaedia of Technical Education,* published by Cassel Petter & Galpin. On the following pages are some extracts from the article he wrote specifically dealing with stained glass including some of his original designs.

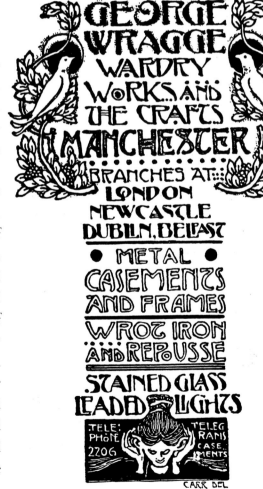

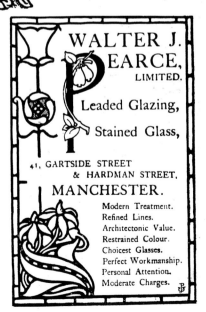

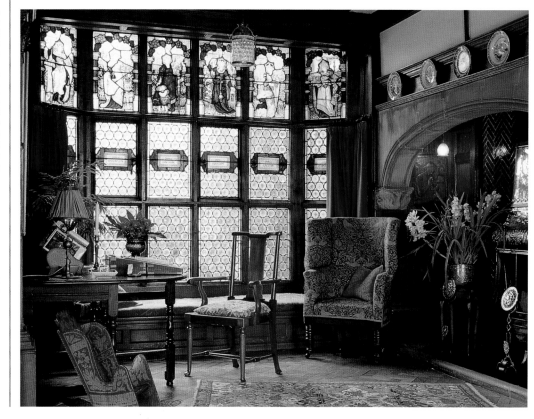

*Wightwick Manor,
Staffordshire, built in
1887–93 and based on
Elizabethan and Jacobean
styles, is now owned by
the National Trust of
Great Britain.*

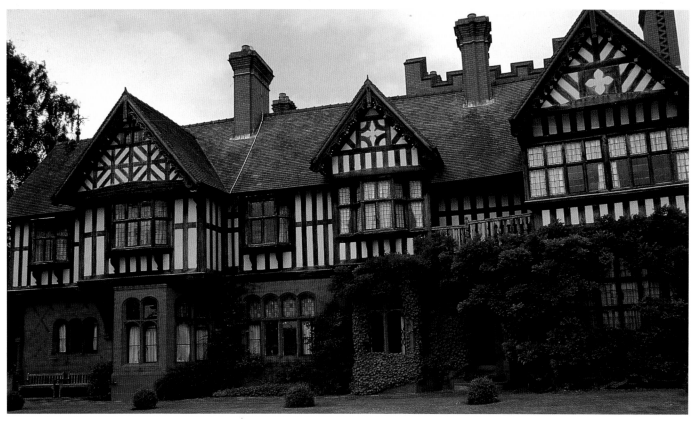

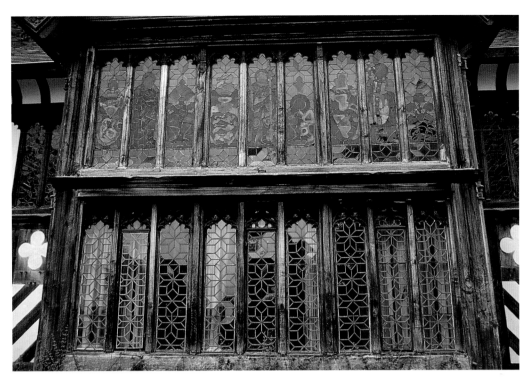

*The house is a fine example of the Arts and Crafts style and contains work by the most famous of the Pre-Raphaelite artists – wallpapers and fabrics by William Morris, watercolours by Ruskin , drawings by Burne-Jones, tiles by de Morgan, and stained glass by Charles Kempe who also advised on the decorations.*

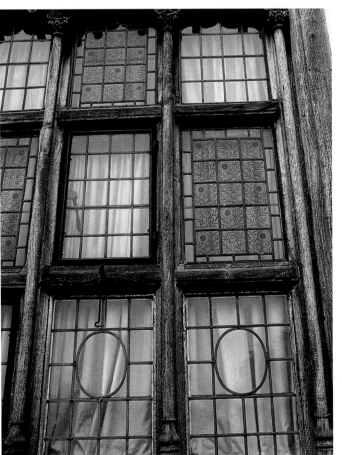

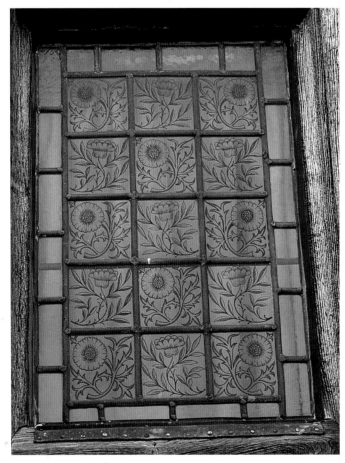

## PRINCIPLES OF DESIGN. XXX
### By Christopher Dresser, Ph.D., F.L.S., etc
### Stained Glass

. . .Soon after the rediscovery of glass in our own country, methods of colouring it were sought out, and beautiful cathedral windows were formed, which, soon after the discovery of the art of producing coloured windows, were of such beauty, and were so thoroughly fitted to answer the end of their creation, that little or no improvement upon these early works has even yet been made, and much of the decorative glass which we now produce is far inferior to these early works both as regards design, colour, and mode of treatment.

. . .A window must fulfil two purposes — it must keep out rain, wind, and cold, and must admit light; having fulfilled these ends, it may be beautiful.

If a window commands a lovely view let it, if possible, be formed of but few sheets (if not very large, of one sheet) of plate glass; for the works of God are more worthy of contemplation, with their ever-changing beauty, than the works of man; but if the window commands only a mass of bricks and mortar inartistically arranged, let it, if possible, be formed of coloured glass having beauty of design manifested by the arrangement of its parts.

. . .A window should never appear as a picture with parts treated in light and shade....but this I do say, that many stained windows are utterly spoiled through the window being treated as a picture, and not as a protection from the weather and as a source of light. If pictorially treated subjects are employed upon window glass, they should be treated very simply, and drawn in bold outline without shading and the parts should be separated from each other by varying their colours.

. . .Strong colours should rarely be used in windows, as they retard the admission of light. Light is essential to our well-being; our health of body depends in a large measure upon the amount of light which falls upon the skin. Those wonderful chemical changes, in the absence of which there can be no life, in part, at least, depend upon the exposure of our bodies to light; let our windows, then, admit these life-giving rays. It must also be remembered that if light is not freely admitted to an apartment the colours of all the objects which it contains, and of its own decorations if it has any, are sacrificed, for in the absence of light there is no colour.

A good domestic window is often produced by armorial bearings in colour being placed on geometrically arranged tesseræ of slightly tinted glass. In some cases such an arrangement as this is highly desirable, for the room may thus get the benefit which a bit of colour will sometimes afford, and at the same time a pleasant view may be had through the uncoloured portion of the window

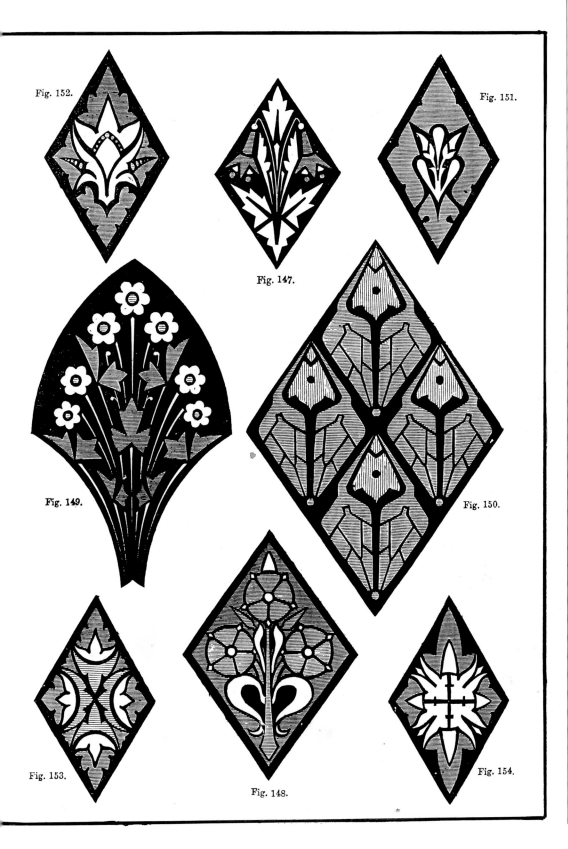

Fig. 152.

Fig. 151.

Fig. 147.

Fig. 149.

Fig. 150.

Fig. 153.

Fig. 148.

Fig. 154.

◀◀

*Christopher Dresser founded a style of window decoration on sketches he made as a young student of art on being 'struck by the beauty of the frost on the window pane'. These he regarded as among his favourite works. This is an example of one such design.*

◀

*A selection of quarries designed by Christopher Dresser. In his article on 'Principles of Design' in* The Technical Educator *c1872, he advocated searching for 'plant-forms either common or peculiar to the neighbourhood in which the work is intended to be placed ... it is as right and necessary to use such forms for decorative art'.*

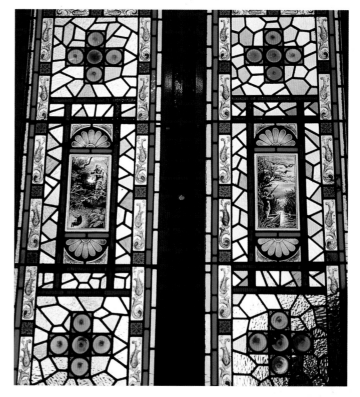

These colourful stained-glass panels have an almost jewel-like quality, and the painted panels in the centre of each are an unusual subject. They are also very well painted, making it quite likely that they were specially commissioned by the original owner of the house.

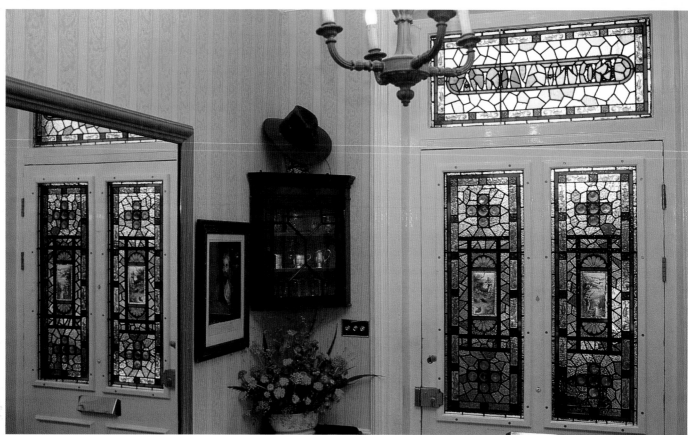

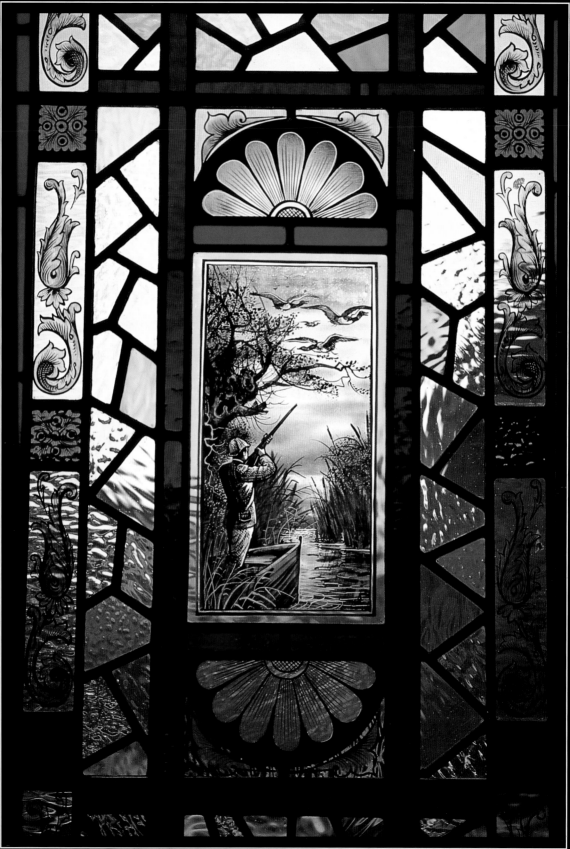

*Two further original designs by Christopher Dresser based on his sketches of frost on a window, together with one in the Gothic style which he chose from the catalogue of 'those excellent artists in stained glass, Messrs Heaton, Butler, and Bayne, of Garrick Street' as being a 'good domestic window with armorial bearings'.*

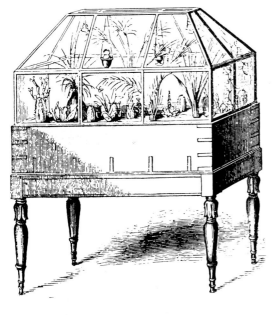

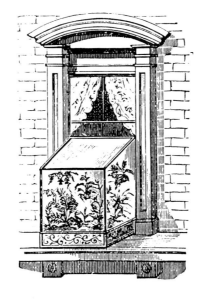

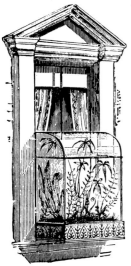

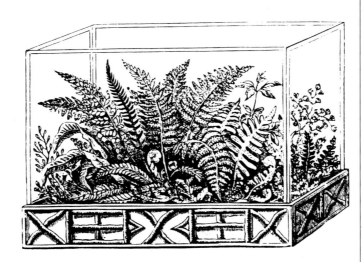

*Wardian cases, so-called because they were invented, quite by accident, by botanist Dr Nathaniel Ward, became very popular in Victorian homes.*

## TERRARIA OR WARDIAN CASES

It was inevitable that if pieces of glass could be held together on a flat surface, the glaziers would realise that glass could be combined to form three-dimensional objects like lanterns or boxes. And other qualities of glass were realised, too: for instance, it transmits heat very efficiently.

When Dr Nathaniel Ward (1791–1868) developed a glass container in which to grow plants, craftsmen found yet another model in which to play with glass.

These charming glass containers, used to decorate the home and to delight any gardener of the exotic, were discovered quite by accident. Dr Nathaniel Ward was a doctor based in London and he was also a

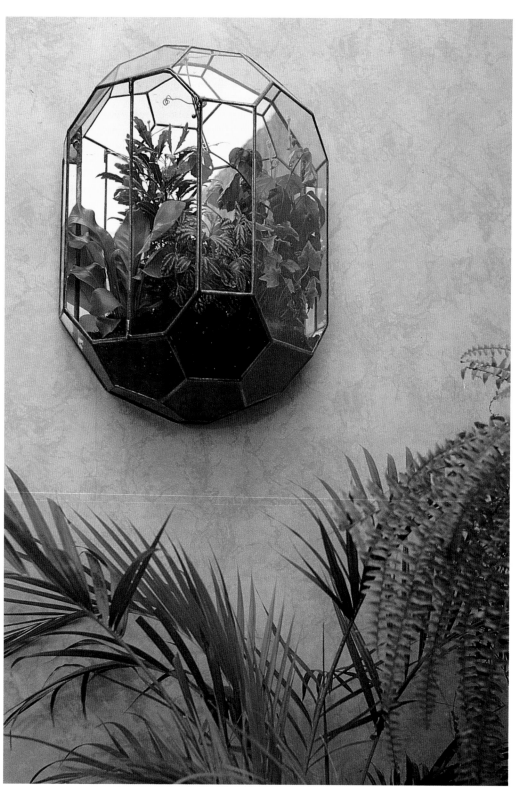

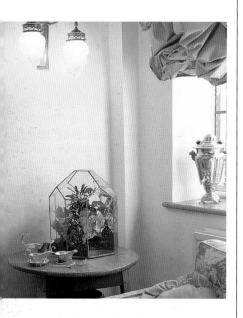

*Tropical foliage plants and ferns are particularly well suited to the micro-climate of warm humidity provided by these neo-Edwardian terraria.*

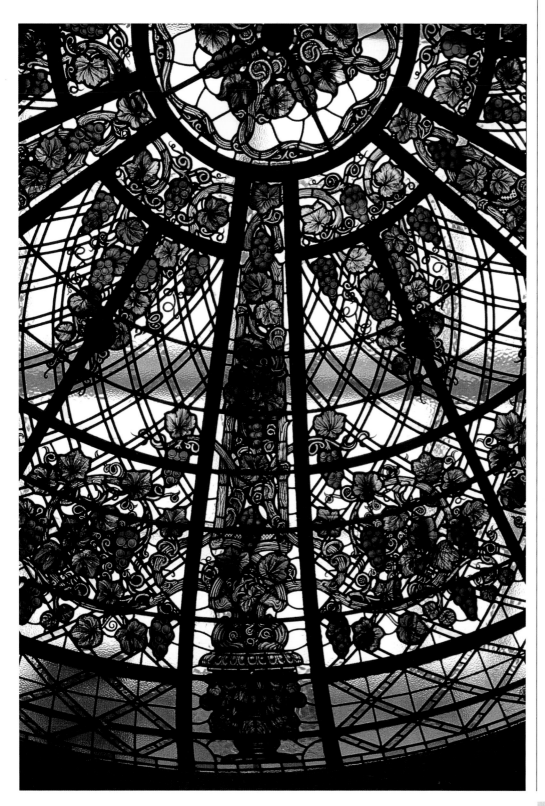

Orangeries and greenhouses had been in existence for several centuries but the conservatory was a mid-Victorian innovation. The reduction in the cost of glass and ironwork and new techniques in heating made it possible for the Victorians to create a luxurious garden room in which to sit and display the new exotic plants now in vogue. Further decoration was added with patterned tiled floors, ornate iron details and stained and painted glass panels or roofs.

naturalist. On a trip to the country in 1829, he found a chrysalis, the development of which he was determined to observe. He popped it into a tightly screwed glass jar with some soil, and carried the whole lot back to the city. But seeds began to germinate in the soil, and even more exciting to the naturalist, they flourished in his airtight bottle for four years without the addition of water. It seems that the chrysalis was no longer of top priority to Dr Ward, because he continued to experiment with plants growing in glass containers. In 1838, he made his first Wardian case from metal and glass.

These cases became very popular in Victorian homes, and a variety of designs were developed by the craftsmen, some of whom chose to design miniature copies of the Palm House at Kew Gardens, or the Crystal Palace. In deference to Dr Ward, the naturalist, it should be mentioned that his glass cases were not used only to thrill home-owners and keen gardeners. Other naturalists and botanists were delighted by the concept.

In 1843 the Scottish botanist, Robert Fortune, was employed by, and thereafter travelled extensively for the London Botanical Society. He relied on Wardian cases to transport the plants he collected on his trips to the East. Using these cases, he took tea plants from China and introduced them to India's north-west provinces. And thanks to Dr Ward's discovery of the principle of enclosed cultivation, bananas were cultivated outside China, and also quinine-producing plants were transplanted from their natural habitat and grown extensively for medicinal purposes.

Wardian cases, or 'terraria', create a self-contained world of soil, climate, humidity and vegetation based on a very simple principle. The plants absorb water from the soil which then passes through the leaves and is given off into the atmosphere. The resulting moisture is trapped in the glass surround where it condenses and trickles back into the soil. This process of recycling can continue for years in a terrarium. Dr Ward managed to leave one case undisturbed for fifteen years, and he claimed the plants remained thriving and healthy without any care at all.

Tropical foliage plants and ferns are particularly well suited to this micro-climate of warm humidity. This is the feature that makes them so attractive for home use, for the leaves and textures of such plants are often beautifully coloured and marked, and are very difficult to grow in more temperate northern climates. No wonder that the Victorians, who so adored the decorative, loved these miniature 'glasshouses'.

## LIGHTING

By the middle of the nineteenth century, oil lamps based on the Argeund lamp were in widespread use, and 'frosted glass' tubes became popular. Despite these advances in oil lamps, the use of candlelight was not abandoned. Candelabra with two

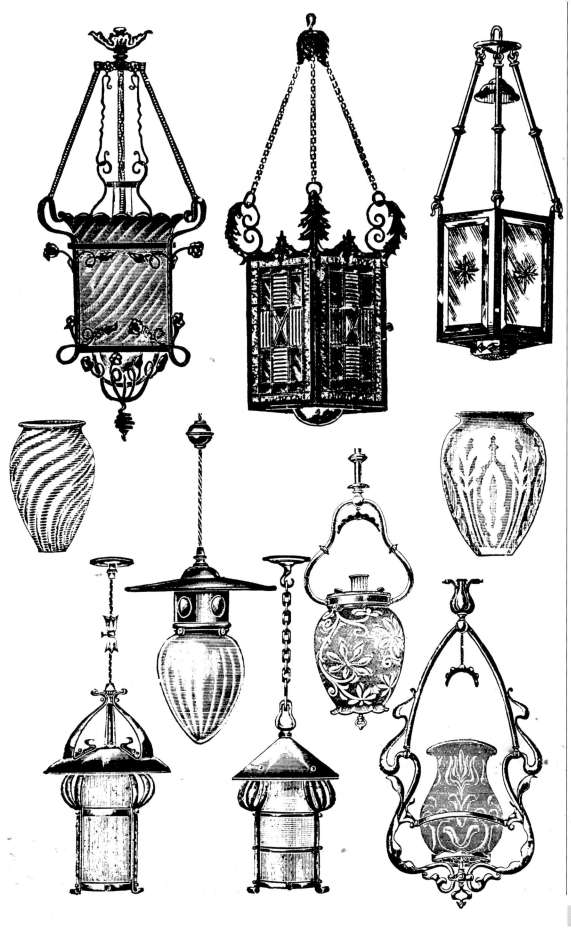

The years between 1820 and 1900 saw major changes in domestic lighting with the developments of paraffin and oil lamps, and of gas and electricity. As these new forms of lighting began to replace candles, rooms became better lit enabling the richer, darker colours, for which the High Victorian era is well known, to be adopted for internal decoration.

65

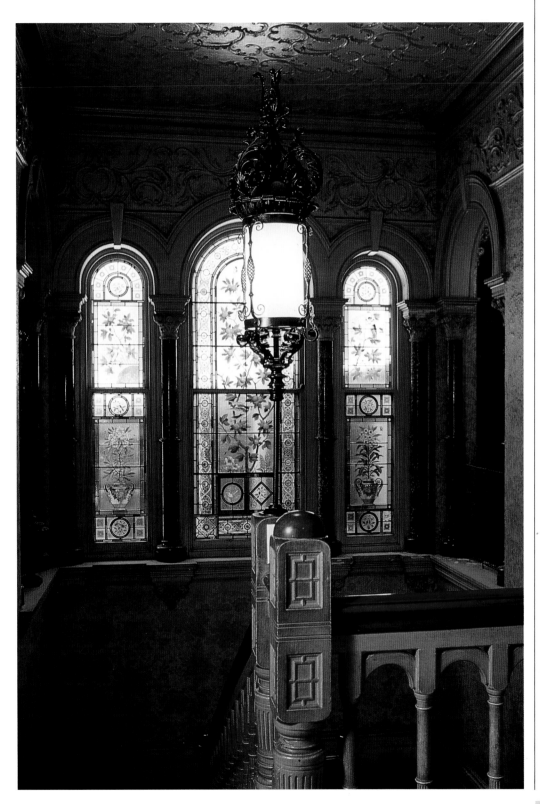

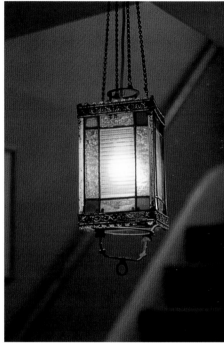

The use of gas for internal lighting became widespread in the late 1880s with the development of the incandescent gas mantle by Carl Auer von Welsbach. In the words of an advertisement dated 1890, 'It is a Pure, Soft, Clear, Steady Light. No Smoke, Less Heat, and effects a saving of more than 50 per cent. over the best form of burners'. It was the principal weapon used to combat the rising competition from electricity.

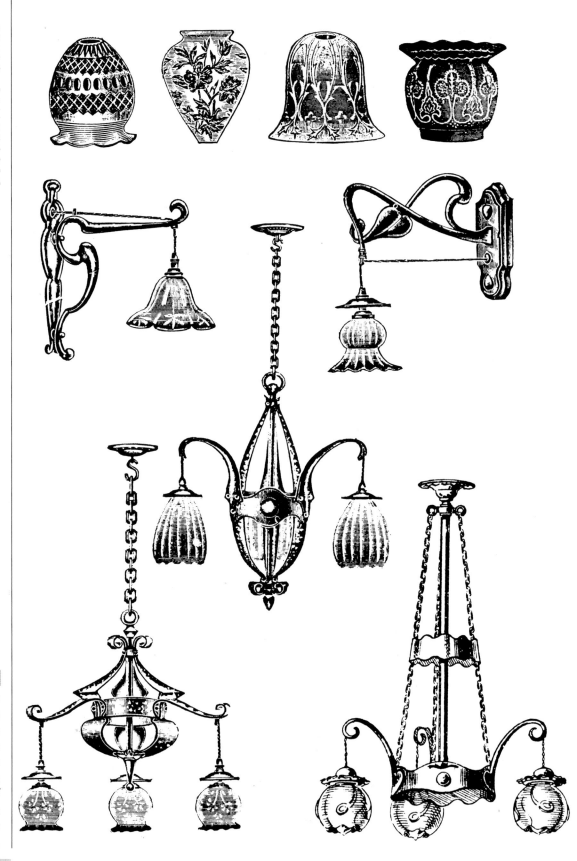

*With the advent of different forms of lighting, whether it be oil, gas or electricity, lamp designers were able to experiment with different ways of presenting them. These illustrations from catalogues of the late 1800s show just some of the myriad designs available.*

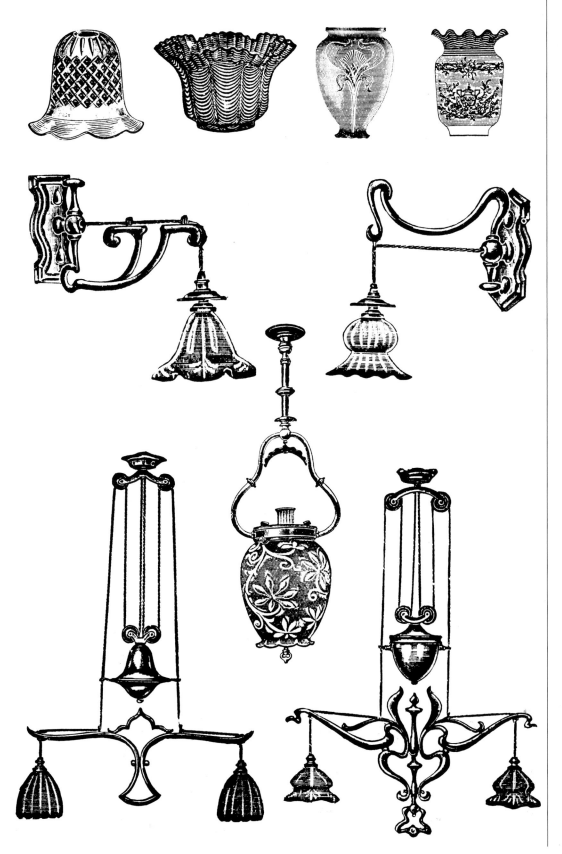

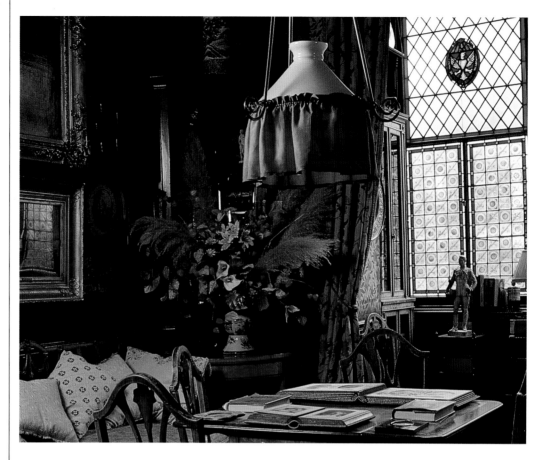

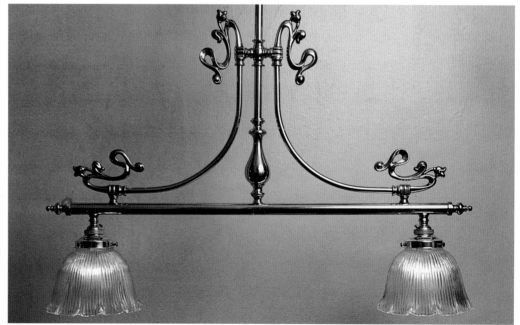

Electricity was first introduced into the home in the 1880s, although because of its expense and initial ineffeciency, it was not in common usage until the turn of the century. However, it had a radical effect on lighting styles.

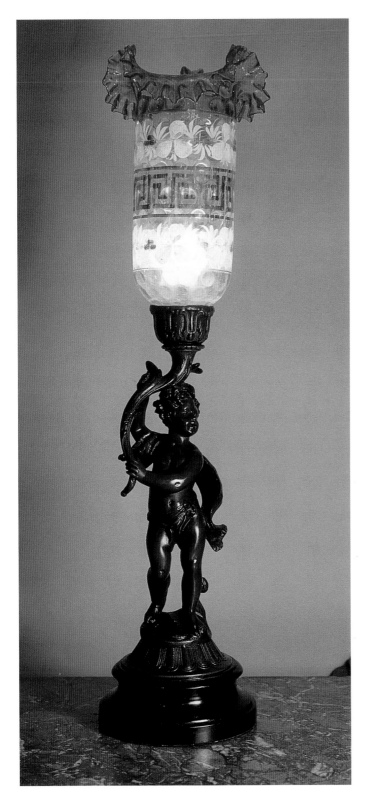

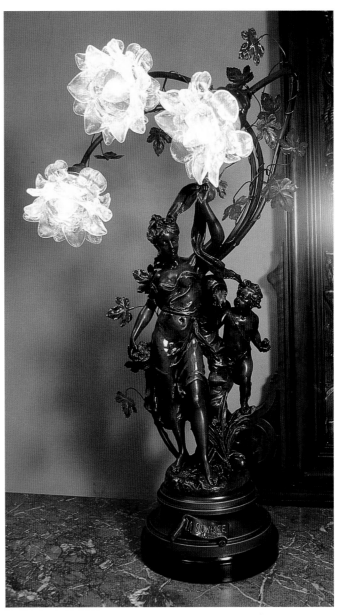

or more arms acting as candle sockets became more ornate in design. They were especially flamboyant when designed in glass. Chandeliers did not lose favour either, and as a material, glass was preferred by designers because of its reflective quality. The Venetians had made the first glass chandeliers in the eighteenth century, and these light-holders become more and more elaborate in design until in the Victorian era they had the appearance of shimmering glass waterfalls.

William Murdoch of Great Britain is usually given credit for being the first to apply coal gas on any considerable scale. He set up a small experimental plant in 1795, and by 1815, Westminster Bridge in London was lit by glass lamps.

However, although Murdoch's experiments brought a radical change in fuel systems, the quality of light was not altogether different from that of candlelight or oil. Gas burns with a yellowish luminous flame similar to that of a candle. Craftsmen simply adapted their skills to the mechanical design requirements of gas fittings, but generally imitated the design of the oil lamps with similar glass tubes. It was in the making of gas street lamps that design became interesting and very ornamental.

It was the advent of electricity that revolutionised the use of light in architecture and radically altered the demands on craftsmen who fashioned the new electric lamps. In the 1880s, after Thomas Edison of the United States had perfected a system to transmit and distribute electrical energy, the novelty and convenience of the system enchanted the consumer. But electric light has a harsh and brutal glare and so Louis Comfort Tiffany, who devoted his life to the twin obsessions of colour and light, resolved the problem of the fierce brightness by transmitting it through coloured glass.

*A further example of the lamp designer's ingenuity, these lamps were illuminated from inside the base and from overhead, and could also be used to display plants, satisfying the Victorian's love of exotic plants.*

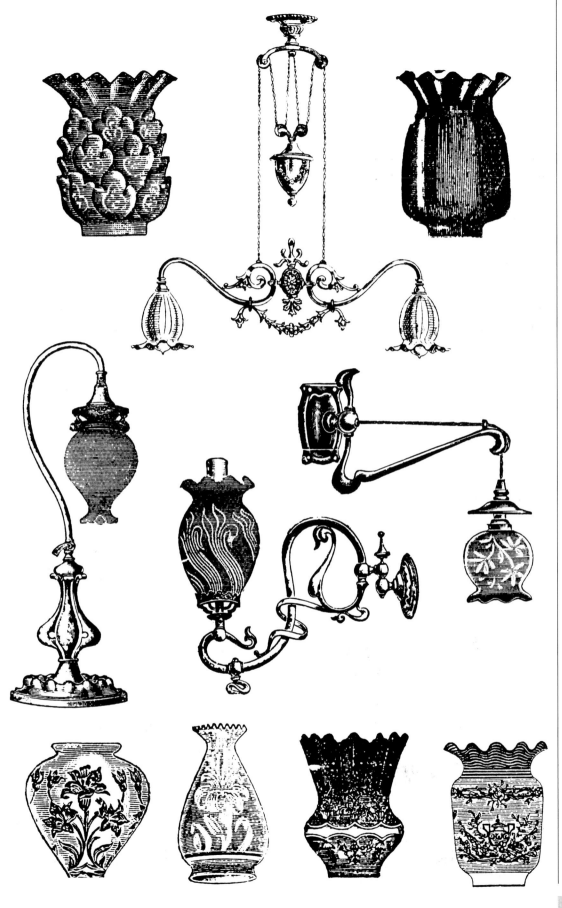

At first, light fittings were connected to a gas pipe and had to be fixed to the walls and ceilings, with the result that candles and oil lamps were still in use elsewhere in the room; but later, table lamps were available that had a long rubber tube attached to the pipe, which enabled the lamp to be more mobile.

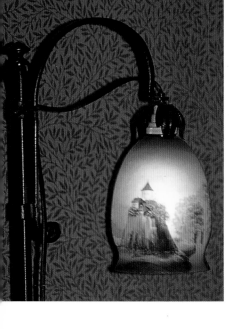

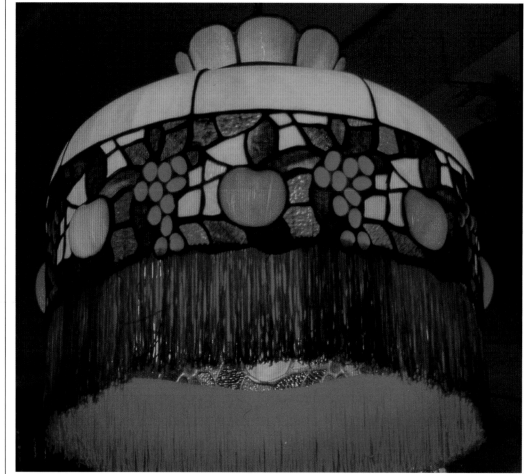

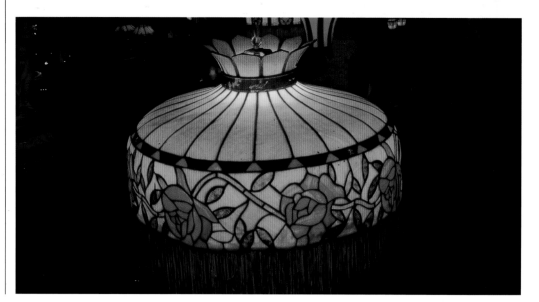

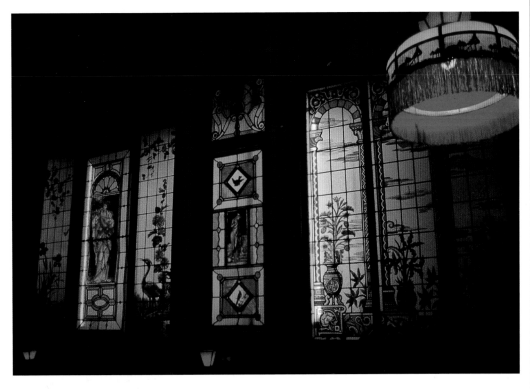

Even in their day, Tiffany lamps were very expensive, and very few families could afford to grace their home with such opulent lighting fixtures. Fortunately there were many firms manufacturing less expensive lamps in the Art Nouveau style.

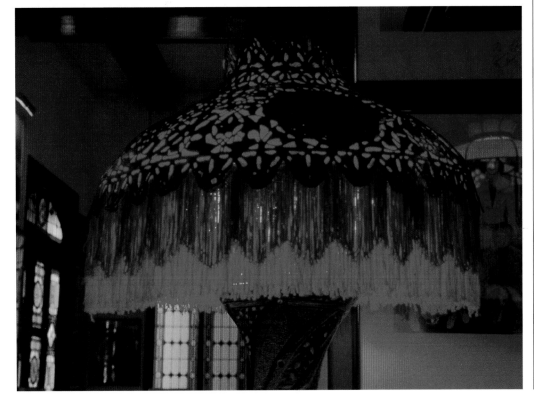

## AMERICAN STYLES

A great glass industry developed in the United States for a number of reasons. Americans were not inhibited by a tradition of religious expression in stained glass, and neither were they averse to using machinery and technology in advancing their craft. They were excited by the Industrial Revolution rather than repulsed. An extremely wealthy class of merchants and industrialists grew from the industrial upsurge in America. This class was not restrained, housed or furnished by aristocratic family possessions. They created their own wealth, and they spent it on lavish homes and office blocks. The glass-makers of America persuaded them to use stained glass in both types of architecture and 'an ancient art was steadily transformed by American materials, styles and techniques'. In the nineteenth century, American stained glass reached great heights of popularity and expertise.

In the United States, glass that was tinted green, blue or yellow from impurities had been available — but interest in coloured glass only really started in the second quarter of the nineteenth century. One of its first uses was as decorative steamboat windows. Mark Twain described the 'lovely rainbow light falling everywhere from the coloured glazing of the skylight'. A style of housing developed called 'Steamboat Gothic' which used these dazzling fragments of coloured glass.

Figurative coloured-glass windows for churches were imported until the early 1840s when the first known mosaic stained-glass window was created in New York. Others followed, and when the Capitol was constructed in Washington DC in 1859, stained-glass ceilings were put into the Senate and House Chambers.

The prolific use of glass 'jewels' in windows, made to imitate precious stones, was especially typical of American style in the nineteenth century. By 1890, these were being used in houses and other secular buildings with a great flourish. 'Chunk' jewels were sometimes as large as 5cm (2in) across and added textural as well as more three dimensional interest. 'Molded jewels' were made as leaves, teardrops, pyramids and in various geometric shapes. Jewels, which were made either by hand or machine, were generally used to best effect when they were grouped in a pattern cluster.

Traditional mosaic glass uses metal 'calmes' or copper foil to support individual pieces, but 'mercury mosaic' windows were developed in the United States during the 1880s with a somewhat different technique. These used hundreds of tiny 'tesserae' held in a bed of solid metal, with totally irregular amounts of metal between each area of glass. The *Scientific American* of April 1886 included an article about the method which was seen as a labour-saving way of making stained-glass windows. In the advertisment, the Belcher Mosaic Glass Co. described how 'metal lines can be made

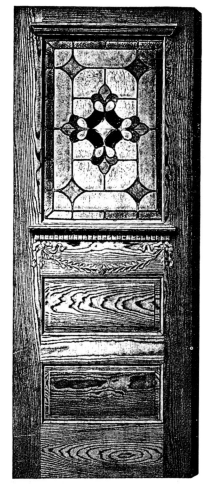

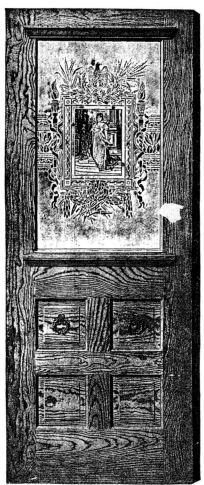

The development of the decorative glass industry in America was different to that in Europe. They had no great tradition of magnificent church windows to inhibit them, added to which they were excited by the Industrial Revolution rather than repulsed by it. The industrial upsurge created a wealthy class of merchants and industrialists who were not restrained by family possessions and who spent their great wealth on lavish new homes and offices.

*Painted details from the door illustrated here. A bull's-eye is a bulging pane with several circular ridges around a 'pontil mark'. It can add considerable charm when used with flat leaded panes which are further enhanced, as in this case, by painting.*

*The fine leaded and painted glasswork in this façade dates from the beginning of the twentieth century. A house name or number was often added in the top centre panel,*

*left blank for this purpose. Geometric motifs were popular, inspired by the simple shapes used by Frank Lloyd Wright and some other architects of the time.*

*This immaculately preserved turn-of-the-century house, retaining all of its original stained and painted glass, is a fine example of the glass-maker's art and makes a good*

*model for restorers looking to replace glass panels in a door of a similar design. Textured glass in front doors creates a handsome façade while also adding privacy.*

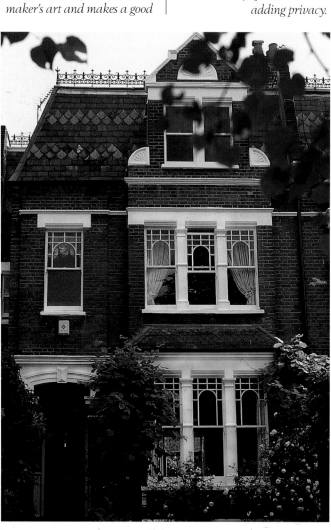

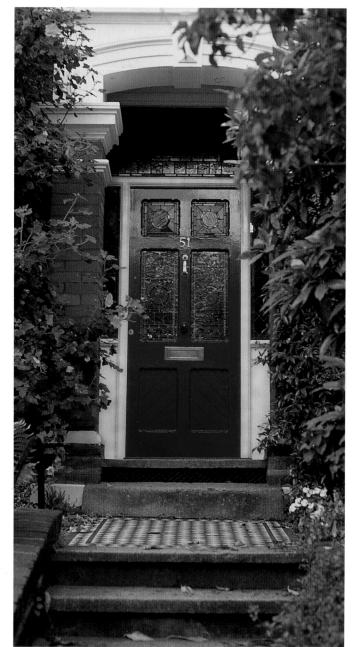

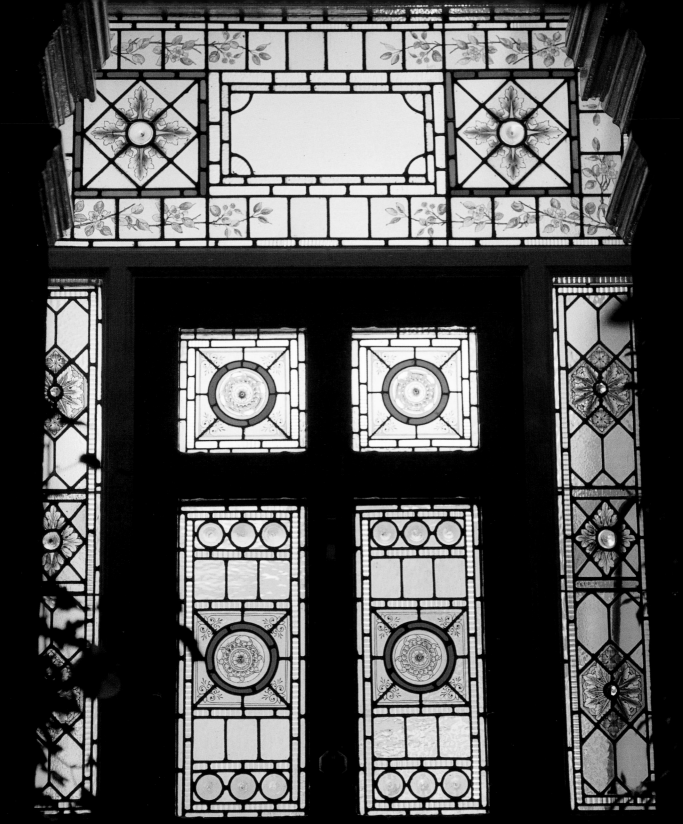

so fine as to be imperceptible in the production of shading effects in colour, as the metal does not overlap the edges of the glass. The work is much stronger than the old style of leaded glass and dispenses, to a great extent, with the heavy and unsightly iron stay bars'. Unfortunately, mercury was used in the manufacture and it was only a few years before workers were contaminated and production ended.

While the American Arts and Crafts tradition was somewhat separate from what was happening in Europe, it fundamentally shared a desire for a more craft-oriented, less-technological age. So as America celebrated its first one hundred years of independence in 1876, there was a revival of pioneer styles. Americans were looking more towards their own history instead of medieval Europe. The writings of Henry Thoreau, with a reverence for nature, were another strong influence. The Association for the Advancement of Truth, which was established in 1863, believed that nature, rather than some earlier academic tradition, should be the main inspiration for art.

The impact of the Arts and Crafts Movement was felt at the Centennial Exposition in Philadelphia in 1876 as British contributions inspired American interest. By October 1878, *Harper's Magazine* was already noting that 'the

*The solid wood-panelled door of the eighteenth century, with its semicircular fanlight above – the only way of allowing light into the hallway – was replaced in the nineteenth century by a variety of designs echoing the diversity of architectural styles. Towards the end of the century, when Art Nouveau became fashionable, its sinuous forms and curved shapes were well suited to the art of stained glass.*

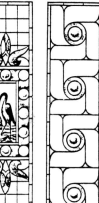

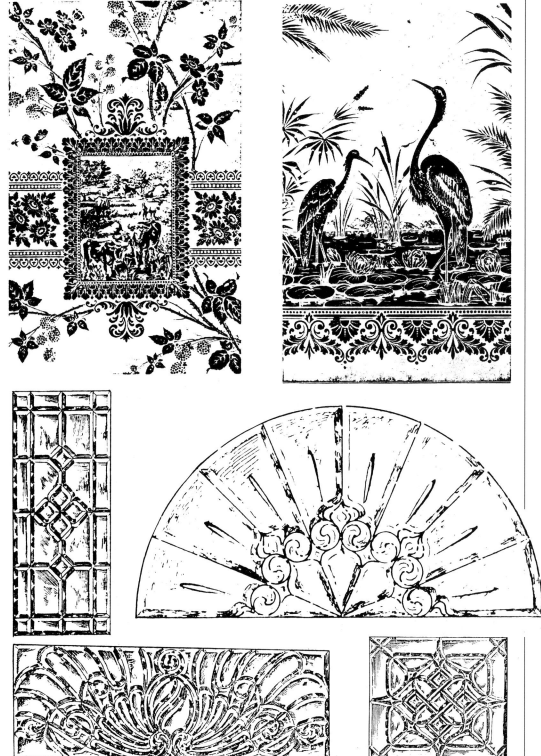

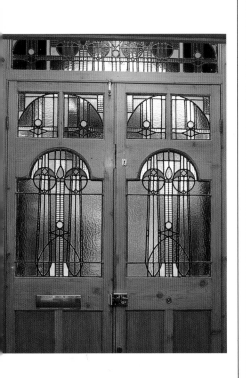

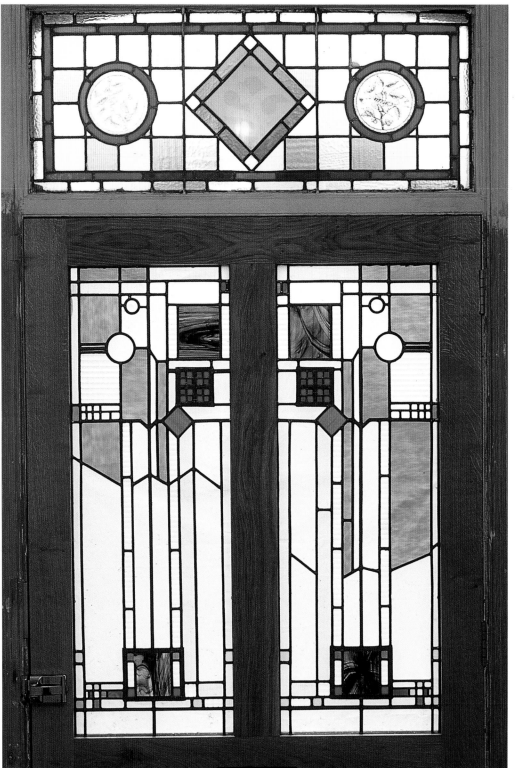

Although not a popular style in other American art forms, such as architecture, Art Nouveau soon dominated stained-glass products. The leaded joints of the glass came to play more of a role in the design than the colours. This trend was particularly evident in the geometric style of Frank Lloyd Wright and his contemporaries whose influence can be seen in these modern windows.

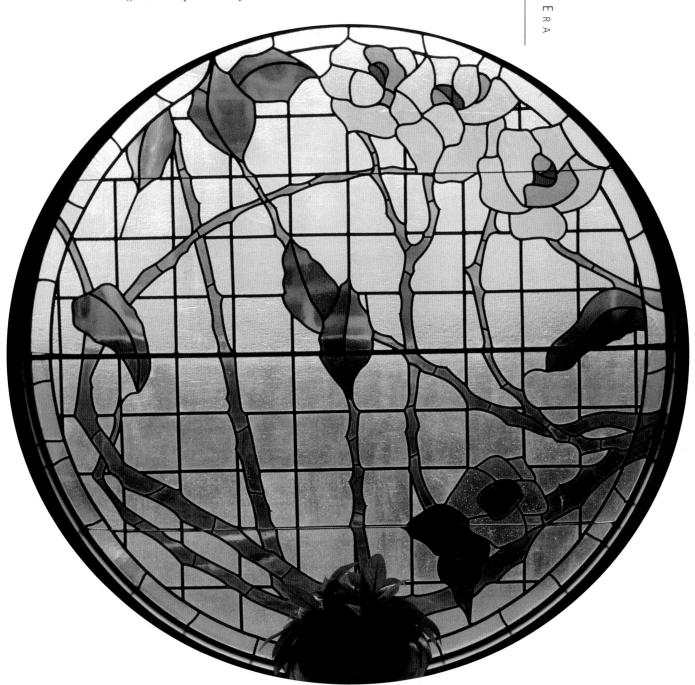

ancient method of decoration furnished by painted glass is again taking its proper rank.' The ideals of William Morris were rapidly becoming known in the United States and influencing designers. In 1903, the Stained Glass Association of America was organised to improve prices and distribute a national catalogue of designs.

While leaders of the English Arts and Crafts Movement cherished hand-crafted

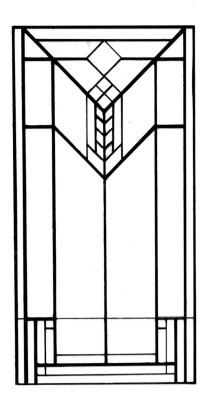

*Original designs for two panels and a light fitting by Frank Lloyd Wright. He first became aware of the Arts and Crafts Movement through the works of Ruskin, and in 1898 became one of the founding members of the Chicago Arts and Crafts Society.*

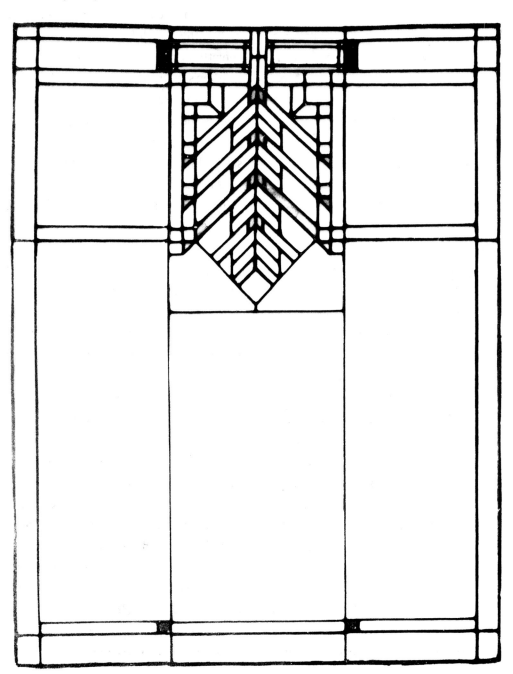

objects and rejected industrialisation, the American movement showed a much greater willingness to compromise with the benefits of mechanisation. Frank Lloyd Wright (1867−1959) was one architect and designer who sought to combine the ideals of Arts and Crafts with the creative possibilities afforded by mass production. He believed that machinery offered creative, technical and social advantages, and allowed a much wider section of the public to enjoy a better life.

Wright first discovered the English Arts and Crafts Movement through reading the works of Ruskin. In 1898, he became one of the founders of the Chicago Arts and Crafts Society. Wright and other young architects working in the same office developed a sparse, geometric style which was used for interior designs and stained glass as well as buildings. The style became known as the Prairie School.

The on-going debate in many countries was how increasing industrialisation could be controlled − and Wright was an important spokesman for the view that mass production could be used to place inexpensive, but well designed objects within the range of ordinary people. While sympathetic to the ideals of Arts and Crafts, he felt the movement was being unreal in its obsession with the hand-made. Wright promoted the idea that machinery and mass-production could be simply another tool for the designer and craftsman.

Wright was greatly attracted to leaded glass and was using it for whole walls by 1889. He is particularly noted for favouring stained-glass screens or grilles as dividers. Wright's preference was for a vertical bias, using elongated, geometrically abstracted plant forms. He used other subjects as well, such as the cheerful motifs of balloons and confetti used in stained-glass windows for a children's playroom at the Avery Coonley Playhouse in Riverside, Illinois (1912). In his designs, he chose mainly straight lines in preference to curves, and used stiffer metals such as brass, zinc and copper as the 'calmes'.

Another residence, the Susan Lawrence Dana house built in Springfield, Illinois in 1900, utilised panels of glass as hanging screens between the entrance hall and gallery. Autumnal colours of glass enhanced the view from either side. Wright also designed lamps for his homes, with stained-glass shades positioned above dining-room tables. In 1915, Wright designed windows for the Imperial Hotel in Japan, using artistically arranged small panes of clear glass.

While the architects of the Arts and Crafts Movement all yearned for a pre-industrial era, the architecture that began developing under the flag of Art Nouveau was eager to embrace the possibilities afforded by a changing world. Architects like Frank Lloyd Wright were a bridge between traditional Arts and Crafts and the exciting new modernism which was developing. Decorative glass, in many forms, was to be an increasingly important element as the new century dawned.

*A design for a dining-room light fitting by Frank Lloyd Wright, c1900. He created angular shades using geometric shapes with a translucent effect, not being as fond as Tiffany was of opulent coloured glass.*

*The illustrations on the remaining pages of this chapter are intended as a style guide for anyone looking to bring some authentic Victorian splendour to their home.*

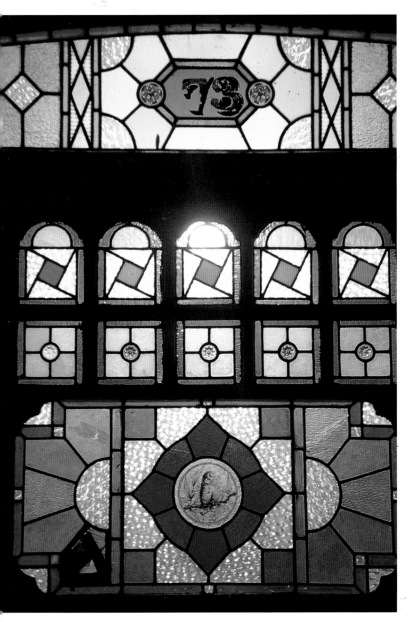

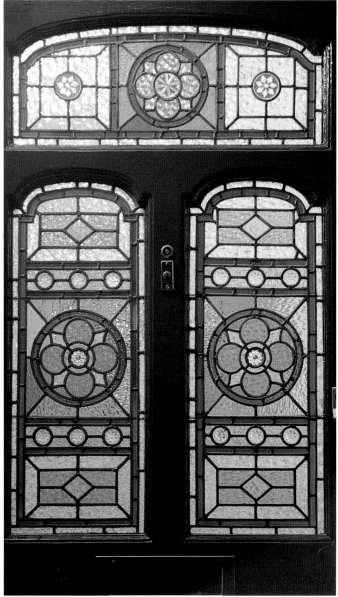

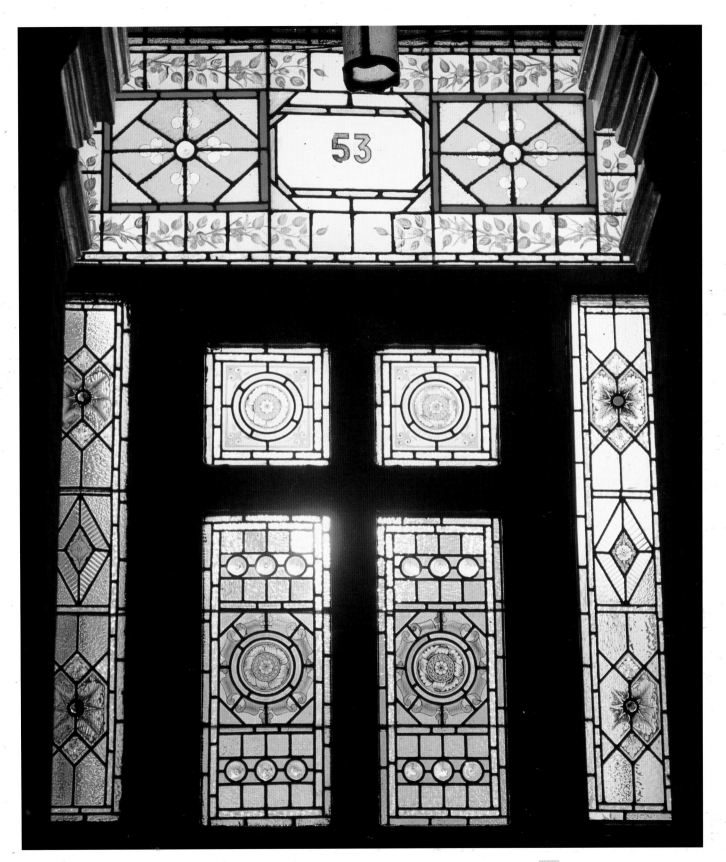

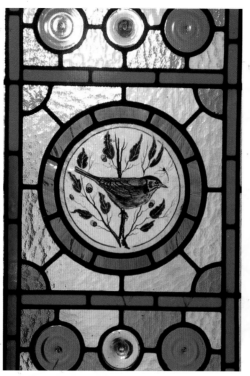

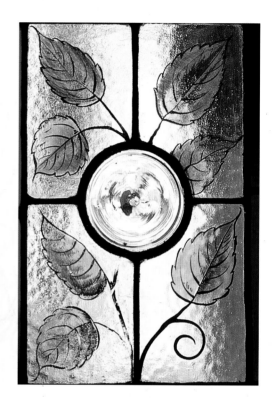

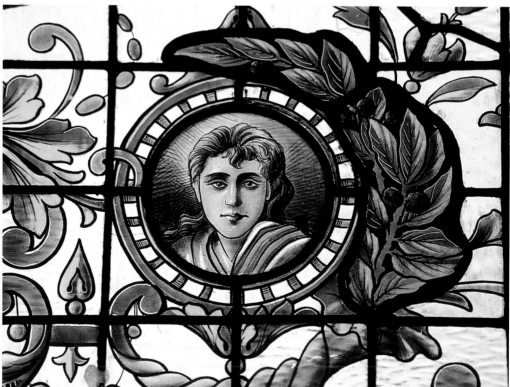

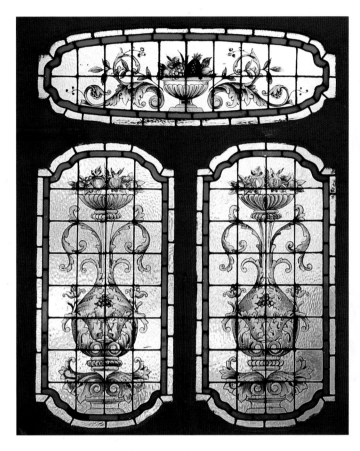

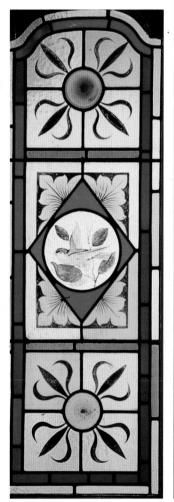

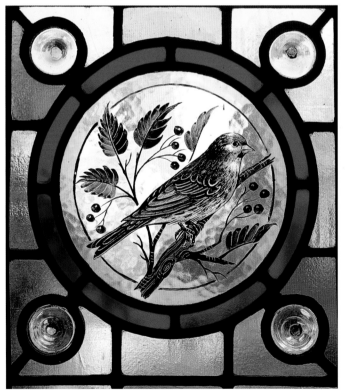

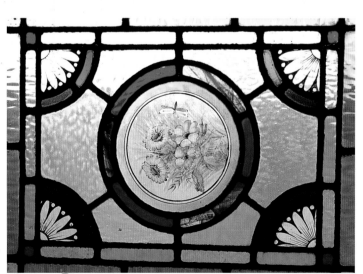

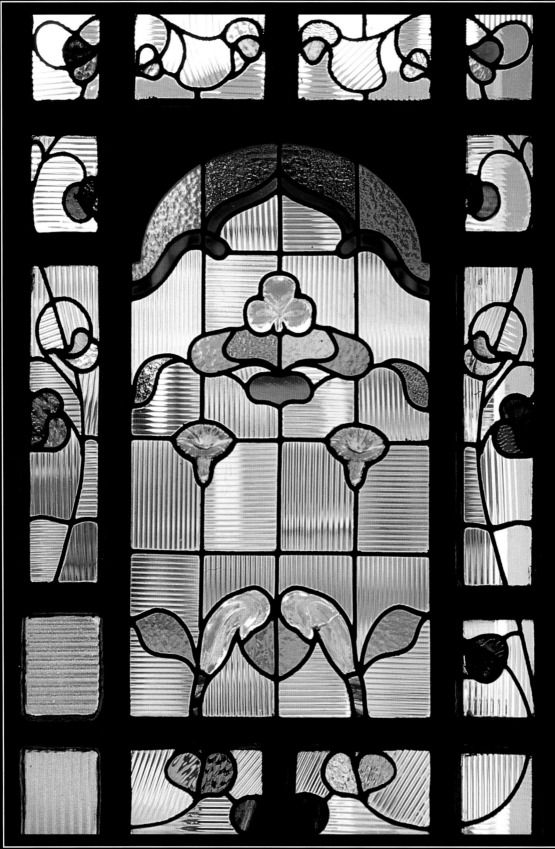

# CHAPTER 3

# *The Birth of Art Nouveau*

The English Arts and Crafts Movement had looked to the past in order to free artists from the constraints of nineteenth-century industrialisation. By the late nineteenth century, there was a reaction against this historicism. A new wave of artists wanted to produce a contemporary styling unlike anything which had been done before. As Otto Wagner, a German architect, wrote in 1895, the 'New Style' was not to be a rebirth, but a birth: modern life alone must be the starting point of artistic creation. Although it lasted only about twenty years, the new art movement which arose in the late 1880s had an enormous impact on architecture, interior design and the decorative arts generally.

## BIRTH OF A STYLE

The 1890s was an exciting time of experimentation. While artists and designers continued to be influenced by natural forms and the understated qualities of Oriental art, they were rejecting the realism of Victorian art. The trend was for a more symbolic approach, capturing what they felt rather than simply what they saw.

While not a single style, the movement had very recognisable elements. The 'Queen Anne' revival of the 1870s had looked for matching sets and symmetry, but the Aesthetic Movement of the late 1870s was moving against this regularity. The compositions of the emerging Art Nouveau tended to be freer and asymmetrical, with sinuous, extended swirls of curved line, giving a much lighter feeling.

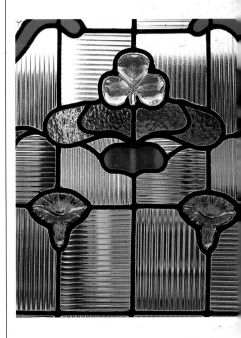

*The new techniques in glass-making and the bold, secular use of stained glass allowed for exciting developments of the art at the turn of the century.*

Another important set of influences were the paintings and etchings of James A.M. Whistler (1834–1903) and his interest in Japanese art. Whistler was an American artist who went to Paris in 1855 and spent the rest of his life between there and London. His work is related to Impressionism, but Whistler was more interested in expressing a mood in his paintings than in the effects of light. Between 1867 and 1877, Whistler designed the famous Peacock Room for a Liverpool shipping magnate named Frederick Leyland. This room, unique and the first to be designed as a whole, is now in the Freer Gallery of Art in the Smithsonian Institute, Washington DC.

There had been an exhibition of Japanese goods in Paris in 1862, including *ukiyo-e* prints and blue-and-white china, which Whistler had visited. He was inspired by the subtle colours, the mastery of using a small space and the reduction of the drawing technique to the barest minimum. The entire stand was bought by a London shop which had made a young man named Arthur Lazenby Liberty their manager. In 1875, Liberty (1843–1917) built his own store in Regent Street, London and set up as Liberty & Co. His and his buyers' patronage of the new style and the young artists working in it, gave the movement its name in Italy.

Flowers were a very popular motif in nineteenth-century/early twentieth-century glass windows, but there were subtle

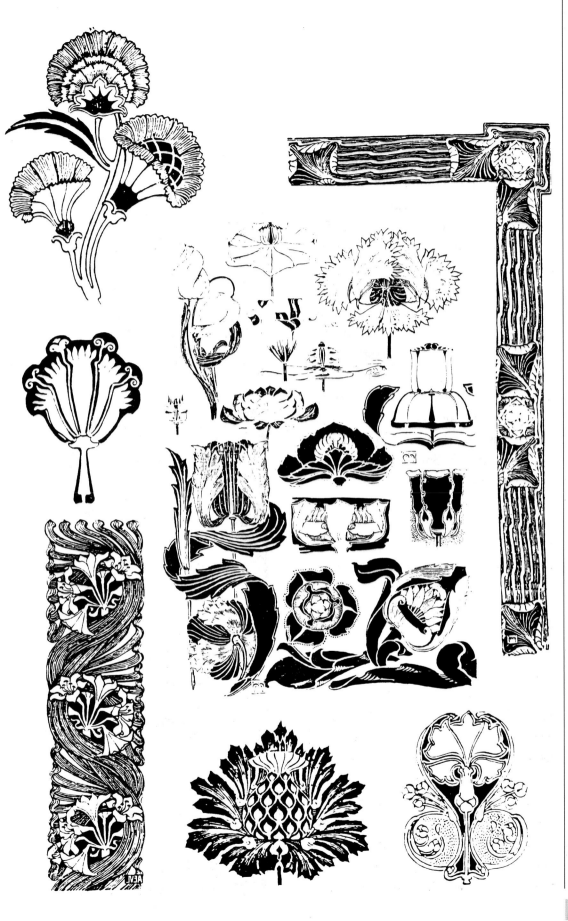

*A selection of stylised flower and plant motifs suitable as painted subjects for panels and borders, taken from a turn-of-the-century book entitled* The Principles of Design *and typical of the sinuous lines and lashing curves that typified Art Nouveau design.*

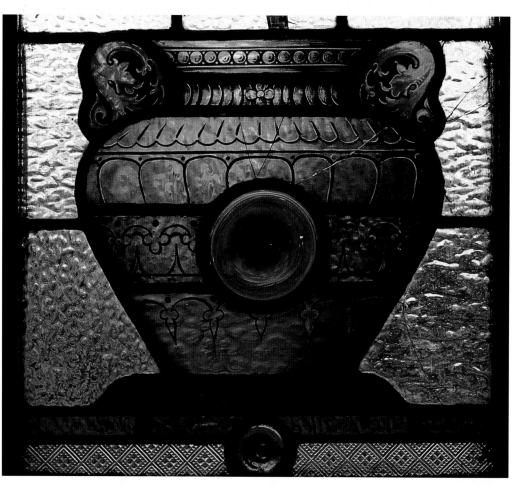

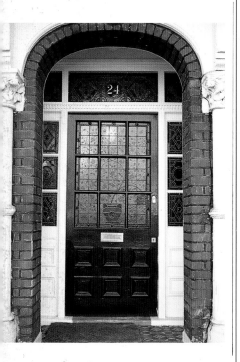

*A simple floral design made up with glass quarries makes a stunning window when teamed with the opulent classical urn.*

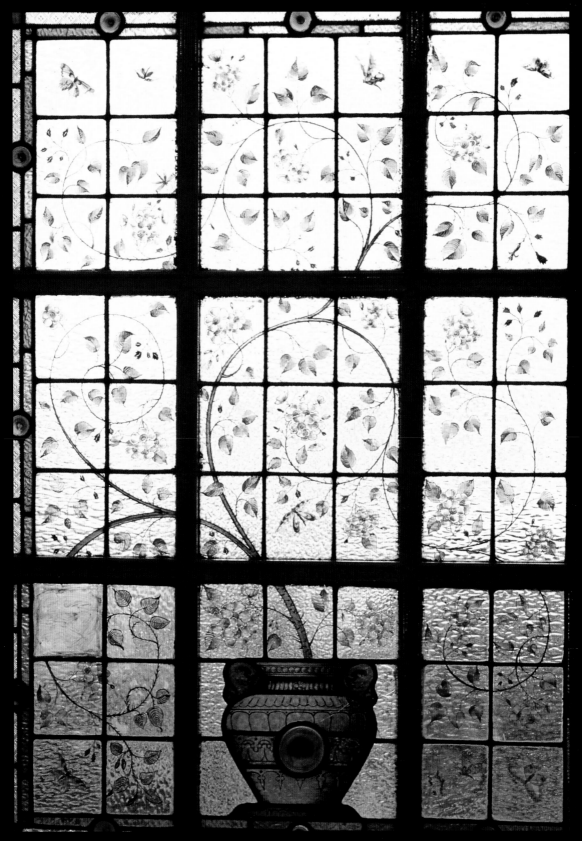

differences in how these were interpreted and stylised by different traditions. Windows following the Aesthetic movement emphasised leaves as much as flowers, using long, thin foliage with sharp points. Neo-Renaissance designs preferred circular flower forms, often with foliage blended into the overall background design. Windows in the Neo-Classical style used flowers more as a garland draped between other forms. Flowers in Arts and Crafts tradition are usually part of an overall pattern, and sometimes a leaf pattern appears on its own without accompanying flowers. As Art Nouveau developed, the preference was for broad leaves and petals displaying characteristic lashing curves.

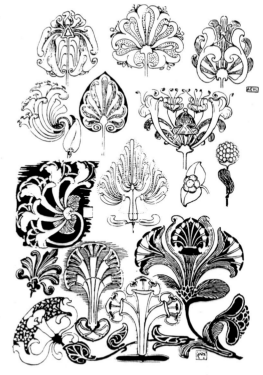

*Flowers were a popular motif in stained-glass panels of the late nineteenth and early twentieth centuries. As Art Nouveau developed, the preference was for broad leaves and petals displaying characteristic lashing curves.*

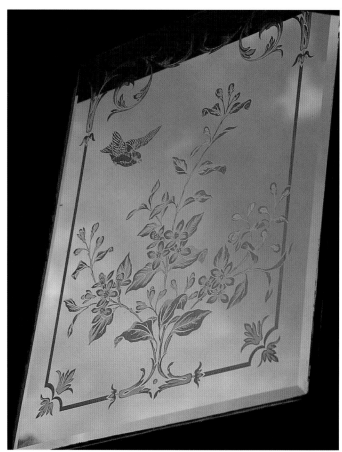

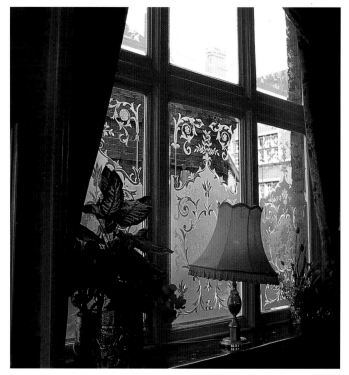

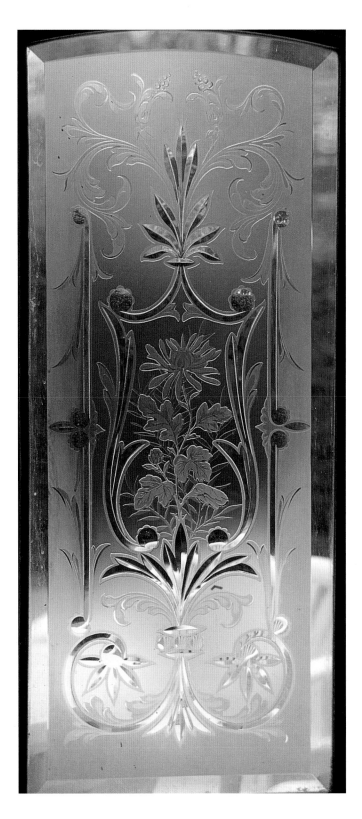

When the only view from a window is onto a brick wall or the plumbing pipes, etched and engraved glass is a beautiful alternative. As far back as 1876, one American writer on the decorative arts, Donald Mitchell, pointed out that such glass was 'full of suggestion to those living in cities whose rear windows look upon neglected or dingy courts, where the equipment of a window with rich designs would be a perpetual delight'.

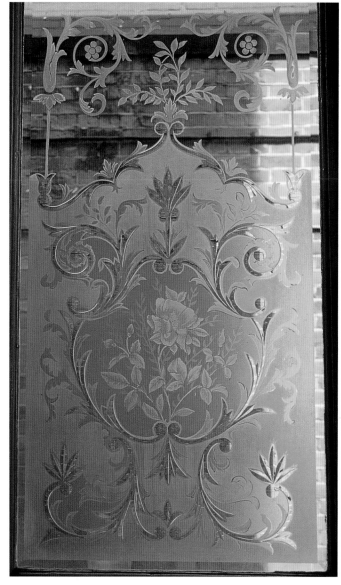

Other British artists and designers working in stained glass included Alex Gascoyne, Oscar Peterson, E.A. Taylor and Arthur Nash who went to work for Tiffany in the United States (see below). Peterson specialised in modelling and etching glass with hydrofluoric acid. He also protected his enamel paintings with a thin layer of plain glass. When heated this fused to the painted surface and so gave it some protection.

*Etched and sandblasted glass was becoming more popular, in keeping with the Edwardians' fervour for letting more natural light into their homes.*

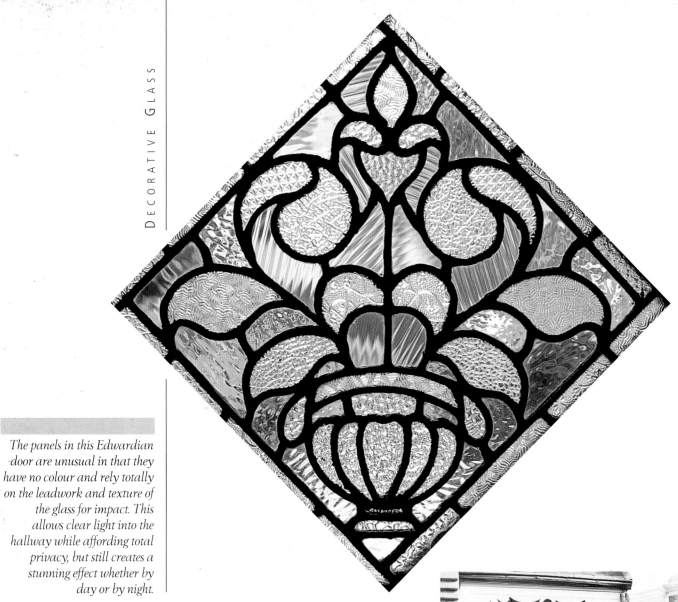

The panels in this Edwardian door are unusual in that they have no colour and rely totally on the leadwork and texture of the glass for impact. This allows clear light into the hallway while affording total privacy, but still creates a stunning effect whether by day or by night.

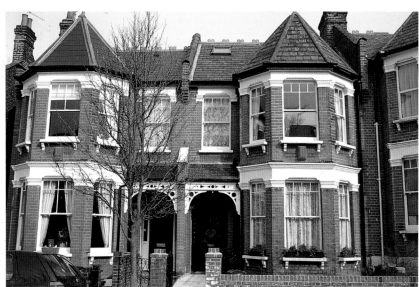

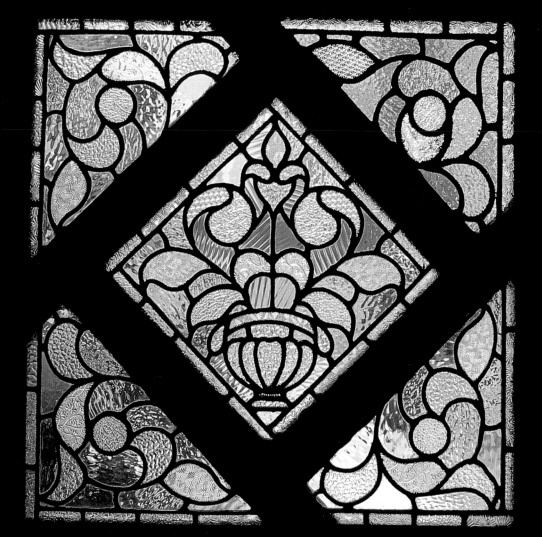

Some of the most attractive designs popular during the Victorian era were the bold, simple stencil patterns used by decorators as ornamental borders and corner designs. The patterns reproduced here are taken from a decorator's journal of the period and could be successfully combined to produce an authentic, original design for an etched-glass window.

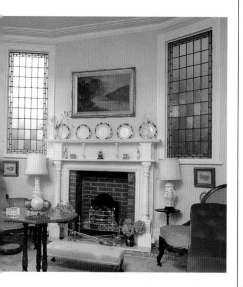

▲

The Edwardian's love of light and airy interiors led them to put windows wherever possible, and it was quite common to find them on either side of the chimney breast. These are made of colourless glass and are probably a modern replacement, but it was more usual for them to be of stained glass.

▶

The influence of early Egyptian art can be seen in the stylised, lotus flower design of these striking panels.

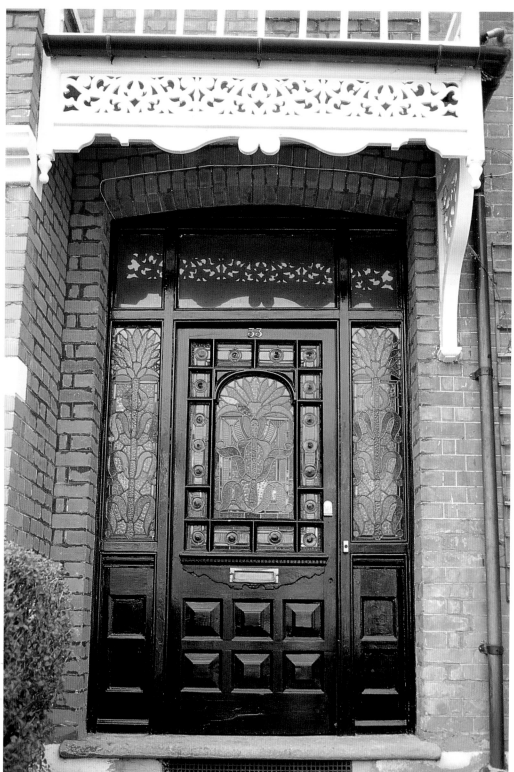

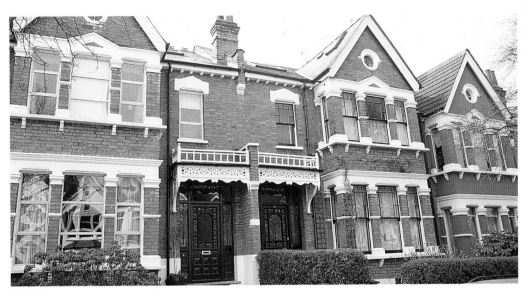

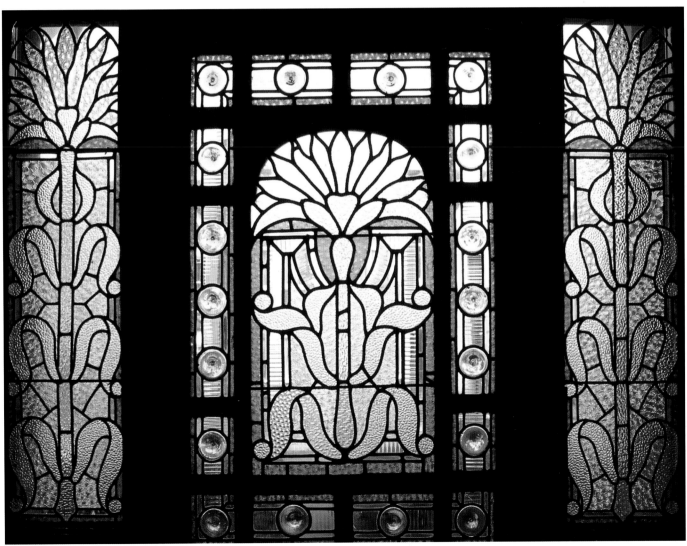

## THE GLASGOW SCHOOL

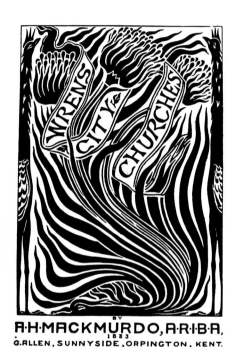

R·H·MACKMURDO, A·R·I·B·A,
1883
G.ALLEN, SUNNYSIDE, ORPINGTON, KENT.

▲

*Arthur Heygate Mackmurdo, founder of the Century Guild, trained as an architect and was a pupil in Ruskin's drawing class. He also accompanied him on trips to Italy where he became an admirer of Italian Renaissance architecture, often using the styles in his own work. The title page of his book entitled* Wren's City Churches *is considered to be one of the first examples of Art Nouveau.*

Arthur H. Mackmurdo, founder of the Century Guild (see the previous chapter), had started working in an early version of Art Nouveau at the start of the 1880s. He took natural forms and translated them into an abstracted, stylised version, without losing track of the original inspiration. He was an important influence on the Deutsche Werkbund (see below).

A group of architects and designers linked with the Glasgow School of Art, including Charles Rennie Mackintosh (1868–1928), evolved a Scottish interpretation of Art Nouveau using ancient Celtic ornamentation. Along with his wife Margaret Macdonald (1865–1933), her sister Frances and her husband, Herbert McNair, they created a spare style with strong vertical elements that is instantly recognisable. Although their work was not well received when exhibited at the Arts and Crafts Exhibition Society show in London in 1896, it soon received recognition in Europe. Mackintosh worked on Hill House, Helensburgh for the publisher

W. W. Blackie in 1902–3; it is one of the purest expressions of his style. However, the best place to see his vision is at the Glasgow School of Art.

The famous leaded-glass door panels for the Willow Tea Rooms in Glasgow were designed by Mackintosh in 1904, but he also designed the furniture, the carpets, the light fittings and the murals. The elaborate twists and curls fitted well with contemporary taste. There was also enthusiasm for

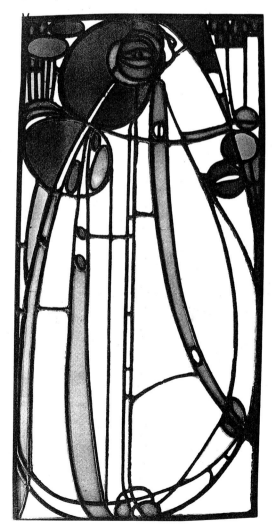

ancient Irish and Anglo-Saxon designs, which became evident in Liberty's early 1900s 'Cymric' range. Early Nordic art, with its spirals and curves, had a similar revival in Scandinavia.

## THE SEZESSION MOVEMENT

In 1901, Mackintosh was invited to furnish a room for the Sezession Exhibition in Vienna. The Sezession (Secession) Movement began in 1896 when several avant-garde artists, who saw no real division between applied and fine arts, split away from the Society of Visual Artists. Like Art Nouveau in France, the Sezession style rejected a return to historical styles and used forms from nature, but preferred geometry as a starting point. Austrian architects used a framework of straighter lines to set off the curves of Art Nouveau, and Mackintosh's sparse rectilinear forms fitted well with this approach.

Members of the Sezession were also involved in the Wiener Werkstatte (Vienna Workshop), which was founded in 1903 and lasted until 1932. In its manifesto, founders Josef Hoffman (1870−1955) and Koloman Moser (1868−1918) did not distinguish between fine and applied arts and felt designs should reflect the innate qualities of the materials used. As with other movements of the time, the Wiener Werkstatte were caught between their

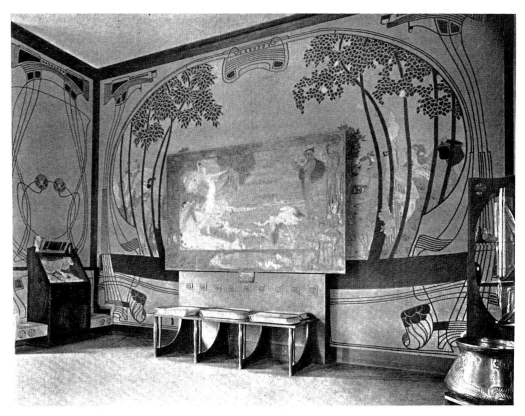

*The starkly geometric designs of Charles Rennie Mackintosh were to be a great influence on the breakaway Secession group which was established in Vienna in 1987.*

*Interior of the Vienna School of Decorative Art as illustrated in* The Studio *magazine of 1900. At this time Joseph Hoffman, architect, and one of the founder members of the Viennese Secession, was a professor there.*

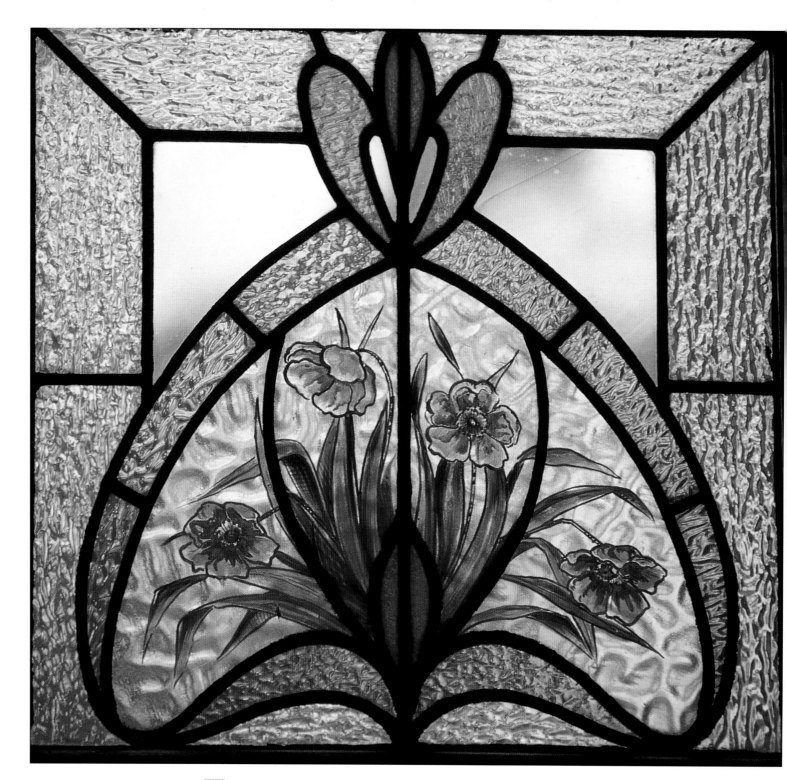

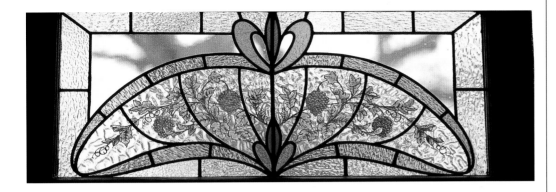

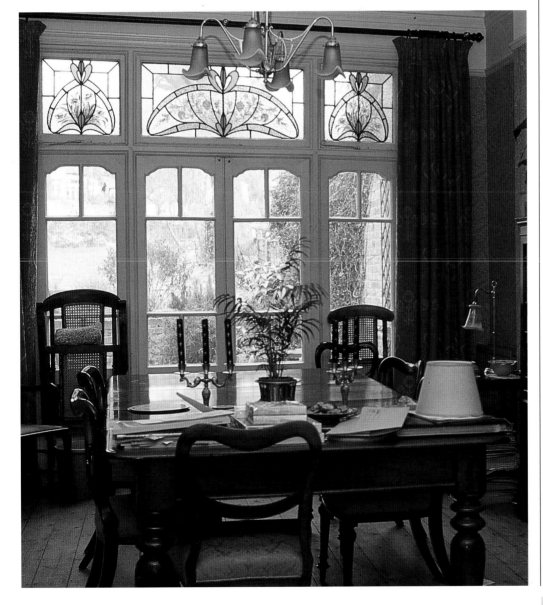

*The swirling lines, sinuous curves and pretty painted flowers of the decorative panels above the French doors in this Edwardian house typify the lighter styles of the early twentieth century.*

admiration for hand-craftsmanship and an awareness of the need to compromise with increasing industrialisation. They wanted good and simple articles for everyday use but, in the tradition of Morris and Ruskin, did not want less satisfying working conditions to achieve this. Their greatest achievement was the Villa Stoclet in Brussels, designed by Hoffman and constructed between 1905 and 1911.

## A EUROPEAN CRAZE

In 1895 a German émigré by the name of Samuel Bing remodelled his Paris oriental shop to support the trend. It is no accident that Bing originally dealt in Japanese art. Trade with Japan had opened to the West in the 1850s and public interest in the simplicity and flat-patterned style of Japanese artists was a strong influence in Art Nouveau. Bing enthusiastically renamed his ten-year-old gallery La Maison de l'Art Nouveau, giving the new movement its French name. The premises became a meeting place for young artists and a showcase for established talent. By the time of the Paris Exposition of 1900, the style had completely conquered the city. You can still see its influence on ironwork at a few of the entrances to older Metro stations!

The style spread rapidly across Europe, producing different variations on the theme. Besides Paris and Nancy in France, German cities such as Berlin and Munich became the main focus for what came to be called Jugendstil (young style). Brussels, Barcelona, Glasgow and Vienna were other major centres, along with New York and Chicago. In Italy, the name Stile Liberty was used, after the famous London store.

*The imposing façade of the building which housed the Paris Exposition in 1900.*

In glass, a wide variety of techniques were employed, including cameo carving, free-form blowing and enamelling. Iridescence in both glass and pottery was also very typically Art Nouveau, with firms such as Johann Lötz in Austria producing award-winning iridescent wares in the 1880s and 1890s. Max von Spaun, who ran the Johann Lötz company, had acquired the secrets of making iridescent glass from an ex-employee of Tiffany. However, he modified and refined the process to suit his own purposes and took out a patent on his process in 1898.

The subtle nuances of colour fitted with the overall look that was being created. The iridescent peacock feather was a popular motif, with other insects and birds featuring prominently as well. The plant world was another major source of inspiration and many artists had a good scientific knowledge of botany.

The Deutsche Werkbund, which brought together architects, craftspeople and industrialists, was formed in 1907. As in England, mass production had been

*A room designed by Professor Joseph Maria Olbrich, a leading German architect and designer and member of the Deutsche Werkbund, exhibited at the 1900 Paris Exposition. Gabriel Mourey, in his review of German Decorative Art at the Exposition for an art magazine of the period, gave special mention to the exhibits of the Darmstadt artists and to Professor Olbrich who planned the entire scheme.*

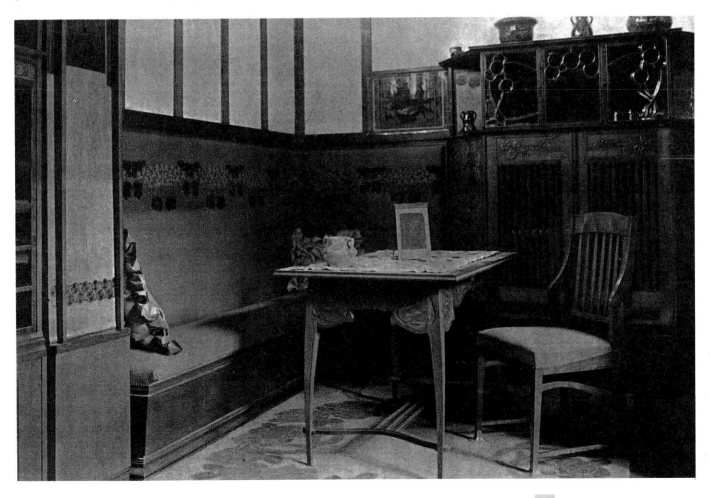

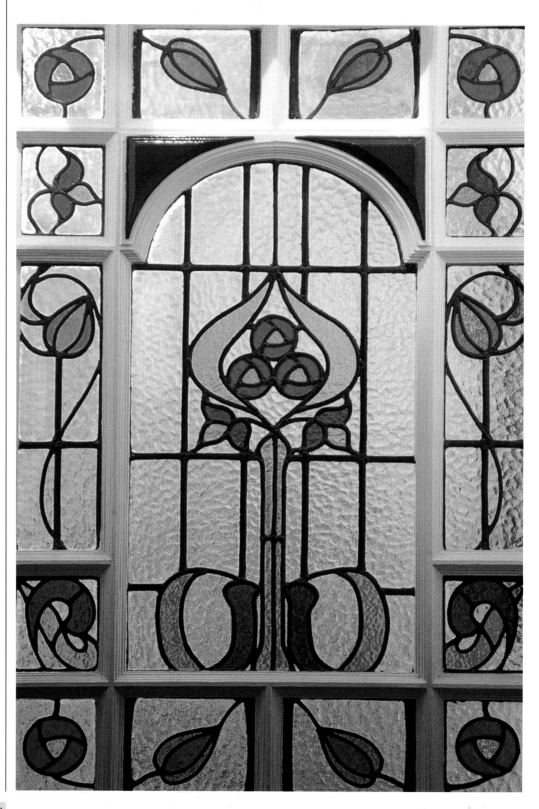

*The curvilinear designs and stylised peacock in the central panels were typical motifs of the Art Nouveau movement and make colourful statements when employed in this way.*

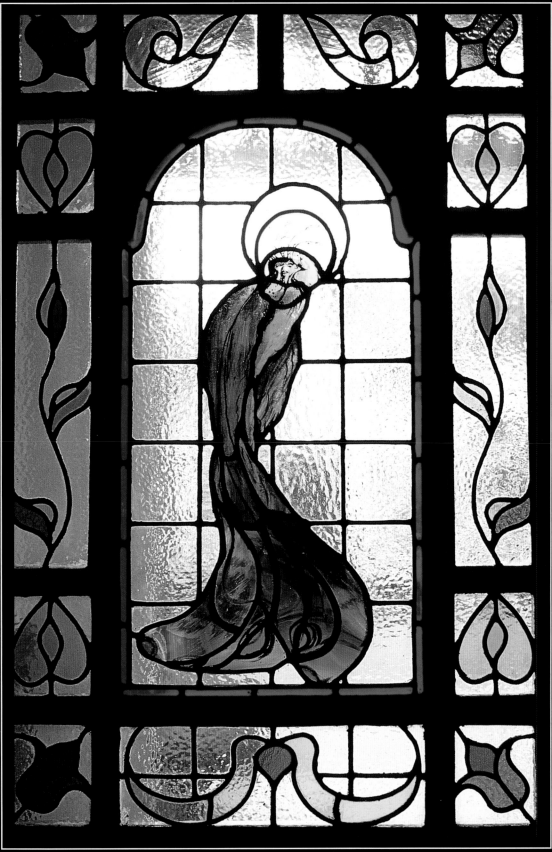

compromising the standards of production in Germany and the Werkbund hoped for reform. While mass production was being criticised, designers and architects could see that machinery could be directed to produce well designed goods. Major architects working in Germany at this time included Joseph Maria Olbrich (1867–1908), Peter Behrens (1868–1940) and the Belgian Henry van de Velde (1863–1957).

In Belgium, the architect Victor Horta (1861–1947) designed the Maison Tassel in Brussels, completed in 1893. This was one of the first houses on the continent in Art Nouveau style (or the Brussels style as it was known in Belgium). Stained glass formed an important part of the interiors. Horta incorporated regular, geometric leadings on skylights to give the impression of a Japanese screen. There are other buildings designed by him in Brussels, including the Hotel Solvay (1895), the Hotel van Etvelde (1898) and the Maison du Peuple (1895–9) which was unfortunately demolished in 1966.

Meanwhile, the Spanish architect Antoni Gaudi (1852–1926) expressed Art Nouveau themes in various Barcelona buildings, including the flower-shaped abstract windows of a small church, the Colonia Güell. The Casa Milá is one of the best examples of his work.

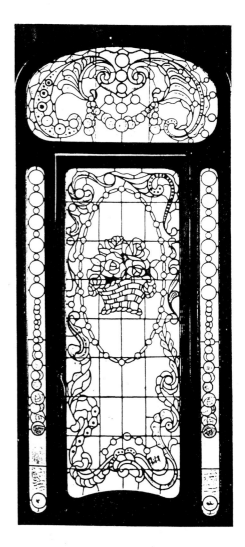

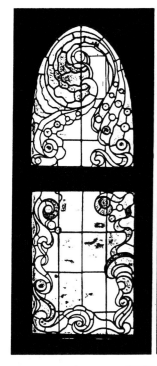
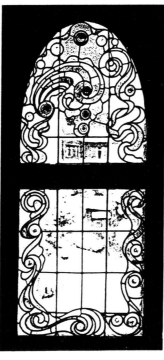
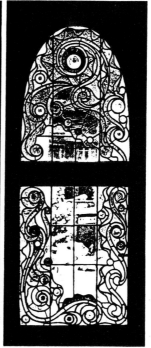

*A selection of designs by Barcelona artists. Although the Art Nouveau movement did not really take hold in Spain generally, there was a Catalan movement, centred in Barcelona, which became the Spanish version of Art Nouveau. It was known as El Modernisme.*

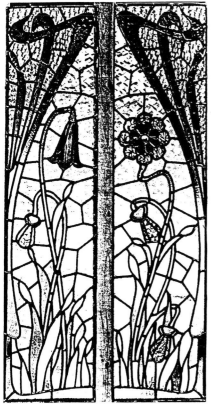
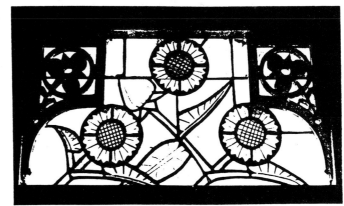
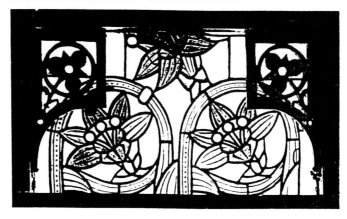

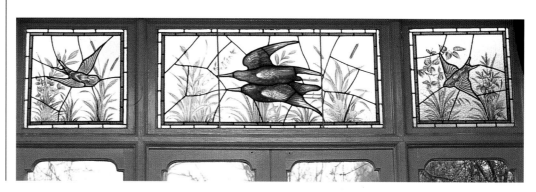

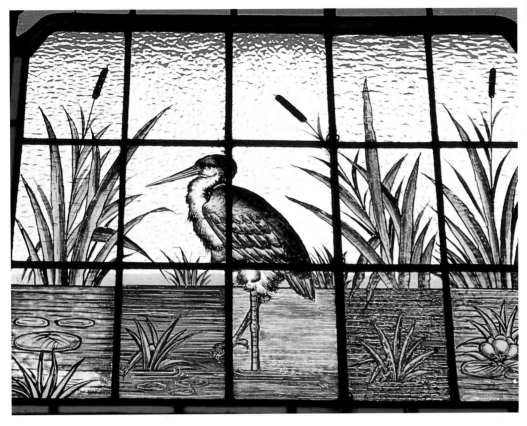

*Bird paintings were still frequently used and made attractive subjects for the smaller windows above French windows, a popular innovation in the Edwardian home.*

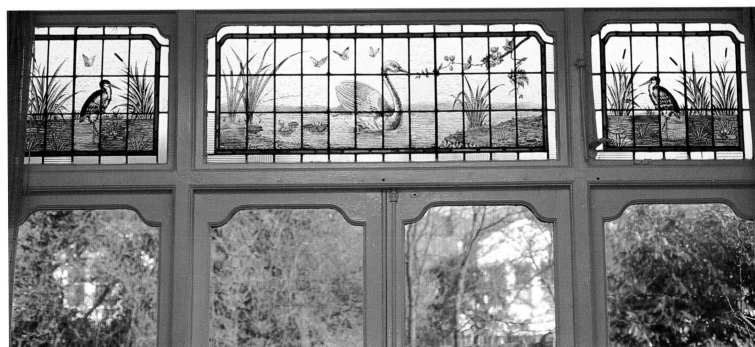

## NORTH AMERICA

In the latter part of the century in New York, two men experimented endlessly to achieve the glowing beauty of Romanesque glass and to move their technique beyond even that great era of stained glass. They were John La Farge (1835–1906) and Louis Comfort Tiffany (1848–1933). The latter artist said, 'I could not make an imposing window with paint' and his stained glass is remarkable for its colour, for its texture and for its technology.

In 1881, the magazine *Scribner's Monthly* wrote about the exciting work being produced by Tiffany and also by John La Farge, a mural painter who had turned his attention to stained glass. Inspired by a visit to Europe in 1872–3, he began experiments with stained glass when he returned to New York and produced his first pieces in 1876. He collaborated with the Boston architect Henry H. Richardson and with Stanford White. A window by La Farge can be seen in St John's Chapel, Southwark Cathedral in London. It was made in 1905 as a memorial to John Harvard. La Farge invented 'opal' glass in about 1890 – this has a colour that can be seen through and which reflects back from the surface of the glass.

When describing their pictures in stained glass, the *Scribner's* article raved about the new effects being created: 'The use of glass of varying thickness is not new, but in the new method of work this is carried out in a manner that is entirely novel

*An advertisement for a company of stained-glass artists from the* Architectural League Yearbook *of America, 1911.*

and gives effects never before attained. The hot glass, while at a red heat, is rolled with corrugated rollers, punched and pressed by … roughened tools … or is stamped by dies. The bull's-eyes produced in making sheet glass, by whirling it round on a rod while still soft, are also cut into various shapes … next to this comes the revival and modification of the old Venetian method of imbedding bits of coloured glass into sheets of clear glass … New styles of opalescent glass, new methods of mixing colours in the glasshouses, have also been tried, and with many surprising and beautiful results. Lastly comes one of the most original features of all, and this is the use of solid masses

◀

*Tiffany also advertised in the* Architectural League Yearbook *of America, 1911, but not, perhaps surprisingly, for stained glass. It is often overlooked that Tiffany Studios did not rely solely on their stained-glass lamps but were also well known for ornamental bronze and wrought-iron work, among other things.*

◀

*A 'Craftsman-style' wardrobe with stained-glass panels in the doors. Furniture-maker Gustave Stickley founded* The Craftsman *magazine in 1901 after visiting France and England and becoming influenced by the Arts and Crafts Movement. His company, renamed the Craftsman Workshops in 1900, produced solid, severe furniture made principally of oak from his own timber mill in the Adirondacks.*

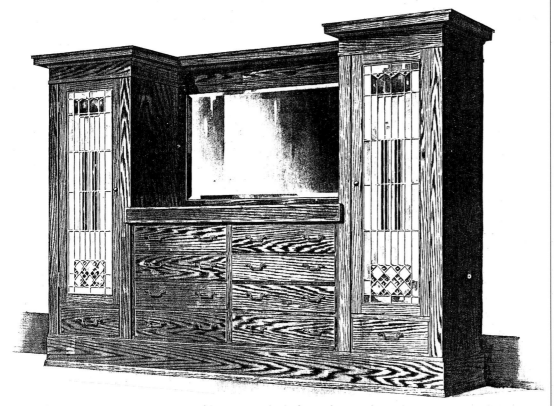

# LEADED COLORED GLASS

Rules for ordering and further description see general information page

**5066.**  $6.20 sq. ft.

**5067.**  $6.50 sq. ft.

**5068.**  $5.00 sq. ft.

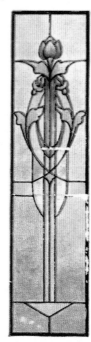

**5069.**  $5.80 sq. ft.

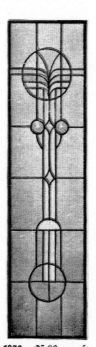

**5070.**  $5.00 sq. ft.

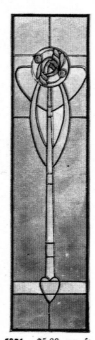

**5071.**  $5.00 sq. ft.

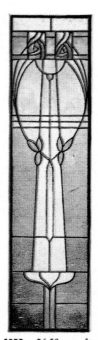

**5072.**  $6.50 sq. ft.

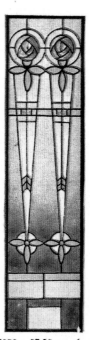

**5073.**  $7.50 sq. ft.

*The designs reproduced on these pages are from a selection of porch panels and fanlights illustrated in an American art glass catalogue of the period.*

# LEADED COLORED GLASS

Rules for ordering and further description see general information page

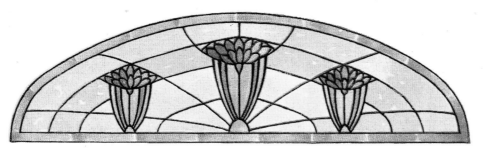

**5048.** $8.50 square foot

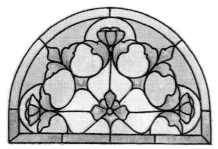

**5049.** $8.50 square foot

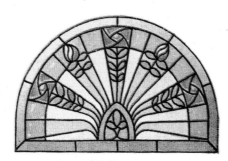

**5050.** $12.50 square foot

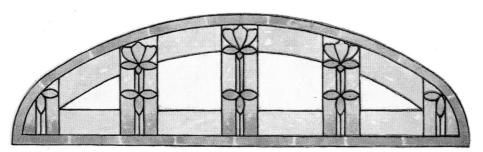

**5051.** $6.50 square foot

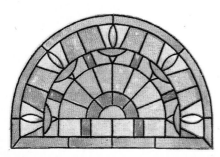

**5052.** $6.00 square foot

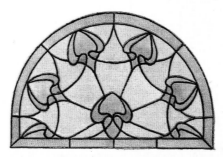

**5053.** $7.00 square foot

and lumps of glass pressed while hot into moulds, giving facets like a cut stone. . . These, when set in the window, have all the effects of the most brilliant gems.'

Louis Comfort Tiffany was the son of a wealthy New York jeweller. In the late 1860s he had gone to Paris to study painting, but his travels also took him to such places as Spain, North Africa and Egypt. He became fascinated by European stained glass, Islamic buildings and lamps, and returned to the United States with a much wider interest in the decorative arts. The dense, glowing brilliance of the stained-glass windows at Chartres made a particular impression on him and he found that the technology for making such windows seemed to be lost. The stained glass then being made in America could not compare with the jewel-like intensity of what he had seen.

Tiffany and three associates formed their own design firm in 1881, producing exotic interiors – the influences of oriental and medieval themes were evident. Tiffany and his colleagues had studied medieval stained-glass windows in great detail. On his travels he had acquired an old window and personally took it to pieces, analysing the construction as well as the colour and design. Tiffany even patented new types of window formation. Unlike other manufacturers who began with a leading outline, Tiffany started by cutting the glass to match his picture jigsaw and wove the leading around the pieces.

When Tiffany redecorated the White House in the winter of 1882–3, he placed an opalescent glass screen featuring eagles and flags in a hall to provide more privacy for the President's family. There were also glass-mosaic sconces designed for the Blue Room. Writing in *The Forum* magazine in July 1983, Tiffany commented, 'Today this country leads the world in the production of coloured-glass windows of artistic value and decorative importance . . . I maintain that the best American coloured windows are superior to the best medieval windows. Our range of colour is far in excess of the thirteenth century.' The screen was destroyed in 1904 on President Theodore Roosevelt's instructions.

One of Tiffany's most famous windows, The Four Seasons, was exhibited by Samuel Bing in Paris to much acclaim. In return, Bing commissioned Tiffany to produce windows based on designs by nine leading French artists, including Henri de Toulouse-Lautrec. Tiffany also collaborated with Charles and Henry Greene, a pair of American brothers who trained at the Massachusetts Institute of Technology School of Architecture. After they graduated in 1892, they moved to Pasadena in California where they developed the distinctive Californian bungalow style of house. The finest example of their work is the Gamble House in Pasadena, which is now a museum.

*A German advertisement for Samuel Bing's Paris shop.*

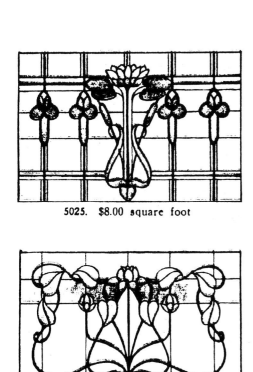

5025. $8.00 square foot

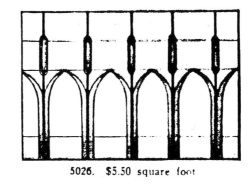

5026. $5.50 square foot

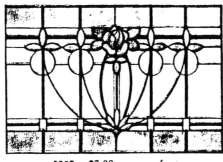

5027. $7.00 square foot

5028. $7.00 square foot

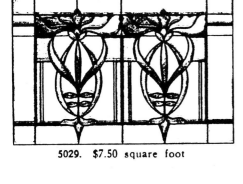

5029. $7.50 square foot

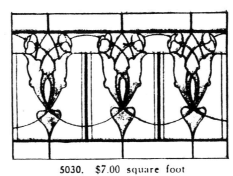

5030. $7.00 square foot

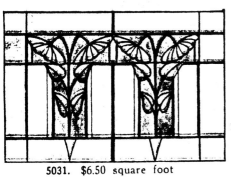

5031. $6.50 square foot

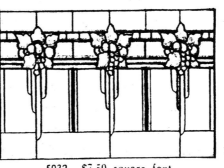

5032. $7.50 square foot

*A further selection of designs for windows from a contemporary catalogue. The designs are becoming more geometric and a lot less florid as the new century progresses and the Art Nouveau movement begins to decline to make way for what became known as Art Deco styling.*

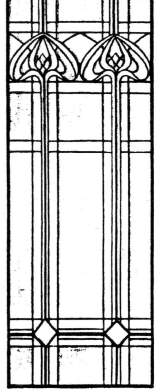

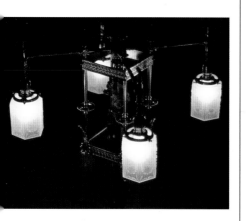

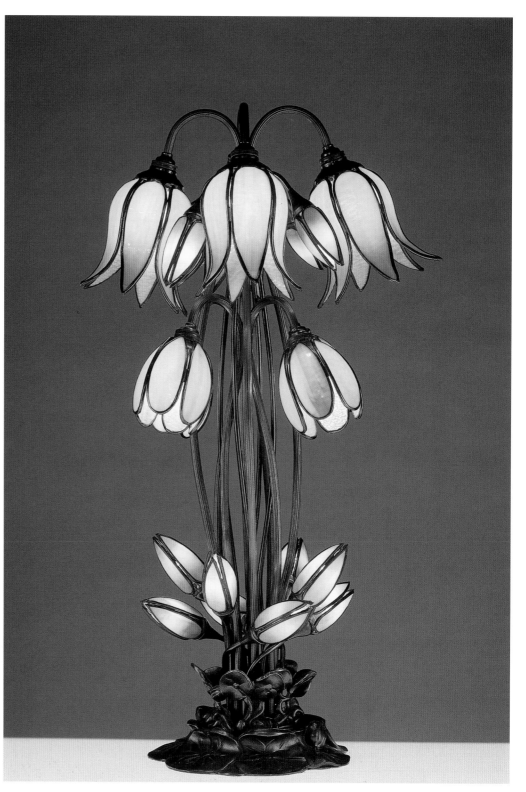

The chandelier illustrated above is an original fitting made for an Edwardian mansion in Toronto, Canada, whereas this lamp (right) is a reproduction of one made by Tiffany Studios.

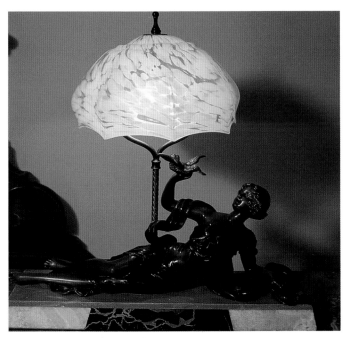

*Electricity was an exciting new development at the start of the twentieth century, that freed designers from the inhibitions of candle- and oil-holders. Consequently they let their imaginations run riot. Bronze was a popular material for the new lamp bases.*

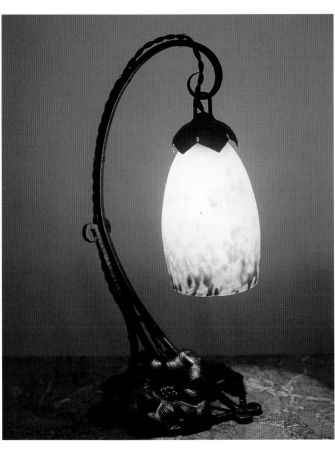

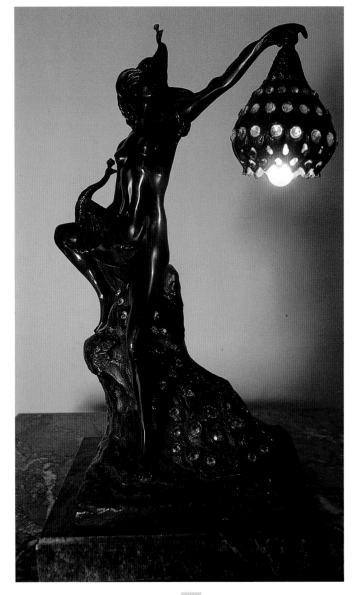

## LAMPS LIKE JEWELS

Tiffany's art glass included 'Lustre' ware, which had been produced first in Europe in the 1870s, but Tiffany adopted the method to make a wider range of subtle effects. He also made 'Agate' ware by putting opaque glass of different colours into a melting pot and mixing them until the result had the appearance of agate or marble. With 'Cypriote' glass, he added lustre to an object whose surface was encrusted by crumbs of yellow glass. 'Lava' glass had basalt or talc added to the molten glass, after which the surface was then gold-lustred. 'Paperweight' or 'Reactive' glass was the name given to translucent Tiffany glass that had become iridescent when heated in a furnace.

Tiffany's famous leaded glass lamps were not made on any real scale until the end of the 1890s. The invention by Swan (1878) and then Edison (1879) of the incandescent filament bulb had revolutionised the design of lighting fixtures. Until that time, lighting was supplied mainly by liquid fuels and gas. The electric light meant that lamps did not have to be upright, which gave designers considerable new freedom. Tiffany had been commissioned to design the interior for the first theatre to be lit by electricity, the Lyceum in New York. It opened in 1885 and Tiffany had solved his concern for the brightness of the light by filtering it through coloured green glass.

Tiffany's table lamps made use of bronze or gilt-bronze bases to support the leaded shades. He used copper foil or bronze to bond the glass pieces, as traditional lead strips did not work well with three-dimensional stained-glass work. He seems to have invented the method of wrapping copper foil around the edges of glass and then soldering. Before the Arts and Crafts era, copper was regarded in Europe as an inferior, cheaper metal suitable only for 'below stairs'.

Tiffany's 'Favrile' art glass was patented in 1894 as 'a composition of various coloured glasses, worked together while hot'. The technique was almost certainly invented by Arthur Nash, an Englishman who had emigrated to the United States in 1892. He had been a partner in the Whitehouse Glass Works in Stourbridge before he left England. Favrile is a variation on the Old English word 'fabrile', meaning hand-made, and the exotic blends were the outcome of much experimentation by Tiffany and his chemists. For Tiffany, there were no barriers to what could be achieved and he spent enormous sums on research.

To make the lampshades, many pieces of Favrile glass were set in a framework of irregular shapes, each assembled by hand and no two being exactly the same. In true Arts and Crafts tradition, Tiffany sought to build an element of individuality into his production line. The artisans, mainly women, who made the shades worked within a set designed mosaic pattern, but had the freedom to select colours and textures from the wide range of glass in stock.

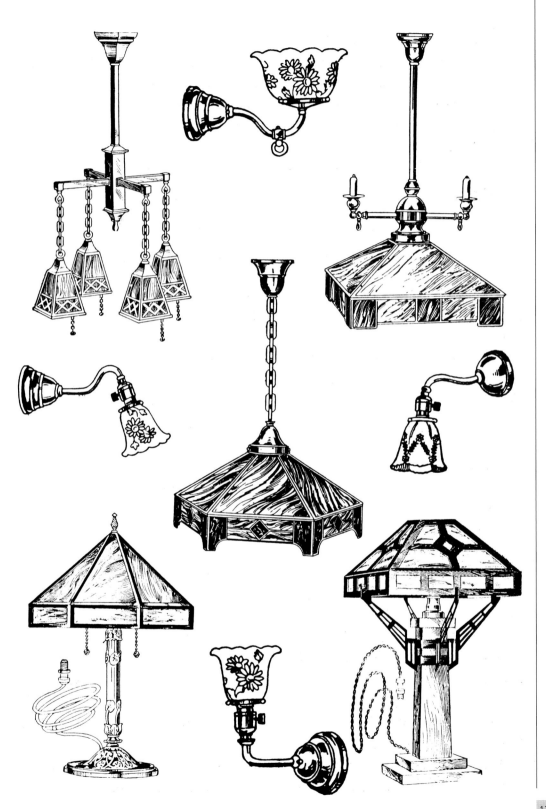

*A selection of light fittings available from a manufacturer's catalogue at the turn of the century. Some of the designs are new, with influences of the Arts and Crafts Movement clearly visible, while others are simply based on those of the old gas lights.*

▼

*Fringes were sometimes added to hanging shades, as in the style below. Clear glass was repeatedly stained with silver sulphide and fired to create the deep orange colour. This shade shows how variations in tone within a single piece of glass produce stunning effects. Tiffany was against the use of brushwork and created imaginative shadings when firing the glass itself.*

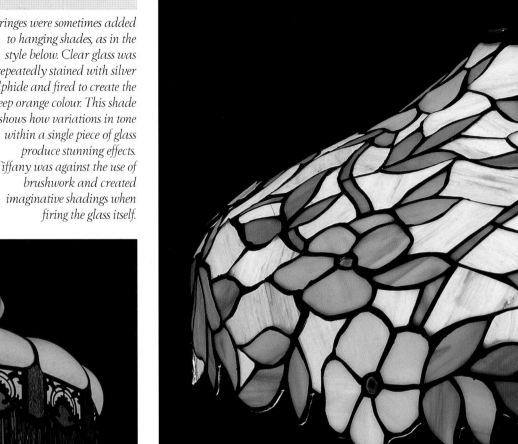

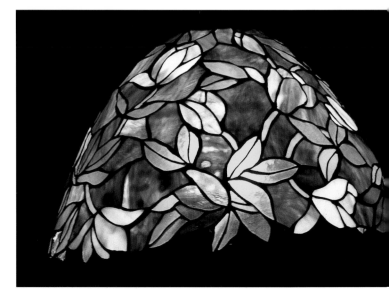

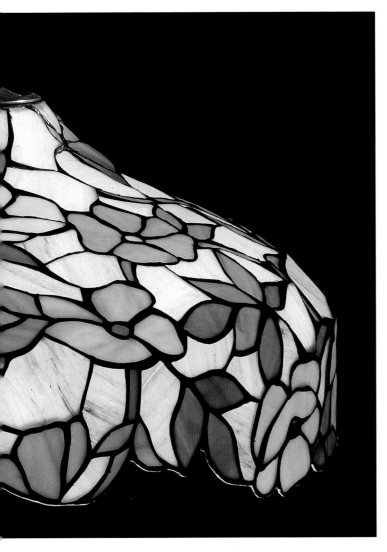

◀▼

*Tiffany-style lamps generally use patterns inspired by plant and insect forms. Famous examples are Tiffany's Wisteria and Dragonfly shades. The table lamp (below) uses the traditional Tiffany spider web theme, while the hanging shade (left) used Viola as its motif. Tiffany used ceramics for his lamp bases, as well as bronze.*

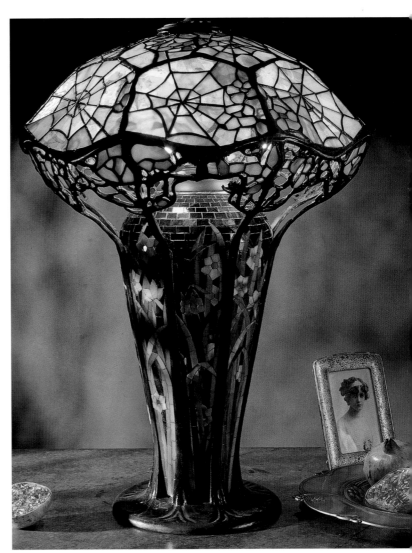

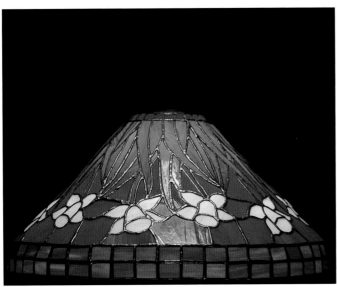

By the late 1890s, Tiffany's works at Corona held nearly 5,000 colours and varieties of glass, which really did allow for the character of each piece to be individually expressed.

While a jewel-like glow limited the practicality of the hanging shades and floor lamps as sources of light, they are highly atmospheric and decorative. His most successful designs reflected the natural plant and insect subject matter so popular with Art Nouveau. One of the most famous lamps was a lily-cluster with morning-glory shades using iridescent gold glass. The Wisteria and Dragonfly lamps are examples of patterns by Tiffany's well paid female designers. He encouraged women to take an active role in the business, well before they were even allowed to vote

Tiffany's designs, using 'fractured' or 'confetti' glass as well as mottled glass, became highly favoured in the early years of the twentieth century. Tiffany believed the beauty of a piece of glass should come from the kiln and explained his quest to make technology fit his artistic aims in December 1917: 'Glass covered with brushwork produces an effect both dull and artificial. . . How many years have I toiled to make drapery glass? My chemist and my furnace-men insisted for a long time that it was impossible. . . New styles of firing ovens had to be built, new methods for annealing the glass.'

Other manufacturers at the time followed Tiffany's lead. While the Handel Glass Company, founded in 1885 in Connecticut, made Tiffany-style shades, their most successful products were reverse-painted table lamps. 'Reverse-painting' was a way of hand-painting the inside of glass lampshades with landscapes or floral patterns. The Quetzal Art Glass & Decorating Co. was founded in Brooklyn in 1901 by two of Tiffany's ex-employees. Other companies specialising in coloured glass included the Lustre Glass Co. of New York, the Vineland Flint Glassworks of New Jersey, the Fenton Art Glass Co. of Virginia, the Fostoria Glass Speciality Co. and the Imperial Glass Co., both of Ohio. In 1904, the Steuben Glass Works of New York launched their 'Aurene' glass, which was based on Tiffany's Favrile glass.

When Tiffany travelled to Europe in 1889 he was impressed by the work of a French glass artist named Emile Gallé (1846–1904). At an international exhibition held in Paris in 1900, known as the Exposition Universelle, Gallé was the rising star of the French pavilions. He had even arranged a complete furnace and craftsmen demonstrating the blowing of glass.

## EUROPE

The town of Nancy, capital of north-east France, had a tradition of glass-making which went back to the Middle Ages. Gallé's father had owned a glass factory there and Emile had become fascinated from an early age. In the late nineteenth and early twentieth centuries, the Nancy school led a revival of cameo decoration and made

*An advertisement for the Handel Glass Company, founded in 1885. While they made Tiffany-style lamps, they were most widely known for their hand-painted shades.*

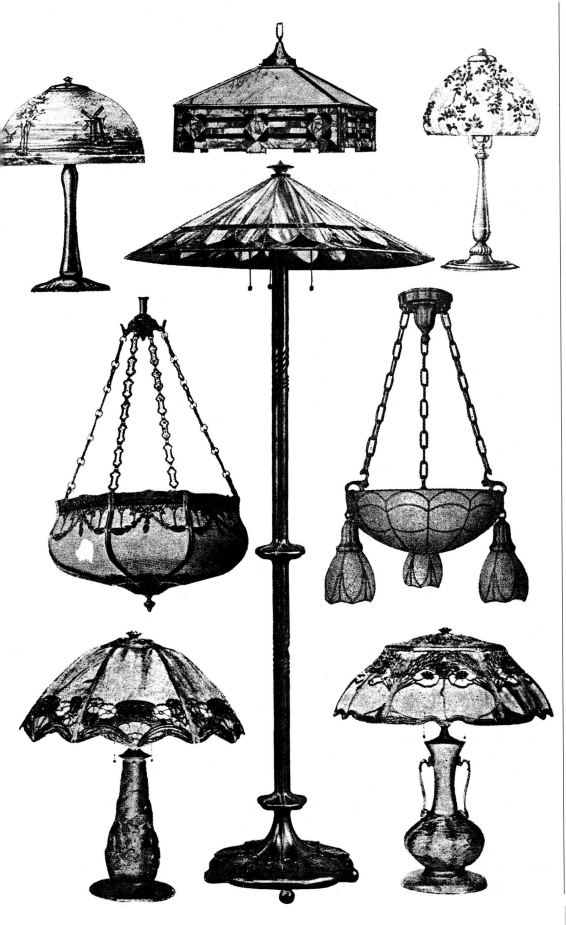

*A selection of Tiffany-style lamps from manufacturers' catalogues demonstrates that leaded glass shades were not an innovation from Tiffany studios. However, his designs were far superior to any similar product and caused a sensation in lamp design, becoming so popular that 'Tiffany lamp' became a generic term.*

*The spirit of the Art Nouveau movement is clearly visible in the simplicity of these windows.*

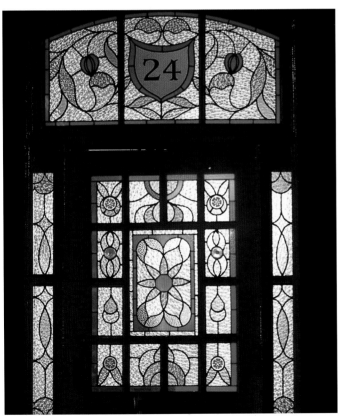

*Where privacy is desired, stained glass is a colourful and imaginative solution.*

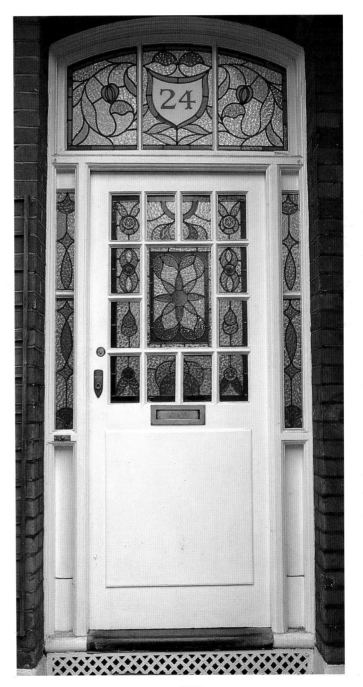

enamelled glass popular. Artists there sculpted glass and explored its surface possibilities. Phillipe-Joseph Brocard, who was a noted glass-worker between 1867 and 1890, taught Gallé his enamelling techniques. His own work had been inspired by fourteenth-century Syrian lamps and he eventually mastered the techniques used then.

Gallé's decorative ideas were based heavily on nature and he had an almost mystical reverence for plants and flowers. His workshop was established in 1874. Carved in oak above his studio door, he put the motto, 'Our roots are in the depths of the woods — on the banks of streams, among the mosses'. Even bubbles in glass were cleverly utilised to represent either raindrops or dew on petals.

It was in the late 1880s that Gallé first applied his great appreciation of natural themes to glassware, with his Magnolia vase. While he experimented with animal and especially insect shapes, flowers were his favourite natural symbol. His Pasteur Goblet, made with blown and cased glass, was etched with microbes and medicinal plants.

Gallé discovered woodwork in 1885 and designed a variety of furnishings using elaborate marquetry. He used this work as an inspiration for *marqueterie de verre*, which he patented in 1898. Shaped pieces of hot glass were pressed into the body of a glass object of a contrasting colour, resulting in a flat surface. The inlaid pieces were then decorated more with carving or engraving.

Gallé's technique of engraving layered glass to give the effect of a cameo was first prompted by a visit to the British Museum in 1871 where he saw the Roman Portland Vase. The cased-glass method he developed from this involved fusing moulded layers of different colours together and then cutting away parts of the top surface with an engraving wheel to make patterns. Cameo glass-works became the mainstay of the Gallé glass-works, while patination was an accidental effect which Gallé adapted to create his highly imaginative results. Ashes or dust from the kiln were spread on the surface to fashion a cobweb-like, matt surface.

Gallé experimented wildly and combined varied techniques on a single piece, using decoration along with etching and engraving. His subject matter ranged over various themes as well, including his love of mythology and oceanography. In the last years of his life after 1900, many of his creations show a dream-like atmosphere. The mushroom lamp of 1902 called Les Coprins is one example, showing a mixture of blown and cased glass on a wrought-iron base.

Lamps were not a favourite medium for Gallé, but he did show some interest, though most that bear the firm's name were actually produced in the 1920s, after his death. The factory, surrounded by tall trees and with a peaceful atmosphere, continued production until 1931.

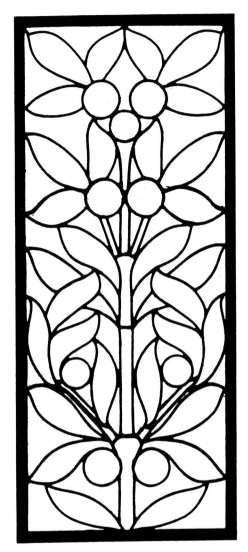

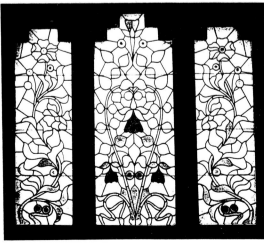

*A further selection of designs from artists of the El Modernisme movement in Spain.*

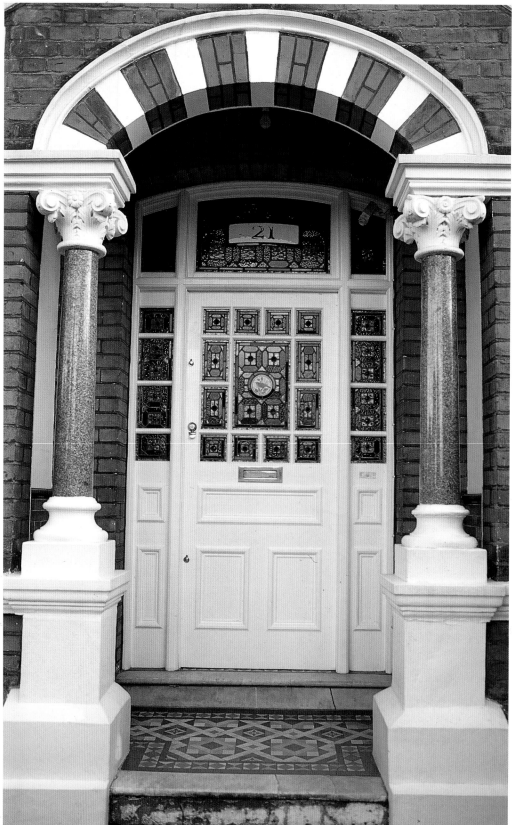

*The colourful diaper pattern in the glass panels on this entrance door echoes the patterns of the encaustic tiles on the porch, making it an impressive feature of this turn-of-the-century house, both by day and by night.*

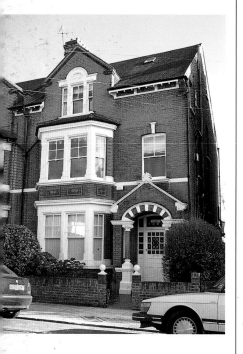

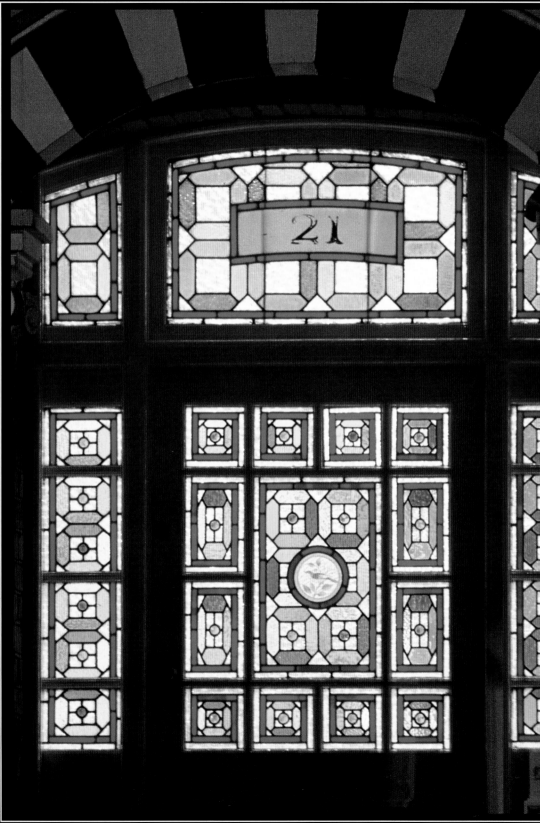

There were a number of other glass-makers in Nancy, including the Daum brothers. They produced decorative vases that appeared somewhat lighter and less serious than the pensive works by Gallé. The Daum factory was founded in 1870 to make window panes and utilitarian items but became more artistic in the 1890s, following the inspiration of Gallé. Art Nouveau glass was produced by Jean-Louis Auguste and Jean-Antonin Daum until 1925.

One of the Daum factory's most important contributions to art glass has been their work in *pâte-de-verre* (glass paste), which they first produced in 1906. The technique grinds glass to a powder, adds a flux to facilitate melting and then adds colour. Objects are made by putting the glass paste in a mould and then firing. Jean-Antonin Daum described the technique as 'the greatest discovery in our time in art glass'.

While the method of *pâte-de-verre* was known in ancient Egypt and revived in the late nineteenth century, it reached a peak in the 1920s and 1930s with artists such as Joseph Gabriel Rousseau and François-Emile Décorchement. The early experiments of Décorchement were typically Art Nouveau, but after 1909 he was producing thinner-walled vessels with details cut into the surfaces and using *pâte-de-cristal* (with a finer-quality powdered glass). By the late 1930s, even his decorative window panels used *pâte-de-verre* instead of painted or leaded glass to achieve a rich effect. Like many other artists of the time, Décorchement's style had shifted from Art Nouveau to the bolder, more geometric patterns of what was becoming known in the 1920s as Art Deco.

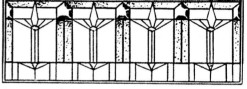

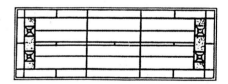

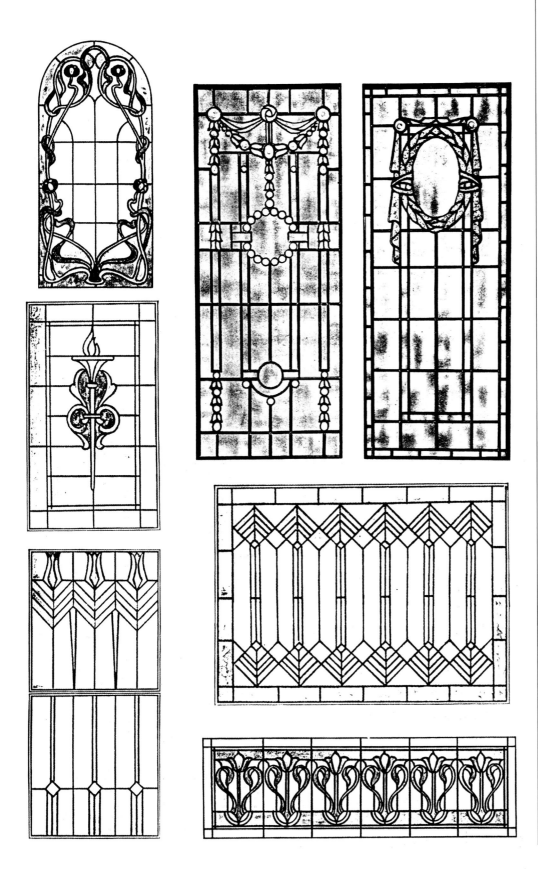

Catalogue designs demonstrating a move away from the flowing curvilinear designs of the Art Nouveau movement towards the rectilinear shapes of what subsequently became the Art Deco movement.

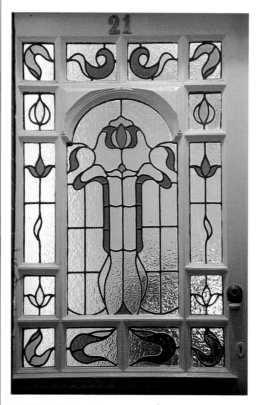

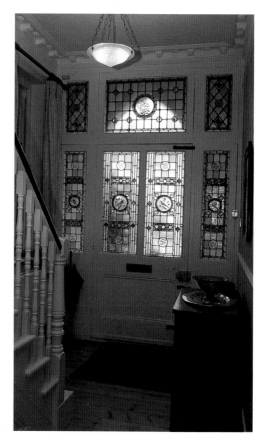

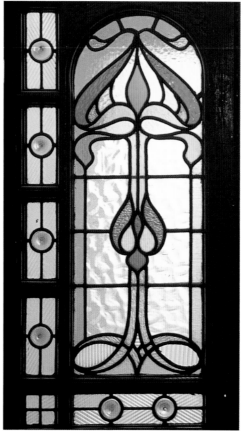

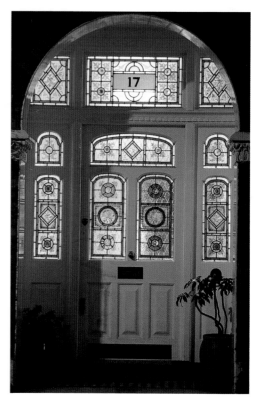

*The illustrations on the remaining pages of this chapter are intended as a style guide for anyone looking to bring some authentic Victorian or Edwardian splendour to their home.*

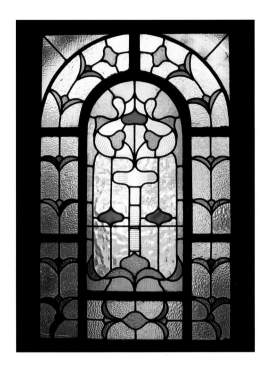

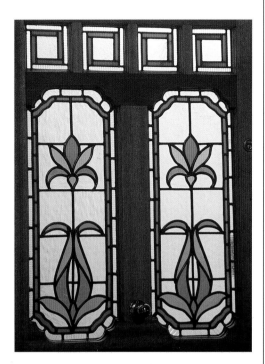

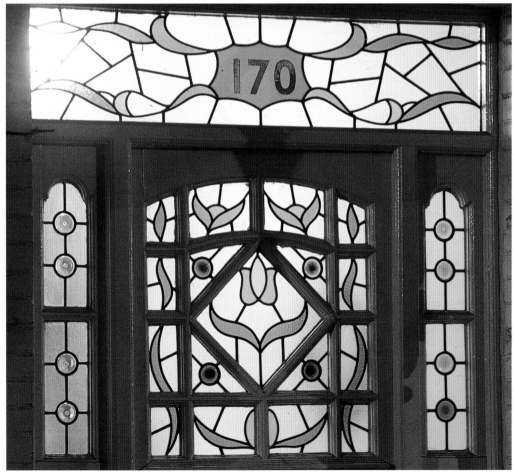

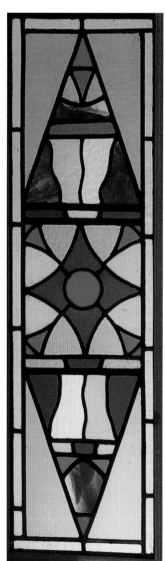

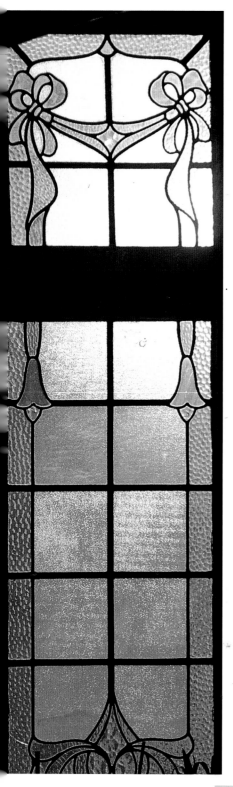
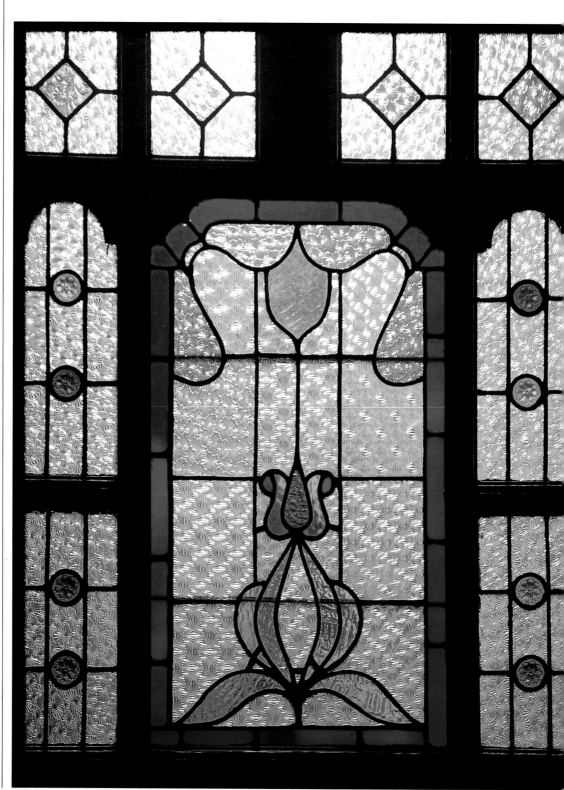

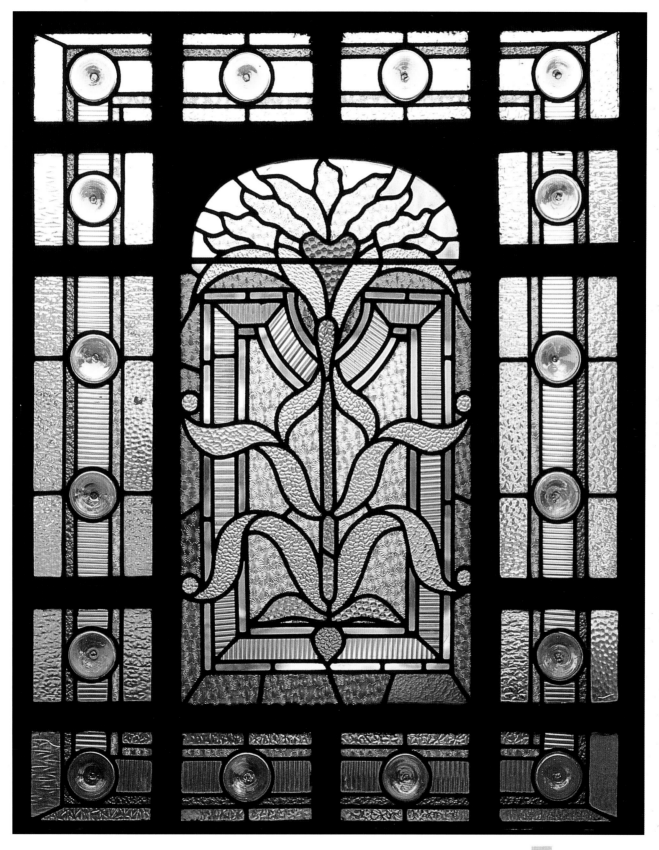

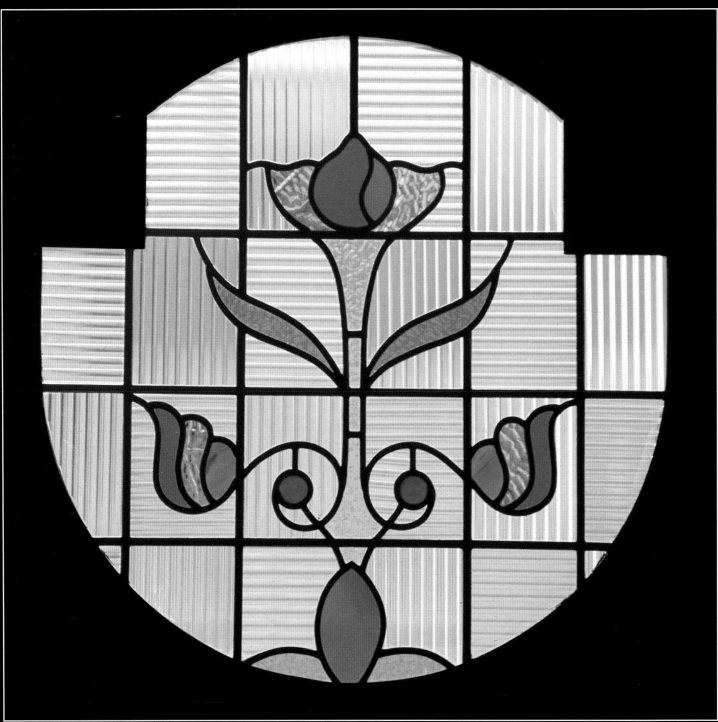

# CHAPTER 4

# Les Arts Décoratifs

The characteristic shapes of the new Art Deco style were geometric or stylised rather than the curvilinear forms of Art Nouveau. A recurring theme, appearing on almost everything from gramophone needle boxes to suburban garden gates, was the sun-ray motif.

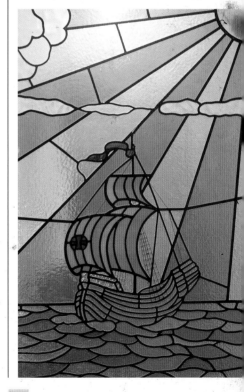

The early twentieth century was a remarkable time for glass creation. By the 1920s, French decorative artists were in the forefront and the Exposition des Arts Décoratifs et Industriels, held in Paris in 1925, was a showcase for much new and exciting work. Abbreviated as 'les Arts Décos', the exhibition gave the emerging new style its name. Its characteristic shapes were streamlined geometric or stylised, rather than the curvilinear plant forms of Art Nouveau. In 1925, many exhibits showed recurring geometric themes of ovals and octagons, as well as graceful female nudes, flower-heads tightly bunched together, spirals, lightning flashes, deer and doves.

The engraved glass which had first become popular at the end of the nineteenth century was revived in the 1920s and 1930s, led by designers at the Orrefors factory in Sweden, founded in 1898. In 1916, the management engaged Simon Gate, a painter with no previous experience of glass, and in 1917 Edward Hald also began work at Orrefors. The two formed an impressive team — they helped to evolve the firm's 'Graal' technique, which superimposed layers of coloured glass and then etched or carved these with relief decoration.

The Daum Factory in Nancy was founded in 1870; by the 1890s it was being run by the brothers Auguste and Antonin Daum. The factory had closed during World War I, but reopened in 1919 and produced some fine Art Deco glassware in the 1920s and 1930s. It is still in operation. During this period they made mainly thick-walled, heavy machine-made wares that were then hand-finished. Surfaces were granular, creating a diffused light, with either abstract geometric or floral designs. Lamps were a major item — the Daum factory made both glass lamps and shades for wrought-iron bases produced by others. Many of these Daum lamps were in the shape of mushrooms, with a matt finish. Others were made of colourless glass, in angular shapes with deep-etched designs.

There were other factories functioning in France during this period and producing Art Deco designs in enamelled glassware. The Cristalleries de Baccarat and Louis Vuitton were both prominent in this field. Their favourite motifs included highly formalised flowers, sprays of blossom, and animals and human figures in a formalised, streamlined style. The more prominent designers included Marcel Groupy, Jean Luce, Georges Chevalier and Madame Cless-Brothier. Déguy and Cristalleries de Schneider were known for their etched glass, often in hard colours, and decorated with geometric motifs or heavily stylised insects and flowers.

Another important influence was the American Steuben Glass Works (by now Steuben Glass Ltd) which was founded in 1903 by the Englishman Frederick Carder (1863–1963). In 1918, the firm became the art glass division of Corning Glass Works. A large part of the output from 1904 to 1933, including table lamps, was in a style developed by Carder known as 'Aurene'. Most Aurene wares had blue or gold iridescent decoration, with a smooth surface. During his thirty years with the company, Carder created a variety of new types of glass with varying surface effects. One kind of art glass known as 'intarsia' was developed about 1920, having a layer of coloured glass etched with a design and cased between layers of clear glass. Carder's work of the 1920s and early 1930s was heavily influenced by the French Art Deco

*A selection of stained-glass design panels on display at the Exposition des Arts Décoratifs et Industriels, held in Paris in 1925. Abbreviated as Les Arts Décos, the exhibition gave the emerging new style its name.*

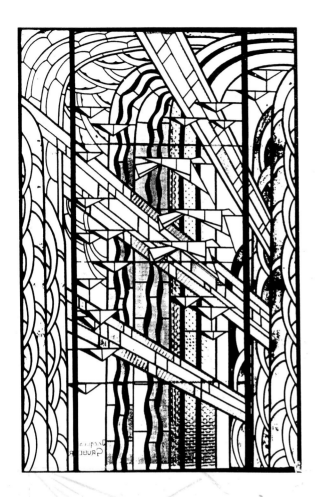

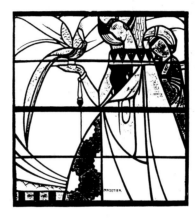

style. After Carder's departure in 1933, the firm went on to specialise in colourless crystal. In 1937, the company commissioned twenty-seven famous artists, ranging from Henri Matisse and Jean Cocteau to Salvador Dali and Eric Gill, to create crystal designs. Another leading American firm was the Libbey Glass Co. in Ohio, which was the largest maker of cut-glass in the world between 1890 and 1915. However, no hand-crafted glass has been made by the company since 1940.

While other fashions in glass were emerging, traditional stained glass retained its appeal. Ireland maintained its strong tradition of stained glass during the whole of the first half of the twentieth century.

The artists were dominated by Sarah Purser who kept her studio in operation until the age of ninety-three. Harry Clarke and Evie Hone were among the Irish glass artists who kept the art alive. The De Stijl (literally 'The Style') design movement which began in the Netherlands in 1917 included artists such as Theo van Doesburg (see also below) and Piet Mondrian. There was much enthusiasm for stained glass, particularly from Gerrit Thomas Rietveld (1888–1964) who was a designer and architect. The Schröder house in Utrecht, which he designed, was the finest realisation of the De Stijl movement's architectural ideas. The Dutch painter and stained-glass artist Johann Thorn

*Overleaf: Illustrations from a catalogue of designs for domestic windows, dated 1926.*

# LEADED LIGHTS

No. 1

No. 2

No. 3

No. 4

No. 5

No. 6

No. 7

No. 8

No. 9

No. 10

No. 11

No. 12

No. 13

No. 14

No. 16

No. 17

No. 18

No. 19

## LEADED LIGHTS

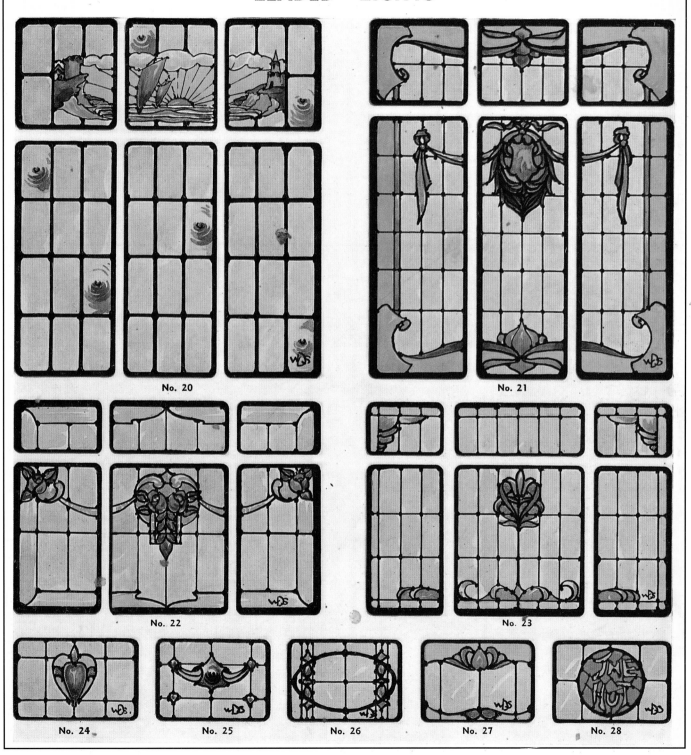

No. 20

No. 21

No. 22

No. 23

No. 24    No. 25    No. 26    No. 27    No. 28

Prikker was also much influenced by the De Stijl movement.

## THE BAUHAUS AND MODERNISM

After the upheaval of World War I, the extravagant style of the Edwardian era was scorned and architects became determined to create a style that combined the functional with the abstract. Avant-garde architects dreamt of glass houses and glass domes; they waxed lyrical and talked of 'glass dreams'. A German writer, Paul Scheerbart, produced a slim but influential book called *Glasarchitecture* which was published in 1914. He visualised a city with gleaming buildings of glass, a glass metropolis of amazing jewel-like houses, in which even the furniture within them was to be made of glass supported by enamelled, steel legs. He described his vision of glass buildings as 'a paradise on earth' and wrote of 'double walls of coloured glass' with lighting fitted between these walls. His volume appeared in the same year as the famous Werkbunde Exhibition in Cologne which introduced and promoted the glass dreams of contemporary architects, particularly the model factory by Gropius and glass dome by Taut.

While Paul Scheerbart and his ilk dreamt of entire cities built of glass, there were more realistic architects who used coloured glass as a live component of architecture, who made philosophical analyses of the effects of stained glass, and who developed a profound understanding of the life-enhancing quality

*The Exposition des Arts Décoratifs et Industriels, held in Paris in 1925, was a showcase for much new and exciting work. The stained-glass panels illustrated here were among the exhibits.*

of coloured light and used it to temper the white glare of light. Plain glass is often used from habit or convention when stained glass would be the superior choice. As far back as 1876, one American writer on the decorative arts, Donald Mitchell, pointed out that coloured glass was 'full of suggestion to those living in cities whose rear windows look upon neglected or dingy courts, where the equipment of a window of rich designs would be a perpetual delight'.

Glass confidently became a main icon of Modernism, the International Style which began developing in architecture and design in the 1920s. Modernism became established first in Germany with the Bauhaus school of architecture and design (1919–1933). Walter Gropius (1883–1969) founded the Bauhaus along with Theo van Doesburg (1883–1931) of the De Stijl movement, and Josef Albers (1888–1977). They included stained glass as part of the course. Important artists such as Paul Klee (1879–1940) were associated with the school, and produced abstract patterns in coloured glass. In its aim to reconcile fine and applied arts, the Bauhaus was one of the last important expressions of the Arts and Crafts tradition. Craft work-shops offered tuition in a number of areas, including glass.

The Bauhaus finally closed in 1933, under pressure from the National Socialists (Nazis) and undermined by internal conflicts. However, its influence was carried to the United States of America by various prominent German designers and architects, such as Mies van der Rohe, Walter Gropius and Marcel Breuer, who emigrated to America in the interwar years. In 1937, the Hungarian Lászlo Moholy-Nagi (1895–1946), who had taught at the Bauhaus from 1923 to 1928, founded the New Bauhaus in Chicago. This later became the Institute of Design. Glass became the Modernist medium for American designers – in everything from cocktail cabinets to frosted glass panelling. During the 1920s and 1930s, glass was being used as a building material more than ever before, with windows as whole walls.

Modernism also gained pace in France with architects like Le Corbusier (Charles Édouard Jeanneret, 1887–1965), whose radical ideas created a great stir at the 1925 Exposition. The architect Robert Mallet-Stevens produced a building for the Exposition with a flat glass ceiling and geometric leaded glass friezes by Louis Barillet. Highly stylised leaded windows and screens were a hallmark of Barillet in the 1920s. Jacques Gruber contributed similarly striking effects by providing a contrast of black and opalescent white through acid-etching or sandblasting.

The technique of sandblasting (a simpler way of producing the effects made by acid-etching in Victorian times) has been used since the late 1920s. Relief work in glass was being tried architecturally on a large scale for the first time, with figures carved in low relief for commercial buildings. There was

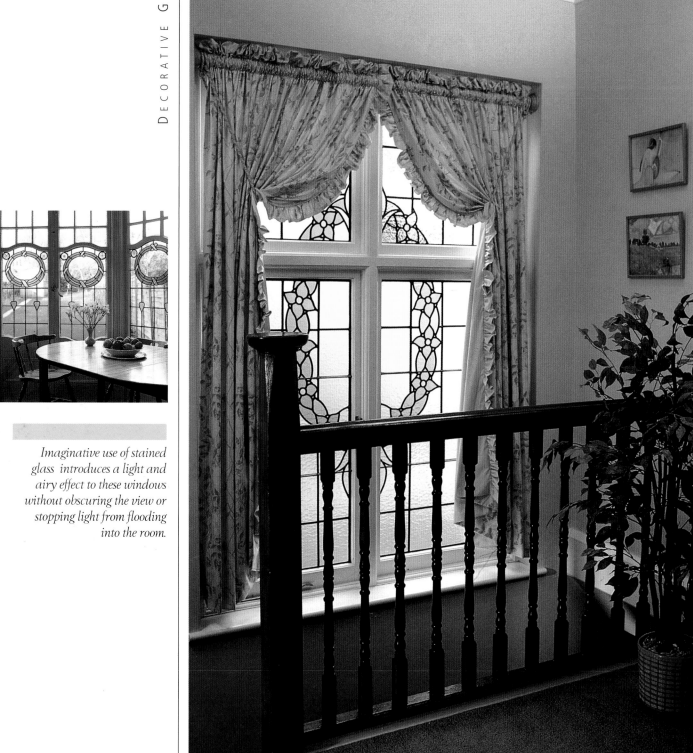

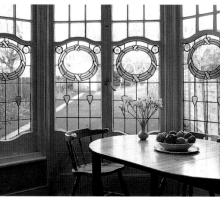

*Imaginative use of stained glass introduces a light and airy effect to these windows without obscuring the view or stopping light from flooding into the room.*

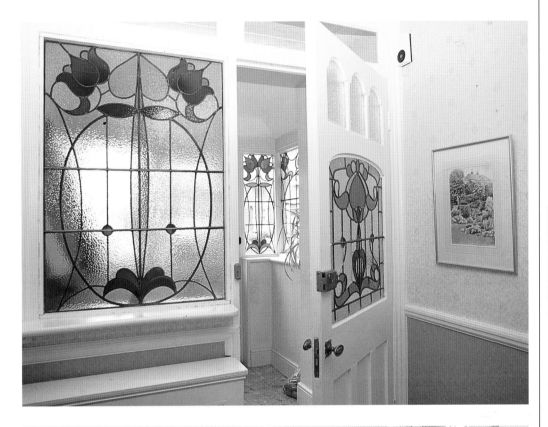

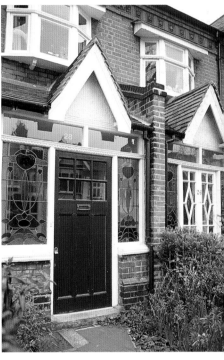

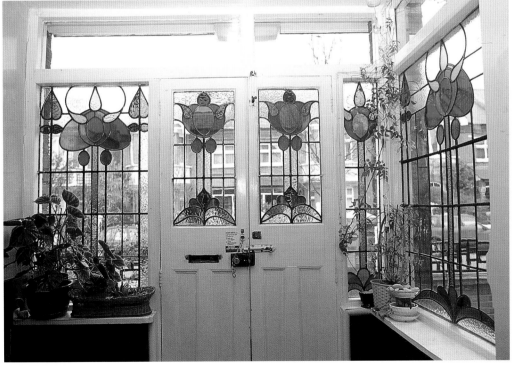

also a revival in decorative pressed glass in the 1920s and 1930s and it became used more structurally as well as decoratively. Modernist British architects were using glass extensively as well, including the back-lit panelling for the Strand Palace Hotel (1929–30). The all-glass Savoy Theatre foyer used illuminated glass columns manufactured by James Powell's Whitefriars glass-works.

As the Union des Artistes Modernes was being formed in 1930 as a rallying point for French modernism, glass was becoming an increasingly popular medium of expression. By 1934, most of the foremost French designers were members. Technological advances were making design options wider. There was even a luxurious glass bed and furniture made for the Maharajah of Indore.

Maurice Marinot (1882–1960) was one of the towering figures in the world of glass between the wars. He was a trained chemist and had studied painting, but a visit to the glass-works at Bar-sur-Seine in 1911, which was run by his friends the Viard brothers, changed the course of his life. Like many other artists, he became totally enchanted with the charisma of glass.

In his earlier efforts, Marinot used enamels in bright colours to show bold flowers and nudes – these were made to his designs by the workers at the Viard factory. In the early 1920s he learned how to blow glass himself and so turned to more sculptural glass in the 1920s and 1930s. Marinot used deep acid etching imaginatively, sometimes contrasting a frosted lower surface with a highly polished upper layer. Some pieces incorporate air bubbles, smoky tints and streaks of subdued colour. He is most noted for interpreting the geometric patterns which characterised Art Deco. Writing in *L'Amour de l'Art* in 1920, Marinot said, 'the two essential qualities of glass are its translucence and its brilliance'.

René Lalique (1860–1945) was another major glass artist of the interwar years. He had started as a jewellery designer in the Art Nouveau style, often featuring brightly coloured glass instead of precious stones. His use of vitreous enamels and cut-glass in jewellery led to an absorption with using the material in other ways. He became a leading glass designer in Art Deco, making prolific quantities of moulded, pressed and engraved glass objects.

Lalique set up a workshop in 1902, hired four glass-workers and started by modelling glass objects using the *cire-perdue* (lost wax) process. In 1907 he began making decorative perfume bottles, and other items followed, ranging from vases and plates to clocks, figurines and even car mascots. His fixtures included wall lights, chandeliers, ceiling bowls and table lamps.

Statuettes were made simply to stand decoratively or with a concealed light in the usually bronze base that lit up the figure. These were often very imaginative, using nude or semi-nude figures. His moulded opalescent glass became very popular, its milky-white pearliness taking on either a

blue or yellow sheen depending on how it caught the light. Other techniques used included frosting with acid, painting or staining with enamels and polishing with high-speed buffers.

Lalique also chose to make many of his creations from clear, uncoloured glass that was demi-cristal (with a 50 per cent lead content). While some items showed the influence of Art Nouveau, using nymphs with flowing hair or mermaids with tails, other items reflected the geometric birds or plants of Art Deco, with zigzag patterning.

Lalique's glass architectural fittings included decorative panels for cruise liners and railway cars, as well as for restaurants, theatres and hotels. His beams, panels and furniture for the Pavillon de la Manufacture Nationale de Sèvres at the Paris Exhibition of 1925 were greatly admired. In 1930–1, he made the decorative panels for the grand dining saloon of the Normandie, launched in 1932 and one of the most stylish and luxurious ocean liners of the decade.

## PRESERVING THE PAST

It is not surprising that the themes of the Arts and Crafts and Art Nouveau movements have enjoyed a revival in recent decades. For many architects and designers of that earlier era, humans were regarded as part of the natural world, highly interdependent on plants and animals. The environmental concerns of the late twentieth century have again highlighted the importance of this interdependence.

The standardisation of so much in modern life has increased the appeal of individually designed and crafted features which can be created with glass, making a building unique. The Arts and Crafts and Art Nouveau movements struggled with encouraging handcrafts against a backdrop of growing industrialisation — and it is an accommodation that still exists today. As individuals, we want to personalise our homes with unique features, but usually have to watch the cost of any project. Incorporating machine-made glasses into designs is only one of the ways that the economic benefits of mass-production can be used to help to achieve the beauty associated with handcrafts at a lower cost.

We are also now realising the value of the existing glass features which survive in older buildings, and the importance of caring for this architectural heritage. The idea of preserving old buildings, landscape and wildlife is widely accepted today — but the origins are also rooted in the ideals of Arts and Crafts. In 1877 the Society for the Protection of Ancient Buildings was founded by William Morris. While its original aim was to save Gothic churches from the wreckage of poor restoration, its concerns soon widened. By 1894 the National Trust was founded, and parallel movements have developed in other countries in the last hundred years. Hopefully less of our heritage will be destroyed as 'old-fashioned' in the future.

At the Paris Exposition in 1925, many exhibits showed recurring geometric themes of ovals and octagons, as well as graceful female nudes, flower-heads tightly bunched together, spirals, lightning flashes, deer and doves. The leaping gazelle motif backed by the ever-present sun-ray design shown above personified the Art Deco style.

# CHAPTER 5

# Renovation & Restoration

Lead glazing or leaded glass is the traditional way of assembling stained, or more accurately coloured glass, and this method of working requires very few specialised tools. This basic technique has been used for centuries and even today, most commercially made, stained-glass windows are produced in this way. Lead is used as the jointing material because of its malleability and low cost as compared to other metals.

This technique of assembling glass panels consists of cutting pieces of glass to shape and inserting them into strips of channelled lead called 'came'. This term comes from an Old English word 'calme', meaning string or length. The lead is cut to the required lengths and soldered together at the points where they meet, forming an integrated section or panel. Large areas of leaded glass are made up of several smaller sections, each of a manageable size and weight, and for extra strength, metal bars corresponding to the outline of the sections are set into the supporting framework. The panel is then tied to these bars with copper wire which has been soldered into the panel. This supports the window and firmly secures it to the fabric of the building. When all the joints have been soldered on both sides, the panel is weatherproofed and strengthened further by filling the small gaps between the glass surface and the lead with a linseed oil putty cement. For delicate work it is often better to use the later technique of copper foiling which can be used equally well for both two- and three- dimensional objects. This technique is particularly suitable for terraria and lampshades, as many smaller pieces can be soldered together to create intricate detail that is impossible even with the very finest lead came. The narrower the foil, the thinner the resulting joints in the design, and the more delicate the appearance of the finished object. When using foil, particular care must be taken in cutting the glass, as any bumps or hollows along the cut edge will be magnified once

the foil has been applied and the pieces are set against each other.

A different technique is used when assembling foiled-glass projects. Once the glass is cut, each piece is wrapped along its edge with a thin strip of foil. The foil is centred on the edge and then flattened securely onto the face of the glass. The wrapped pieces are arranged in position and tacked together at strategic points with blobs of solder. Molten solder is then drawn along the seams with a hot soldering iron and left to cool, leaving the pieces of glass securely joined by a neatly rounded bead of solder.

When a curved surface such as a lampshade is being constructed, the individual pieces are usually set on a mould and soldered in place at the correct angle. Foiling is more widely used in the USA but with the increasing availability of supplies it is becoming more popular in Europe.

There are various other methods that can be used to construct stained-glass panels: for instance, using *dalle-de-verre* which is glass made in thick slab form. This was developed in France in the 1930s. However, the traditional method of lead glazing and the more recent use of copper foil are still the most common techniques for working with coloured glass.

The first stage in making a stained-glass window is to make a scale drawing on paper. Once the sketch is finalised the design is scaled up into a full-size pattern or cartoon (cartoon is the traditional name for the full-size drawing) to cut the glass against. Basic drawing tools are all that are required at this stage — a rule, paper and pencil. When the design is drawn to full size it is transferred to tracing paper using a fibre-tipped pen that produces a line equal to the inside dimension of the lead. Coloured crayons or water-colours are useful to give a better idea of what the finished panel will look like.

## THE TOOLS

Cutting the glass to shape requires a special glass cutting tool with either a diamond tip or a tungsten carbide wheel to score the glass surface. This produces a weakness in the structure of the glass along the score line.

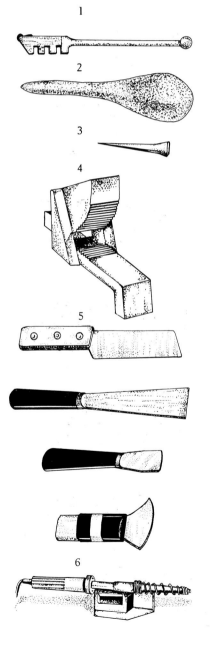

◀

*1. Glass cutter with grozing notches 2. Lathekin
3. Glazing or horseshoe nail 4. Lead vice
5. A selection of lead trimming knives
6. Soldering iron*

A diamond cutter is best for cutting straight lines, but a cutter fitted with a tungsten carbide wheel is better suited to cutting the curves and shapes more often used by the stained-glass craftsman. Some cutters have replaceable cutting wheels and are equipped with a weighted ball end for 'tapping the score' and breaking the glass. The notches are used for nibbling the edge of the glass to the desired shape — these are called grozing notches. Between cuts, the cutter

should be dipped in a light machine oil to lubricate and prolong the life of the wheel. When not in use it should be stored in a small screw-top jar containing an absorbent pad which has been soaked in a mixture of two parts white spirit and one part light household oil.

Pliers are used to assist in the glass-breaking process, and while ordinary flat-nosed pliers are acceptable, there are pliers made specifically for breaking glass. There are three types available, but the most versatile have smooth flat jaws which meet only at the very end. The jaws pinch the glass directly along the score line — when a downward pressure is applied the score opens up and the glass breaks along the line.

Running pliers are similar to glass breaking pliers but are applied to the edge of the glass at 90° to the score. Better quality pliers have a screw stop adjustment to prevent the jaws from crushing the glass by closing too tightly.

The third type of pliers are called grozing or nibbling pliers. These are used to chew thin slivers from any cut-glass pieces that are slightly misshapen.

Having cut the glass, the next step is the leading process. Before it can be used the lead must be stretched. This both straightens and strengthens it. A lead vice is screwed to the work-bench and the first 25mm (1in) of the lead is fed into the jaws of a lead vice. This is gripped by the serrated teeth, and using a pair of ordinary pliers, the lead is pulled and stretched until it is perfectly straight.

The channels of the lead are opened up by using a wooden stick called a lathekin. A lathekin is simply a smooth, flat piece of hard wood approximately 6mm ($\frac{1}{4}$in) thick, tapered down to approximately 3mm ($\frac{1}{8}$in) at one end, but any piece of smooth, thin, hard wood will do as a temporary measure — for example, an old wooden ruler or a piece of thin plywood cut to size. The lathekin is wedged into the channel and pulled along the entire length of the lead to open the channels of the came.

The prepared lead is then cut to the desired length with a lead knife. These knives are available in two basic shapes, either chisel-ended or finished with a convex curve. The blade must be kept sharp by regular use of an oilstone. Lead knife handles are often weighted to act as a hammer for tapping leading nails into the production bench. (As a temporary measure an old-fashioned table knife cut short and with the blunt end sharpened will suffice.)

An essential piece of equipment is the building board. This simply consists of a piece of particle board larger than the size of the finished panel with two battens fixed to conform with the outline and dimensions of the work in progress.

Leading or glazing nails are used to hold panes of glass and lead in position on the building board during construction. These nails are generally 35–50mm (1$\frac{1}{2}$–2in) long, square in section, with large square heads. (50mm (2in) ovals will do as a substitute.)

Once the entire panel has been leaded

▲

*1. For stretching lead 2. Long-nosed pliers 3. Grozing pliers 4. Running pliers with screw adjustment 5. A selection of useful brushes*

up, the joints are secured with solder. Prior to the soldering all the joints are cleaned with a small wire brush. Flux is then applied to the joints to assist in the flow and bonding of the molten solder.

Electric soldering irons come in a range of sizes and are measured in watts. It is wise to get an iron with a rheostat temperature control – this enables the iron to be plugged in for an extended period of time without the tip becoming overheated. The working end or tip is replaceable and should be wiped clean on a damp sponge frequently during use. This will prolong its life and assist

the soldering process. A good all-purpose choice for stained-glass work is chisel-ended with a 9mm ($^3/_8$in) wide tip.

Once all the joints of the window have been soldered on both sides of the panel, then the final stage of cementing and cleaning can commence. Cement is forced into the small gap between the flanges of the lead came and the glass using a stiff-bristled brush. The cement is left to dry and later the excess is picked out with a metal tool like a bradawl. To finish off, the glass is cleaned by rubbing a clean, stiff-bristled brush vigorously across its surface.

# THE MATERIALS

### SELECTING THE GLASS

Most colour in everyday life is seen as reflected light, but the colour in stained glass is unusual in that it is filtered light. Depending on the light source, the colour in glass can vary in intensity, appearing quite different under different circumstances. This effect is one of the great attractions of stained glass as an artistic medium.

When choosing glass, bear in mind the amount of available light in the panel's final position. Very dark glass is not really suitable for internal locations as its effect will be lost without adequate back-lighting.

In terms of colour, individual choice varies; however, there are a few things to bear in mind. Blue and red side by side for example, will create a mauve haze, producing an almost blurred image. If this is not the

intention, small areas of white or clear glass can be introduced to reduce this effect. This principle was often used in the twelfth and thirteenth centuries when blues and reds were used extensively. Yellow set beside red and blue will create a strong effect but this could overwhelm a design and make it appear gaudy.

When working with oranges, purples and greens, lighter tints can be interspersed to soften the overall effect and pull forward the main elements in the design.

Although colour is a very important feature which can change the whole atmosphere of a particular space, a common fault, especially with beginners, is the use of too much colour. Use strong bold colour in small areas, perhaps for a central motif, and leave the softer, lighter colours to provide

the background. This will result in a composition with a natural focus.

---

## THE JOINTING MATERIAL

Lead comes in a variety of widths, and is usually 1.8m (6ft) long. Most of the lead is channelled on both sides to accommodate adjoining panes of glass. This type of section is referred to as 'H' lead. Lead channelled on one side only is called 'C' lead and is used for perimeter work. Both lead types are available in round and flat profile. Cames are measured across the flanges for the width dimension and across the channel for the height dimension.

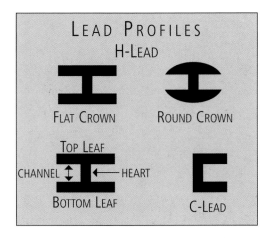

LEAD PROFILES
H-LEAD
FLAT CROWN    ROUND CROWN
TOP LEAF
CHANNEL — HEART
BOTTOM LEAF    C-LEAD

The centre part of the came, called the 'heart', is also measured in both height and width. Some cames have a hole running the length of the heart to accommodate a thin strip of reinforcing steel. This steel strip adds rigidity to the panel without disrupting the overall design. Cames are also produced in copper, brass and zinc for aesthetic reasons and strength.

The most common alternative jointing material to lead is copper foil. It has an adhesive backing and comes in 32m (36yd) long rolls in a variety of widths. Copper foil is wrapped around each piece of glass prior to soldering. Once the pieces of glass have been wrapped with foil they are butted together in position and molten solder is drawn along the entire seam. Copper foil has a great advantage over lead in three-dimensional projects because the glass can be positioned at any angle prior to soldering. Many Tiffany-style lamps are made using this method. They are assembled on a mould which holds the glass pieces in position and at the correct angle while they are soldered together.

---

## SOLDERING

Lengths of lead came are always soldered together at the joints. The most useful solder for stained-glass work is an alloy of 60 per cent tin and 40 per cent lead and is termed 'tin solder'. This ratio is important and results in a solder which reacts quickly yet hardens to make a strong joint. Tin solder melts at approximately 361° F and the range between the solid and molten state is roughly 13°F. The solder used should be the solid core variety, 3mm ($^1/_8$in) in diameter.

Flux is a chemical used to clean the joint prior to soldering. It usually contains either oleic acid or ammonium chloride, both of which prevent the formation of metal oxides as the metals are heated. This

provides a clean surface to ensure a solid bond between the solder and the jointing material. Flux can either be brushed or rubbed on from a tallow candle.

## CEMENTING

The cement, which fills in all the gaps between the glass and lead making the panel weatherproof, is made from linseed oil putty thinned down with white spirit to a porridge-like consistency. Black powdered dye is often added to the cement to make it blend better with the lead came.

Finally the excess cement is cleaned away from the surface of the finished piece with powdered chalk (whiting). This absorbs the moisture from the residual putty so that it can be brushed off easily.

In addition to these basic materials, a variety of chemical applications — referred to as patinas — can be brushed on to alter the appearance of the solder or copper foil through a chemical reaction.

### CEMENT RECIPE
75 per cent linseed oil putty
10 per cent white spirit and 5 per cent linseed oil mixed
10 per cent lamp black
whiting

Place the lamp black in a bucket. Slowly add the white spirit and linseed oil, mixing with a wooden spoon. When thoroughly blended, add the putty, a little at a time, ensuring that it is thoroughly blended before adding any more.

To adjust the consistency, add more white spirit to thin or whiting to thicken.
To darken the cement, add more lamp black.

The cement can be used immediately or stored in a container with a tight-fitting lid.

# THE TECHNIQUES

Once the design for a panel has been decided on, measure the opening and draw it to scale. Finalise the design on the small-scale sketch, making any alterations necessary, and then fill in the glass spaces with coloured pencils to get an impression of the final effect. (If you make a few photocopies of the sketch first, you will be able to try several different colour combinations.) Alternatively, outline the lead lines on the sketch with Indian ink and fill in the spaces with watercolours to get a better representation of the completed piece. Once you are satisfied with the design, pin it up where you can look at it over the next few days — it is far easier to alter the drawing than to change the completed and installed panel.

## DRAWING THE CARTOON

When completely satisfied with the design, make up the cartoon. Use white paper for the cartoon unless you will

be working on a lightbox, in which case use tracing paper. The lightbox is used mainly when a design employs a lot of dark or translucent glass. It makes it easier to see the line of the cartoon.

If the design is very simple it should be possible to draw it up to full size freehand by referring to the smaller sketch. However, most designs are complex enough to warrant using a grid to enlarge the design.

## ENLARGING THE DESIGN

Divide the design into a number of squares – the more complex the design, the smaller the squares. Now divide the full-size paper into a similar number of larger squares. Use this grid as reference to redraw each line in the small box into the corresponding large box. With a little patience you will be able to transfer the design, accurately creating the full-scale cartoon . An easy method of reduction is to take measurements for the panel in inches and convert them into centimetres (eg 12in becomes 12cm).

## MAKING A PATTERN

Once the full-size cartoon has been produced there are two methods of cutting the glass to shape. The simplest method is to place the glass directly on the cartoon and cut to the line seen through the glass, but this method only works for very pale colours that can be seen through easily. If the glass is dark or opalescent a pattern must be cut. To make the pattern, lay some thin white card on a flat surface and place a piece of carbon face down onto it. Cover the carbon paper with the cartoon and pin the papers together to stop them slipping during the copying process. Carefully and firmly, trace all the lines on the cartoon using a sharp pencil. While the sheets are still pinned together, number each piece. Separate the sheets and cut out the cardboard pattern. Go over the lines with a thick pen to compensate for the thickness of the heart of the came. To make it simpler to estimate how much glass of each type and colour is needed, mark each piece for colour, then group all pieces of the same colour and measure out the area of glass required.

## CUTTING THE GLASS

Once the glass has been selected, place the first colour over the corresponding outline on the cartoon. Place the cartoon on a lightbox if necessary. Arrange the outlines so that there is minimum wastage. Leave at least 6mm ($^1/_4$in) around the shape to trim off. Alternatively, place a pattern piece on top of the glass and draw around it with a pen that marks on glass. The thinner the line drawn by this pen, the more accurate the cut will be. When cutting the glass, use the inside of the pen line as the guide.

Traditionally a diamond was used to score the glass, but today a steel or tungsten carbide wheel is used in stained-glass work because these are more effective when producing curved lines.

The purpose of the glass cutter is to score the glass surface thus producing a line of weakness. When the glass is put under pressure along the score line this weakness develops into a crack which runs the length of the glass, and then breaks.

There are two important points to remember when cutting glass:

- The glass must be made to separate soon after it has been scored because of the structural changes that take place within it.
- NEVER go over the same score twice. It will damage the cutting wheel and will have no effect on the glass except to make it less likely to break cleanly.

If these rules are observed, cutting glass is not a difficult operation. Practise on scraps of glass first and get acquainted with the tools and materials before working on more expensive glass.

## CUTTING TO A PATTERN

The key word is accuracy. No matter how few pieces of glass you intend to assemble, each piece must be cut with precision. It is simply not enough to be able to cut glass roughly to shape and hope for the best. Take your time while scoring the glass. If necessary stop the cutter halfway along the score as long as the downward pressure is kept constant and the cutter is not removed from the surface of the glass. This will enable you to review the outline before making a detour. When cutting glass to a copper foil outline, get the wheel to travel down the centre of the thin line.

When cutting for lead, make sure to use the thin line for its intended purpose – that of the 'heart' of the lead came – cut the left-hand piece of glass to the left edge of the line and the right-hand piece of glass to the right-hand edge of the line. Think of it as two lines.

Cut all the glass of one colour at a time, starting with the largest piece. Once cut, check it against the cartoon or pattern piece. If it is satisfactory, mark the cartoon or place the pattern to one side so that it is not cut again.

Arrange the cut glass on a copy of the cartoon.

## SAFETY PRECAUTIONS

- Wear light gloves when handling glass, and an eye mask when cutting it.
- Lead can be a health hazard if handled over a long period of time, so be sure to cover any skin cuts when handling the metal and wash your hands frequently.
- Wear a dust mask when using cement.
- Soldering should always be done in a well ventilated place. If possible use a fan to blow away unhealthy fumes.
- Never leave a soldering iron unattended and always hold it only by the handle.
- Never wipe the cutting bench clean with the hand, use a brush.

Keep the glass cutter in a jar containing a layer of cloth soaked in a mixture of one part household oil and two parts white spirit. Between every two or three cuts, dip the cutter in the jar to keep it clean and lubricated. This will prolong its life. Replace it when it becomes blunt.

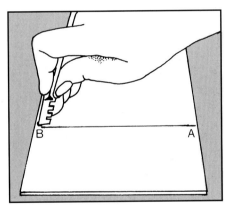

Gently place the cutter on the edge of the glass nearest you. Apply a downward pressure and push the cutter forwards from point A to point B keeping the downward pressure constant. Listen for the glass 'singing' as the cutter travels across. Continue until you get to within 3mm ($\frac{1}{8}$ in) from the opposite edge, then lift the cutter. The score should be clearly visible and continuous. Do not go over the same score twice as this will reduce the chance of a clean break and will blunt the cutter.

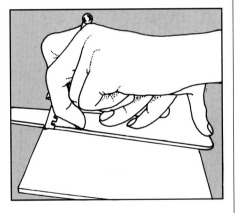

For a perfect straight line place a straight-edge on the glass and hold it firmly in place. Place the cutter on the opposite edge of the glass and line up the face of the cutter with the straight-edge. Apply an even downward pressure, pressing slightly against the guiding edge. Pull the cutter towards you.

## BREAKING THE SCORE

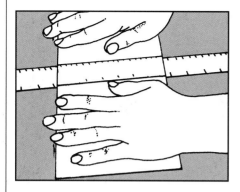

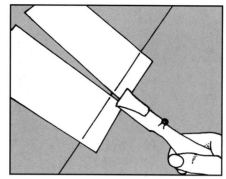

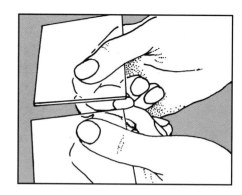

Having checked the score, place the glass on a rule with the score uppermost, centred along the edge of the ruler. Place the palm of one hand on one side of the score and push the glass to the bench. Place the palm of the other hand on the opposite side and slowly apply pressure until it snaps. This method is very safe and is ideally suited to large panes.

To break glass using pliers, place the glass 50mm (2in) over the edge of the bench with the score uppermost. Place the jaws of the pliers directly over the score with the concave jaw on top. If the pliers have an adjustment screw, set the jaws to lightly grip the glass then unscrew half a turn. Squeeze the jaws gently together. The glass will first crack at the edge nearest you, and will run all the way along the score to the other end. These pliers are designed for straight cuts but can be used for very slight curves.

This method is most suitable for medium-sized pieces of glass – straight or slight curves only. Make your hands into fists and hold the glass with thumbs on top and fingers underneath, score side uppermost. Line the score up with the join between your two index fingers. Grip the glass firmly and roll your knuckles apart. Dull the edges of the cut by scraping the cut edge with a piece of scrap glass at right-angles or use a carborundum stone.

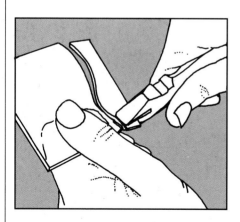

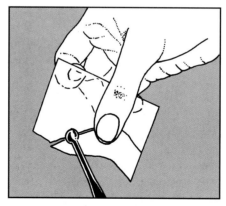

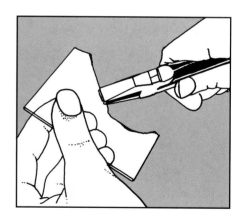

Breaking pliers are used to grip small pieces of glass that cannot be broken out by hand. Hold the bulk of the glass in one hand and place the pliers almost on top of the score at the edge of the glass. Grip the glass firmly with your hand and the pliers and break the score downwards. This method is especially useful for curved cuts.

Tapping the score: holding both sides of the glass, lightly tap the score on the underside, moving along the score as the crack appears until the glass separates. This method is suitable for all sizes of glass and all types of cut. It is used mainly in conjunction with other breaking methods. Used by itself it leaves an uneven edge which is often quite sharp.

Glass can be gently nibbled away to clean up uneven edges by using grozing pliers. Grip the glass lightly with the pliers covering only 1.5mm ($^1/_{16}$ in). Slowly increase the biting pressure of the jaws and roll the pliers down. Repeat this procedure until all the excess is removed.

The same method of scoring straight lines applies to curved lines. Some cuts will be concave and some will be convex. In both cases a series of scores is necessary.

Start at point A and push the cutter to point A1. Turn the glass around so that point B is nearest to you. Cut from point B towards line A taking care not to touch the first score. Repeat the procedure for point C and D. You now have a series of fairly straight scores that, when broken out, will result in a curved cut A–A1.

It is important to break the scores in the right order. Start with point B and break this score by hand or with pliers. The glass will separate from point B to A. Next proceed to point C and break the score. Then follow on with point D. The number of cuts depends on the length and steepness of the curve.

A lightbox will make the task of cutting dark glass easier. Build a box 20cm (8in) deep and 5cm (2in) longer than the fluorescent tubes. Paint the inside of the box white. Attach two fluorescent light fittings to the bottom at 6in intervals. Drill holes in the sides of the box for ventilation and fix a piece of frosted glass, shiny side up, on top. Follow the manufacturer's instructions for wiring the light fittings.

## THE LEADING PROCESS

Before the lead can be used it must be stretched to straighten it and to remove any kinks or twists which have resulted from handling. This is done by gripping one end of the strip in the jaws of a vice while holding the other end with pliers and pulling back firmly and evenly. This procedure will add approximately 75mm (3in) to a 1.8m (6ft) length of lead came. Once the lead has been stretched, it must be opened with a lathekin so that the pieces of glass can be slotted into the channels of the came easily.

When cutting an acute angle the lead knife may crush the heart and cause the leaves to fold over. To counteract this, place a nail into the channel before cutting to give the heart added strength, and cut against it.

Once they have been stretched, store the cames in a long box, wrapped in paper or polythene to avoid them becoming kinked or twisted. It is not advisable to buy lead rolled into a coil.

Keep any leftover scraps of lead in a small box for future use.

Before starting to solder, rub over all the joints with a wire brush until the lead oxide is removed – this will give the joints the appearance of silver.

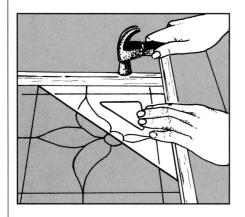

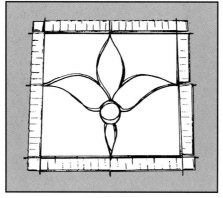

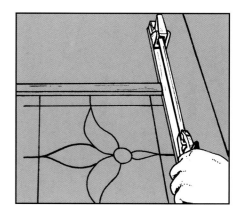

Take a piece of chipboard 150mm (6in) larger all round than the finished panel. Lay the full-size cartoon in the centre of the board. Fix a 50x25mm (2x1in) wooden batten along the longest edge. Fix a second batten at 90° to the first. Use a set square to ensure it is positioned accurately.

Lay all the pieces of glass on the pattern and check they are all cut accurately. Place the pieces on a full-size copy of the cartoon.

Select a length of C-lead suitable for the perimeter of the panel. Place one end of the lead in the lead vice and untwist its entire length. Grip the other end of the lead with a pair of household pliers. Take up the tension and slowly pull out the lead. The lead will straighten and stretch a few inches. Take care that it does not snap.

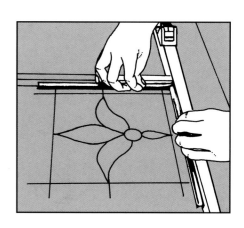

To open up the channels of the lead to accommodate the glass, insert a lathekin into the channel and run it along opening up the leaves. Keep the lathekin oiled or waxed to assist its progress.

Cut the lead to length using a lead knife or cutting pliers. Gently rock the blade of the knife through the lead rather than using a sawing or slicing motion as this could crush the heart. Keep the blade upright and always cut on a firm surface with a sharp blade. Having cut the joint, open up the leaves. When using pliers, simply place the jaws over the lead at the required length and angle and squeeze gently.

The first two border leads should be at least 25mm (1in) longer than the cartoon. Place the longest lead against the battens so that the end butts up to the adjacent side. Using the lead knife, open up the top inside leaf at the corner and insert the next lead.

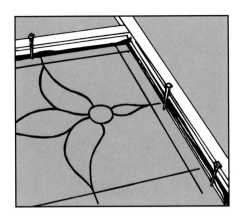

The leads and glass are temporarily held in place with glazing or horseshoe nails which are removed as the work progresses. Start by placing a nail against the edge of each free end of the two perimeter leads. If you do not have glazing nails, 50mm (2in) ovals can be substituted.

Take the corner piece of glass and slide it into position in the leads. Lift the glass slightly to ensure a sound fit. Gently tap the glass into position using a wooden block or the weighted handle of the lead knife. Once in position, make sure that the edge of the glass conforms exactly to the cartoon. This is important as a slight discrepancy in fit here will be magnified as you travel across the panel.

When you are satisfied that the first piece is positioned correctly, take the next piece of stretched lead. Place it over the piece of glass and open up the perimeter lead to slide it in. Mark the lead for length and remove it for trimming.

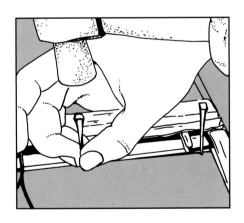

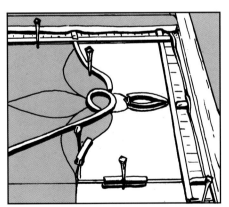

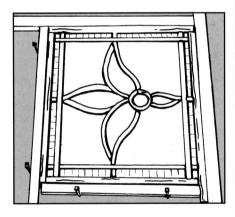

Trim the lead to the correct length and angle. Replace it in its correct position and check its accuracy. Carefully insert a glazing nail to hold it in position, taking care not to place it too close as this could chip the glass. Surround the nail with your hand to prevent the hammer from slipping and smashing the glass. A small piece of scrap lead can be placed between the glass and the nail to protect the edge of the glass.

Repeat this procedure, in a logical sequence across the panel, placing each pane of glass so that it gives maximum support to the last and provides a good base for the next. Take care that the leads butt tightly together at the joints. An alternative is to tuck the end of each internal lead into the last.

When all the pieces of glass are in position, the last two leads are laid and the perimeter leads trimmed. To ensure the squareness of the panel, lay battens against the exposed edges and nail them into position.

# THE SOLDERING PROCESS

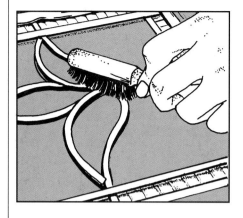

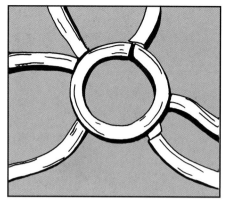

A soldering iron is used to heat the solder which is applied to each joint. When cool the solder sets hard and sticks the leads together. The most suitable solder for lead is a mixture of 60 per cent tin and 40 per cent lead.

Flux is an agent applied to metals before they are soldered to assist in the flow of the solder.

All soldering should be done in a well ventilated room and a fan should be used to blow away the fumes.

There are several types of flux suitable for lead work – the most common is oleic acid in liquid or paste form but the best is a tallow as it is non-corrosive, and reduces wear on the tip of the iron. It comes in paste and candle forms.

Before starting to solder, the joints have to be cleaned and fluxed ready to accept solder. Brush all joints with a wire brush until the lead oxide is removed. All joints will appear bright silver. It is possible to use medium-grade wire-wool but this sometimes leaves deposits that interfere with the soldering process.

Occasionally lead will appear to shrink. This is the result of slight shifting of the glass and lead as you work across the panel. To compensate for this, small slivers of matching lead can be inserted. Cut the length necessary to fill the gap. Lay it on its side and cut down the heart to give a 'T' section. Place the tail of the 'T' in the gap. This will need to be repeated on the reverse side once the panel is turned over.

## SOLDERING TIPS

The tip of the iron must be tinned before use. Tinning is a term used to describe coating the surface with (tin) solder.

A good joint is small and smooth. It should join the leads securely and be almost invisible. The usual reasons for bad joints are a cool iron, too much or too little solder or incorrect application. A soldering iron is not a paint-brush. Its motion should be confined to up and down and only on long joints should it be moved laterally. Make sure that the bench is level or the liquid solder will run.

Having soldered all joints, clean off the flux residue with the wire brush.

Never leave an iron unattended

Never let the iron overheat

Always keep the iron tinned and clean and use a wet sponge while soldering.

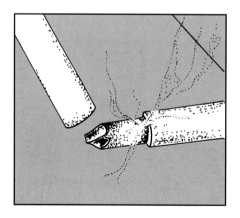

Coat the tip of the cold soldering iron with flux. Turn on the iron and let it heat up. Wait until the flux begins to smoulder.

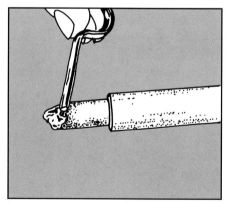

Hold the hot iron against some solder and move the solder over its surface. As soon as it starts to melt, quickly switch the iron off and apply solder to the entire surface, fluxing liberally. Once the iron is completely tinned, switch it back on and allow it to heat up. Wipe any excess solder from the tip of the iron with a damp sponge. The iron is now ready for use.

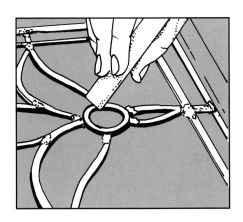

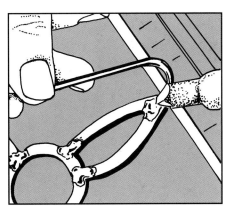

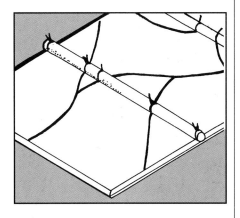

Plug in the iron and allow to heat up. Brush all the joints liberally with flux or run over them with the end of a tallow candle to prepare them for soldering. Make sure that the iron is at the right temperature and will not melt the leads.

Place the solder stick on the joint and apply heat to the solder. The iron should melt the solder within 23 seconds. Leave the iron on the joint for 5–6 seconds, then lift off vertically. Take care not to melt the leads. Longer joints require you to draw the solder along the entire seam. Start at one end, feeding solder as you travel along the joint.

If the glass panel is larger than 4,000sq cm (4sq ft), it may be necessary to attach a steel or brass bar across the back. The bars are placed approximately every 49cm (20in) of window length. This prevents the panel from sagging. Solder copper wire lengths to a convenient lead joint. Lay the bar in position and twist the wires tightly around it. Solder the wires in position.

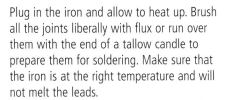

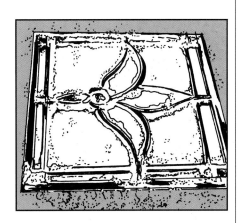

To waterproof the panel, putty-cement (see recipe on page 164) is forced between the leads and the glass. Lay the panel on a flat surface covered with newspaper, load a scrubbing brush with cement and apply it to the panel with a circular motion. When all the leads have been filled, clean the brush. Scrub the panel again to remove the excess cement. Repeat the process on the reverse side.

Close the leaves of the perimeter leads together by running a lathekin along the leaf several times. Repeat the process on the reverse. If the internal leads are flat profile, they can be flattened. Any excess cement will ooze out and should be removed with the stiff brush.

To remove excess moisture from the cement, spread liberal amounts of whiting over the panel and leave for 4–5 hours. Then remove with a soft brush. Repeat on the reverse of the panel. Scrub the panel vigorously with a clean scrubbing brush and go round each shape with a blunt stick to pick any remaining deposits of cement from the glass. Leave to dry for one or two days before installation.

# RESTORATION

The great revival of interest in period stained glass has made demands on the glass craftsman to to restore old panels of glass which have fallen into serious disrepair, as well as to renovate panels which are in danger of becoming derelict. The first step in any renovation or restoration project is to assess the glass panel in terms of construction, design and materials. Then the damage to the panel must be considered to determine the best approach for rectifying the problem. A small isolated area of damage, such as a cracked pane in an otherwise stable panel, can often by taken care of with the panel *in situ*. However, a major overhaul of a large panel will require many hours of work and often a temporary replacement must be fitted to the window or door opening while the work is being carried out.

Exterior door panels and windows can suffer a number of defects. The causes of damage to stained glass and leading are many. These range from general deterioration of the lead and discoloration of the glass

▲

To remove the window from the frame, force the point of a hacking knife into the putty until it meets the wooden frame, and twist the blade until the putty cracks and falls out. Work around the frame until all the putty has been removed. Take care not to damage the glass further or to dig too deep and damage the wooden frame.

▶

A small Victorian window in need of restoration.

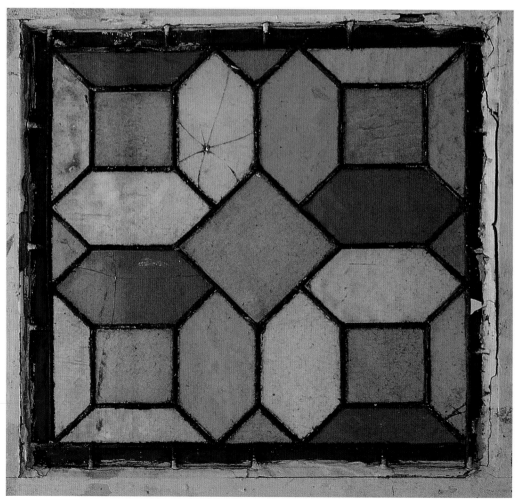

from sheer age, to mechanical damage due to climatic erosion or vandalism. Chemicals in the atmosphere can have a particularly devastating effect on very old panels and can cause them to be extremely susceptible to wind damage; but in most cases, fragile lead can be renewed and missing or damaged glass replaced with pieces matching the original in colour, tone and texture. However, if the panel is rare or very old, professional advice should be taken rather than risking its value by

▼

Lay the panel on the bench. If it is bowed do not try to flatten it as this may break the glass — support the hollow by packing it with crumpled newspaper. Cover with tracing paper and carefully run a wax block over the leads to make an accurate rubbing. Make a tracing of the rubbing using a black fibre-tipped pen. Use a pen with a nib that produces a line 3mm

(1/8in) wide to represent the heart of the lead came. Annotate the drawing with comments about colour, texture and lead widths and use this as reference when reassembling the panel. Check whether the leads are round or flat profile. Mark on the new pattern the positioning of any copper ties for saddle bars or any other reinforcement.

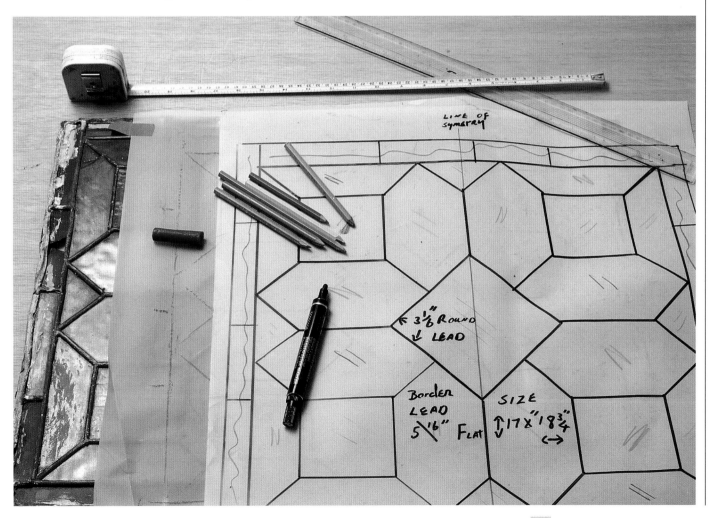

attempting restoration at home.

Often panels which at first appear to be in hopeless condition can be revived into beautiful examples of stained-glass craftsmanship. Even if there are several pieces of broken or missing glass, it is often possible to replace them with pieces cut from glass of a similar age and colour, thereby providing an almost perfect substitute. It is also possible to buy new glass in a wide variety of colours and finishes which makes finding a suitable replacement easy.

The most common form of damage is, not surprisingly, broken panes of glass which, when confined to a single pane here and there, is not particularly serious. Extensive restoration is required when large areas of glass need replacing or perished lead has caused the panel to sag. If this is the case, then the panel will have to be entirely stripped down and rebuilt. In cases where a complete section has been destroyed but the pattern is symmetrical, it may be possible to make a pattern by using the opposite side. If this is not possible it may be that there are similar examples in the surrounding neighbourhood which can be used as a template — failing that, there are many examples illustrated in this book which should suit any Victorian or Edwardian house.

Before beginning any repair it is a good idea to photograph the panel to use as reference while the repair is being carried out; it is also an enjoyable reminder of the state the glass panel was in before it was rescued.

Major repairs begin by taking the panel out of its framework. This is a critical stage because the panel is susceptible to even greater damage when it is being moved unless extreme care is taken. Do not try to flatten a distorted panel as that can cause the glass to crack and the entire panel to collapse. Accurate measurements should be taken of the panel in its framework so that the repaired panel will be sure to fit properly when it is returned. If the opening is irregular it is a good idea to produce a template to ensure that the panel is rebuilt to the correct shape.

Once the panel has been removed from its frame, it is laid on a workbench and a rubbing is taken of the leadwork. A tracing is made of the rubbing, from which a cartoon or working pattern is derived. The cartoon is notated with the colour and type of glass in each position to make the reassembly easier. Other notation includes the thickness of the original leads and the location of any tie-bars or other reinforcement points. Once all the relevant information has been noted, the panel can be stripped down.

Using the step-by-step instructions on the following pages, the panel is dismantled and the old lead is discarded. As the pieces of glass are removed they are carefully laid over the cartoon in their corresponding positions. Any pieces which are broken are also set aside as reference until replacements have been cut. The panel can now be reassembled following the instructions in the techniques section beginning on page 164.

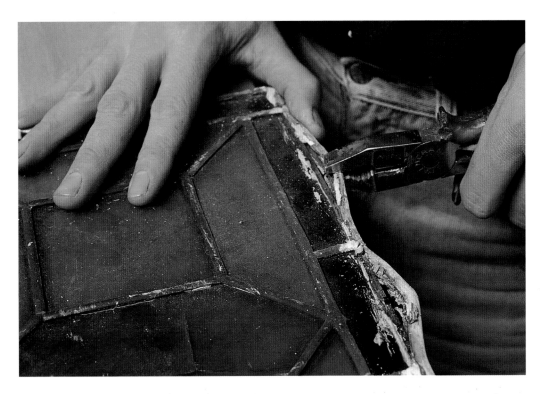

Slide the window 13mm (¹/₂in) over the edge of the bench. Starting at the edge of the panel, grip the lead gently with a pair of pliers halfway between two solder joints. Carefully pull the lead away from the glass to form a loop. Make sure that the lead is pulled horizontally away from the glass or the glass may break.

Cut each loop of the lead in the middle with a lead knife.

Holding the pliers perpendicular to the panel, grip one of the tails of the lead and roll it towards the solder joint, slowly increasing the pressure until the lead breaks free of the joint. Continue all the way along the first side. If any of the glass is free, remove it carefully and place it on the pattern.

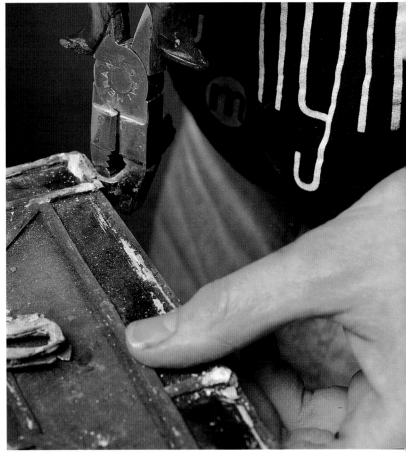

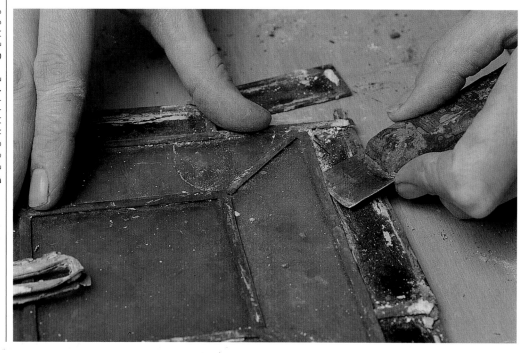

Using the blade of the lead knife, gently scrape away the cement from under the lead. Do not try to open the channel of the lead as there is a great risk of cracking the glass. Stubborn pieces of glass can usually be unlocked by removing the adjacent pieces. When two or more sides of the glass piece are free, trim the cames with the lead knife.

▲▶

Continue removing the glass pieces and trimming the lead across the entire panel, laying out all the pieces of glass on the annotated pattern. Cracked or broken pieces should also be laid in their appropriate positions.

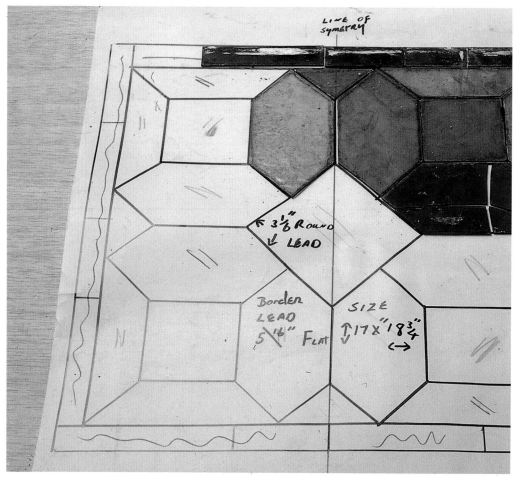

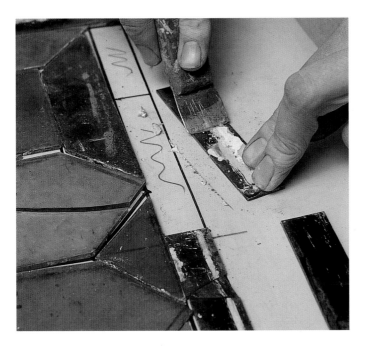

◀

Once all the lead has been removed and the glass laid out on the pattern, the excess cement can be cleaned off the panes. Place the piece of glass flat on the workbench and carefully chisel away the bulk with the lead knife. Keep the bench swept clean. Finally brush the remainder of the cement with a brass-bristled brush. Spots of paint can be removed with a liquid paint stripper. Replace the piece in position on the pattern.

▼

Lay the pieces of a broken pane on a sheet of paper, fitting them together in their original shape. Draw around the glass with a thin line and cut out along the inside of the line. Use this as a pattern for cutting the new piece of glass. If only part of the pane is present, draw around that on tracing paper and place this on the inked pattern. Line it up and continue with the remainder of the shape.

◀

Using this pattern, cut a clear glass template for use during the leading process to check for a good fit. Before leading can begin, lay all the glass out carefully on the rubbed pattern, making sure that it conforms to the line as closely as possible. (Instructions for the leading process can be found in the chapter on tools and techniques.)

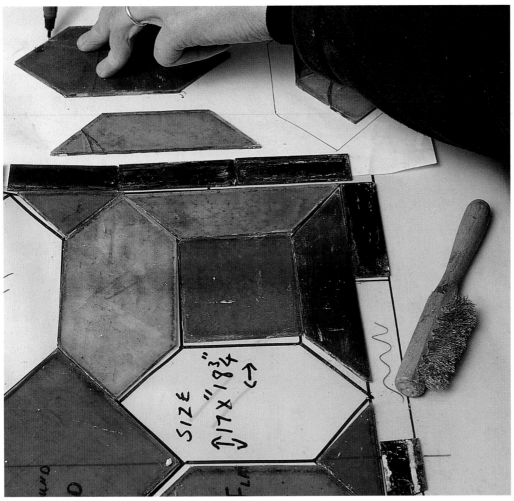

## MINOR LEADED REPAIRS

Replacing pieces of glass will always leave the leadwork slightly scarred. It is therefore best performed on the outside of an external window. If the broken pane is on the perimeter of a panel the repair can be performed more easily by hacking out the putty or removing the beading to allow greater access.

If two adjacent panes are broken it makes opening the lead considerably more difficult as the lead is unsupported and may stretch. If this is the case it may be worth considering re-leading the panel.

Assess the overall condition and if any other symptoms are present – perished lead (pay particular attention to the joints), other broken panes, sagging etc – then the panel warrants a more thorough restoration.

▼

Work the leading knife under the flange of the came. Carefully scrape away any cement. Go over the same area several times to remove as much cement as possible.

▼

Open the came by levering up the lead flange to at least 90° from the face of the glass.

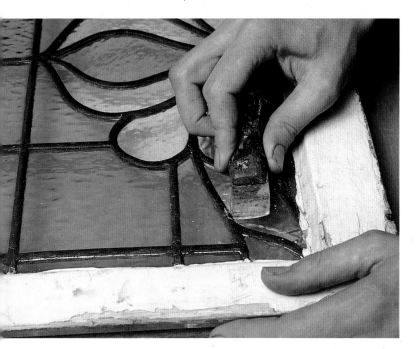

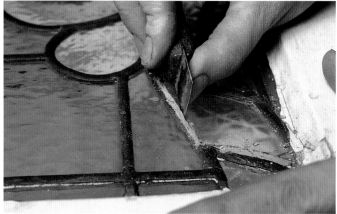

▶

Make several scores on the surface of the glass with a glass cutter. Avoid running the wheel over the same score line twice. Tap the score lines from behind with the end of the glass-cutting tool. Remove the broken glass.

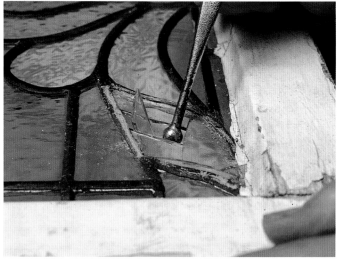

When all the glass is removed, ensure that the channel of the came is completely clean as any cement residue may cause the new glass to break when pressure is applied.

If the shape has a long tail and glass is trapped in the lead it can be crushed using a hammer and punch. Take care not to damage the adjacent piece of glass.

Make a template using a piece of clear glass. Cut the template fractionally smaller than the actual opening to make fitting the replacement slightly easier.

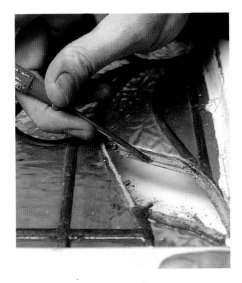
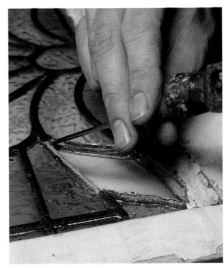
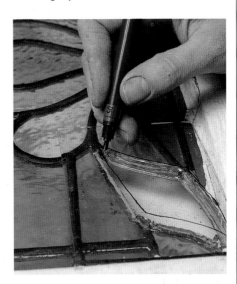

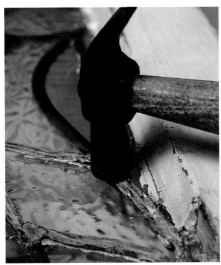
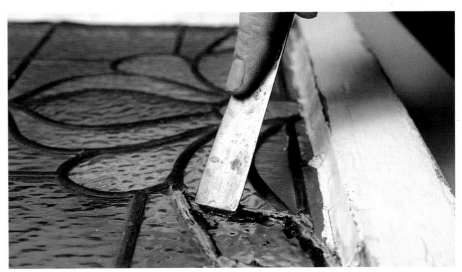

Cut the piece of glass using the template as a guide and insert into the cames. Supporting the glass from behind, draw the blade of the lead knife along the length of the lead repeatedly to flatten it against the glass. Lightly and gently, tap down the corners and joints with a small hammer.

Cement the gap between the flange of the lead and the surface of the glass, forcing it in with a stiff brush. The cement should darken the lead and help to disguise any damage that has occurred during renovation.

# STUDIOS & SUPPLIERS

## UNITED KINGDOM

Abbey Stained Glass
413 Brighton Road
Gateshead
Tel: 0191 479 4265

Peter Allen Studio
28 Kingsgate Workshop
114 Kingsgate Road
London NW6
Tel: 0171 372 1292

Amins Stained & Leaded
Glass Specialists
St Ronan's Road
Monkseaton
Whitley Bay
Tel: 0191 251 4893

Anderstain Glass Art
Unit 17 Alternon Estate
New York Road
Shiremoor
Tel: 0191 251 0951

The Art of Glass
Manor Farm
Wood Lane
Earlswood
Solihull B94 5JH
Tel: 01564 793992

Barron Glass
Unit 4
Old Coalyard Farm Estate
Northleach
Glos GL54 3HE
Tel: 01451 860282

Joseph Bell & Son
68 Park Street
Bristol BS1 5JX
Tel: 01272 268543

Philip Bradbury Glass
83 Blackstock Road
London N4 2JW
Tel: 0171 226 2919

Beverly Bryon
Unit 31 Kingsgate
Workshops
110 Kingsgate Road
London NW6
Tel: 0171 624 3240

Chapel Studios
Hunton Bridge
Abbots Langley
Herts WD4 8RE
Tel: 01923 266386

Decorative Glass
Suppliers
Lilycroft Mill
Dubb Lane
Bingley
West Yorks HX5 9JP
Tel: 01274 510623

Design Lights Stained
Glass Studio
1 Chorley Road
Blackrod
Bolton
Lancashire BL6 5JR
Tel: 01204 667896

Carl Edwards Studio
21 Priory Road
Hampton
Middlesex TW12 2NS
Tel: 0181 941 9975

The Glass Market
Broad Lane
Wooburn Green
High Wycombe
Bucks HP10 0LL
Tel: 01494 671033

Goddard & Gibbs Studios
41–49 Kingsland Road
London E2 8AD
Tel: 0171 739 5653

John Hardman Studios
Lightwoods House
Lightwoods Park
Hagley Road West
Warley B67 5DP
Tel: 0121 429 7609

Hartley Wood & Co
Portobello Lane
Monkwearmough
Sunderland
Tyne & Wear SR6 0ND
Tel: 0191 567 2506

Alisoun Howie
110 Kingsgate Road
London NW6
Tel: 0171 625 8595

Iona Art Glass
The Woodlands
Warkworth
Tel: Alnwick 711533

Ireson Associates
110 Gloucester Road
London NW1
Tel: 0171 328 4132

Kyme's Stained Glass
69 Gilkes Street
Brentall Business Units
Middlesborough
Cleveland TS1 5EH
Tel: 01642 242612

Lankesters Leaded
Lights Ltd
The Grange
Hammond Street Road
Cheshunt
Tel: Cuffley 874621

Steve Law Glass
   Restoration
44 Newman Road
Erdington
Birmingham B24 9AQ
Tel: 0121 373 5175

Lazenby Leaded Lights
3 Killerby Lane
Cayton
Scarborough
North Yorks YO11 3TP
Tel: 01723 585465

Lead & Light Warehouse
35a Hartland Road
London NW1
Tel: 0171 485 0997

Matthew Lloyd-Winder
Stained Glass Studios
63 Amberley Road
London N13
Tel: 0181 886 0213

The London Crown
   Glass Company
Pyghtle House
Misbourne Avenue
Gerrards Cross
Bucks SL9 0HH
Tel: 01494 871966

The London Door
   Company
165 St John's Hill
London SW11 1TQ
Tel: 0171 223 7243

Luxford Stained Glass
   Studio
83 East Barnet Road
New Barnet
London EN4
Tel: 0181 449 7971

MS Glass Decorators
336 Aldridge Road
Streetly, Sutton Coldfield
West Midlands B74 2DT
Tel: 0121 352 0434

Middlesex Glass
2 South Street
Old Isleworth
Middlesex TW7 7BG
Tel: 0181 568 7207

Moor Andrew Associates
14 Chamberlain Street
London NW1
Tel: 0171 586 8181

E S Phillips & Sons
99 Portobello Road
London W11 2QB
Tel: 0171 229 2113

Pilkington Glass
Freepost
Upton
Wirral L49 9AB

Regency Stained Glass
R/o 63 Station Road
Winchmore Hill
London N 21
Tel: 0181 800 9008

Rosegold Designer
   Leaded Lights
Rosegold Workshops
24c North Tyne Ind Estate
Whitley Road
Longbenton
Tel: 0191 270 2772

SGO Decorative Glass
Unit 29
Wearside Business &
   Innovation Centre
Wearfield
Southwick Riverside

Sunderland
SR5 7TA
Tel: 0191 516 8829

Claire Smith
Unit E
Spencer Mews
Spencer Avenue
London N13
Tel: 0181 889 6288

Stained Glass Centre
IWF Ltd
78a Forsyth Road
Jesmond
Newcastle NE2 3EU
Tel: 0191 281 0945

Stained Glass & Period
   Glazing Co
Warryfield Barn
Walford
Ross-on-Wye
Tel: 01989 66331

The Stained Glass
   Workshop
202A Upper Richmond
   Road
East Sheen
London SW14 8AN
Tel: 0181 878 5009

E J Swengler
25 Daglands Road
Fowey
Cornwall PL23 1JN
Tel: 01726 832132

Andy Thornton Archi-
   tectural Stained Glass
Ainleys Industrial Estate
Elland
West Yorkshire HX5 9JP
Tel: 01422 375595

Top Glass
8 Lloyd Court
Gateshead
Tel: 0191 460 3179

Touch of Glass
119 Hornsey Lane
London N6
Tel: 0181 444 9959

Touch of Glass
Rear of 2 Norham Road
Whitley Bay
Tel: 0191 251 1323

Townsend's
108 Boundary Road
London NW8
Tel: 0171 372 4327

The Traditional Stained
   Glass Company
The Studio
13E Queensway
Enfield
Middx EN3 4SA
Tel: 0181 805 2379

Victorian Stained
   Glass Co
The Studio
83 Stamford Hill
London N16
Tel: 0181 800 9008

Youngs
The Workshop
Tredegar House
Newport
Gwent NP1 9YW
Tel: 01633 810612

Unicorn Glass Workshop
Tooses Farm
Stoke St Michael
Bath BA3 5JJ
Tel: 01749 840654

Cate Watkinson Glass
Studio 3
Newcastle Art Centre
69 Westgate Road
Newcastle
Tyneside
Tel: 0191 261 9625

UNITED STATES

Albert Stained Glass
57 Front Street
Brooklyn NY 112202
Tel: 718 625 6464

Altamira Art Glass
202 1/2 S Marion Street
Oak Park, IL
Tel: 708 848 3799

Anything in Stained Glass
1060 Route 47 South
Rio Grande, NJ 08242
Tel: 609 886 0416

S A Bendheim Co Inc
61 Willett Street
Passaic, NJ 07055
Tel: 800 221 7379

Benson Design Studio
237-BN Euclid Way
Anaheim, CA 92801
Tel: 714 991 7760

John Bera Studios
774 N Twin Oaks
   Valley Road
San Marcos CA 92069
Tel: 619 744 9282

Circle Studio
3928 N Elsaton Avenue
Chicago, IL
Tel: 708 275 5454

Colorsmith Stained Glass
   Studio
369 E Burlington
Riverside
Chicago, IL
Tel: 708 447 8763

Creative Stained Glass
   Studio
2533 Kipling, Space A
Lakewood, CO 80215
Tel: 303 232 1762

Dave's Glass Art
1001 W Foothill Blvd
Azusa, CA 91702
Tel: 818 334 0816

Delphi Stained Glass
2116 East Michigan Ave
Lansing, MI 48912
Tel: 800 248 2048

Franciscan Glass Co Inc
100 San Antonio Circle
Mountain View, CA 94040
Tel: 800 229 7728

Franklin Art Glass
   Studios Inc
222 East Sycamore Street
Columbus, OH 43206
Tel: 614 221 2972

Glass Horizons, Inc
333 1st Street NE
St Petersburg FL 33702
Tel: 813 823 8233

Giannini & Hilgart
1359 N Noble
Chicago IL
Tel: 708 276 0951

Harmony Art Glass Co
6323 N Clark
Chicago, IL

Jennifers Glass Works Inc
4875 South Atlanta Road
Smyrna, GA 30080
Tel: 800 241 3388

Mosaic Muse
2629 N Troy
Chicago, IL
Tel: 708 943 1810

Mountain Light
 Glassworks
600 Central Avenue
Highland Rark, IL
Tel: 847 432 2090

Nostalgic Glass Works Inc
1004 Brioso Drive
Costa Mesa, CA 92627
Tel: 714 646 7474

Old World Restoration
1702 N Milwke Avenue
Chicago, IL
Tel: 708 862 5435

Regina Art Glass Inc
9435 Irving Park Road
Schiller Park, IL 60176
Tel: 1 800 371 8331

Robin's Stained Glass
 Studio
11424 N 71st Street
Scottsdale, AZ 85254
Tel: 602 998 3430

Stained Glass Emporium
4031 Oakton
Skokie, IL
Tel: 847 677 0811

Stowell Studio
600 Forest Drive
Bailey, CO 80421
Tel: 303 838 5528

## CANADA

Artistic Glass Company
2112 Dundas St West
Toronto
Ontario M6R 1W9
Tel: 416 531 4881

Bullas Glass Ltd
15 Joseph Street
Kitchener
Ontario N2G 1H9

P & B Stained Glass
 Studio
125 Montreal
St John
New Brunswick E2M 5E8

Fantasy In Glass
 Glassworks
703 The Queensway
M8Y 1L2

Hollander Glass Canada
 Inc
Toronto
3095 Universal Drive
Mississauga
Ontario L4X 2E2
Tel: 905 625 7911

Lakefield Stained Glass
8 Burnham Street
Lakefield
PO Box 908
Ontario K0L 2H0

Victor Thompson
1434 42nd Street SW
Calgary
Alberta T3C 1Z3
Tel: 403 246 1301

VH Designer Glass Plus
1680 Lakshore Road W
Port Credit
Tel: 905 822 7828

## AUSTRALIA

Astor Glass Industries
154 Hume Highway
Lansvale NSW 2166
Tel: 02 726 2766

Bevelite Glass Pty Ltd
2/14 Anvil Road
Seven Hills NSW 2147
Tel: 02 674 5040

Castlead Works
129 Boundary Road
Peakhurst
NSW 2210
Tel: 02 533 4333

Creative Strained Glass &
 Lead Line Designs (1974)
624 Beaufort Street
Mt Lawley WA 6050

Design Centre of
 Tasmania
Cnr Brisbane & Tamar
 Street
Launceston, TAS 7250
Tel: 003 315506

Dowell Australis Ltd
PO Box 244
Preston Vic 3072
Tel: 03 484 0591

Glassform
Level 6
51 Queen Street
Melbourne, Vic 3000
Tel: 03 614 5711

Nielsen & Moller Pty Ltd
PO Box 289
Caringbah NSW 2229
Tel: 02 525 9933

Seraphic
PO Box 110
Welland SA 5007
Tel: 08 347 0377

## ARCHITECTURAL SALVAGE

### UNITED KINGDOM

Alscott Renovation
  Supplies
The Stable Yard
Alscot Park
Stratford-on-Avon
Warwickshire CV37 8BL
Tel: 01789 450861

Architectural Antiques
1 York Street
Bedford
Tel: 01234 213131

Architectural Heritage
Taddington Manor
Taddington
Nr Cutsdean
Cheltenham
Gloucester
Tel: 01386 73414

Architectural Heritage
107-109 Highcross Street
Leicecster
Tel: 01533 515460

Architectural Antiques &
  Salvage Centre
27 Dalton Lane
Hackney
London E8
Tel: 0171 923 0783

Architectural Salvage
  Register
043 203221
*For a £10 registration fee
they will search for items
on your behalf or find a
buyer for items you want
to sell.*

Aspmead Reclaimed
  Building Materials Ltd
Kirkhams Yard
Cadley Hill Road
Swadlincote
Derbyshire DE11 9EQ
Tel: 01283 550729

Cromwell Reclamations
Benson Hall
Station Road
Buntingford
Herts SG9 9HT
Tel: 01763 71127

Brighton Architectural
  Salvage
33/34 Gloucester Road
Brighton
Sussex BN1 4AQ
Tel: 01273 681656

Cardiff Reclamation
The Gardenstore
Newport Road
St Mellons
Cardiff
Tel: 01222 798332

Conservation Building
  Products  Ltd
Forge Lane
Cradley Heath
Warley
West Midlands B64 5AL
Tel: 01384 64219

Dorchester Reclamation
  & Salvage
Midway Down Farm
Copyhold Lane
Winterbourne Abbas
Dorchester
Dorset DT2 9LT
Tel: 01305 889779

Fens
46 Lots Road
London SW10
Tel: 0171 352 9883

Paul Hayes Architectural
  Antiques
Crumblies, The Pit
Hare Lane
Gloucester
Tel: 01452 301145

The House Hospital
68 Battersea High Street
Battersea
London SW11 3HX
Tel: 0171 223 3179

House of Steel
400 Caledonian Road
London N1
Tel: 0171 607 5889

In Doors Ltd
Mill Street
East Milling
Kent
Tel: 01732 841606

Bruce Kilner
Ashton's Field Farm
Windmill Road,Worlsey
Manchester, M28 5RP
Tel: 0161 702 8604

In Situ
28 Seymour Grove
Old Trafford
Manchester
Tel: 0161 848 7454

Lassco
St Michael & All Angels
  Church
Mark Street
off Paul Street
London EC2
Tel: 0171 739 0449

Magpies Emporium
Park Road
Farringdon
Oxon, SN7 7BP
Tel: 01367 242805

Nottingham Architectural
  Antiques
668 Woolborough Road
Nottingham
Tel: 01602 605665

Peco of Hampton
72 Station Road
Hampton
Middlesex
Tel: 0181 979 8310

Old Mill Antiques Ltd
The Old Mill
Main Street
Kinbuck
Perthshire, FR15 0NJ

Oxford Architectural
  Antiques
The Old Depot
Nelson Street
Jerico
Oxford OX2 6BE
Tel: 01865 53310

Oxford Architectural
  Salvage
16–18 London Street
Farringdon
Oxfordshire
Tel: 01367 243840

Salvo Magazine
PO Box 1295
Bath
Tel: 01225 445387
*For details of architectural
dealers nationwide and
overseas.*

Solopark Limited
The Old Railway Station
Station Road
Nr Pampisford
Cambridge CB2 4HB
Tel: 01223 834663

Tatters of Tyseley
590 Warwick Road
Tyseley
Birmingham B11 2HJ
Tel: 0121 707 4351

Townsends
81 Abbey Road
London NW8
Tel: 0171 624 4756

Andy Thornton
  Architectural Antiques
Victoria Mills
Stainland Road
Greetland
Halifax
West Yorkshire HX4 8AD
Tel: 01422 377314

Victorian Pine
298a Brockley Road
Brockley
London SE4 2RA
Tel: 0181 691 7162

Walcot Reclamation
108 Walcot Street
Bath
Tel: 01225 444404

The Warehouse
17 Wilton Street
Holderness Road
Hull
N Humberside
HU8 7LQ
Tel: 01482 26559

## UNITED STATES

1874 House
8070 SE 13 Avenue
Portland
Oregon 97202

ADI
2045 Broadway
Kansas City
Missouri 64108

Architectural Salvage
  Cooperative
1328 East 12th Street
Davenport

Architectural Salvage
  Warehouse
337 Berry Street
Brooklyn
New York
NY 11211

Florida Victorian
  Architectural Antiques
901 W1St (Wwy 46)
Sanford
Florida 32771

Great American Salvage
34 Cooper Square
New York
NY 10003

Housewreckers NB &
  Salvage Co
396 Somerset Street
New Brunswick
New Jersey 08901

Kayne & Son
Custom Forged Hardware
76 Daniel Ridge Road
Candler
North Carolina 28715

New Boston Building
  Wrecking Co Inc
84 Arsenal Street
Watertown
Massachusetts 02172

Ohmega Salvage
2406 San Pablo Avenue
Berkeley
California 94702

Off the Wall Architectural
  Antiques
950 Gleeneyre Street
Laguna Beach
California 92651

Old Home Building &
  Restoration
PO Box 384
West Suffield
Connecticut 06093

Old House-New House
  Restoration
169 N Victoria Street
St Paul
Minnesota 55104

Pasternak's Emporium
2515 Morse Street
Houston
Texas 77019

Red Baron's
6230 Roswell Road
Atlanta
Georgia 30328

Salvage One
1524 S Sangamon Street
Chicago
Illinois 60608

Second Chance
230 7th Street
Macon
Georgia 31202

Speciality Building Supply
PO Box 13529
Jackson
Mississippi 39326

United House Wrecking
  Corporation
535 Hope Street
Stamford
Connecticut 06906

Urban Archaeology
137 Spring Street
New York
NY 10012

Victorian Warehouse
190 Grace Street
Auburn
California 95603

You Name It Inc
Box 1013
Middletown
Ohio 45044

LIGHTING

UNITED
KINGDOM

Albert Bartram
177 Hivings Hill
Chesham
Bucks HP5 2PN
Tel: 01494 783271

Ann's
34a/b Kensington Church
  Street
London W8 4HA
Tel: 0171 937 5033

Antique & Decorative
  Lighting Dealers
  Association
Littleton House
Littleton
Somerset TA11 6NP
Tel: 01458 72341

Ashley & Rock Ltd
Morecambe Road
Ulverston
Cumbria LA12 9BN
Tel: 01229 583333

Besselink & Jones
99 Walton Street
London SW3 2HH
Tel: 0171 584 0343

Best & Lloyd Ltd
William Street West
Smethwick
Warley
West Midlands, B66 2NX
Tel: 0161 558 1191

Chelsom
Unit 4
Hurlingham Business Park
Sullivan Road
London SW6 3DU
Tel: 0171 736 2559

Christie's
8 King Street
London SW1Y 6QT
Tel: 0171 839 9060

Classicana Ltd
Indiwell Mill
Swimbridge
North Devon EX32 0PY
Tel: 01271 830834

Classic Reproductions
Unit 16
Highams Lodge Business
  Centre

Blackhorse Lane
London ED17 6SH
Tel: 0181 531 8627

John Cullen
216 Fulham Palace Road
London W6 9NT
Tel: 0171 381 8944

Davinghi
117 Shepherds Bush Road
London W6
Tel: 0171 603 5357

Dernier & Hamlyn
47/48 Berners Street
London W1P 3AD
Tel: 0171 580 5316/8

Elite Lighting
18 Bromley Hill
Bromley
Kent BR1 4JX
Tel: 0181 290 0371

Elstead Lighting
Unit 7, Forge Works
Mill Lane, Alton
Hampshire GU34 2QG
Tel: 01420 82377

The End of the Day
  Lighting Company
54 Parkway
London NW1 7AH
Tel: 0171 485 6846

Forbes & Lomax
205b St John's Hill
London SW11 1TH
Tel: 0171 738 0202

Fritz Fryer Decorative
  Antique Lighting
12 Brookend Street
Ross-On-Wye
Herefordshire HR9 7EG
Tel: 01989 67416

Jones Lighting
194 Westbourne Grove
London W11
Tel: 0171 229 6866

Kensington Lighting Co
59 Kensington Church
  Street
London W8 4HA
Tel: 0171 938 2405

Lewden Electrical Industries
5 Argall Avenue
London E10 7QD
Tel: 0181 539 0237

Lighting Association
Stafford Park
Telford
Shropshire TF3 3BD
Tel: 01952 290905

Lights on Broadway
17 Jerdan Place
Fulham Broadway
London SW6 1BE
Tel: 0171 610 0100

Magic Lanterns
By George
23 George Street
St Albans
Hertfordshire AL3 4ES
Tel: 01727 865680

Marston & Langinger
Geroge Edwards Road
Fakenham
Norfolk NR21 8BNL
Tel: 01328 864933

W Moorcroft
Sandbach Road
Burslem
Stoke-on-Trent
Staffordshire ST6 2DQ
Tel: 01782 214323

Olivers Lighting Company
6 The Broadway
Crockenhill
Swanley
Kent BR8 8HJ
Tel: 01322 614224

Philips Lighting
City House
420–430 London Road
Croydon CR9 3QR
Tel: 0181 665 6655

Roger of London 344
Richmond Road
East Twickenham
Middlesex
Tel: 0181 891 2122

Sotheby's
34–35 New Bond Street
London W1A 2AA
Tel: 0171 493 8080

Stiffkey Lamp Shop
Stiffkey
Nr Wells-Next-the-Sea
Norfolk NR23 1AJ
Tel: 01328 830460

Stuart Interiors
Barrington Court
Barrington, Ilminster
Somerset TA19 0NQ
Tel: 01460 40349

Sugg Lighting
Sussex Manor Business
  Park
Gatwick Road, Crawley
West Sussex RH10 2GD
Tel: 01293 540111

Christopher Wray
600 King's Road
London SW6 2DX
Tel: 0171 736 8434

# INDEX

Architectural Association 23 Kirsty Maclaren11, 34 35, 38, 39, 42, 43, 46, 47, 50 top, bottom left and centre, 51, 58, 59, 86, 87 , 88, 89, 90, 91, 94, 95, 102, 103, 106 right, 107, 110, 111, 114, 115, 118 top, 119, 134, 135, 138, 139, 142, 143, 144, 145, 146, 147, 155 Kevin Mallet 6, 7, 10, 42 Pictures for Print 14, 15, 18, 19, 22, 26, 27, 30, 31, 50 bottom right, 54 bottom, 55, 62, 63, 66, 67, 70, 71, 74, 75, 78, 79, 82, 83, 98, 99, 106 left, 118 bottom, 122, 123, 126 left, 127, 130, 131 top left and bottom left, 142 left, 150, 151, 154, 158, 167, 168, 169, 170, 171, 172, 173, 174, 175, 177, 178, 179, 180, 181 National Trust 54 top Christopher Wray 126 right, 131 right

Pictures for Print would like to thank Ed Mervish of Honest Ed's Restaurants, Toronto, Canada and The King's Head Hotel, Enfield, Middlesex for their cooperation and permission to photograph the glass in their establishments.